W9-DAR-254

After Silence

After Silence

A History of AIDS through
Its Images

AVRAM FINKELSTEIN

UNIVERSITY OF CALIFORNIA PRESS

University of California Press, one of the most
distinguished university presses in the United
States, enriches lives around the world by
advancing scholarship in the humanities, social
sciences, and natural sciences. Its activities are
supported by the UC Press Foundation and by
philanthropic contributions from individuals
and institutions. For more information, visit
www.ucpress.edu.

University of California Press
Oakland, California

Library of Congress Cataloging-in-Publication Data

Names: Finkelstein, Avram, 1952- author.
Title: After silence : a history of AIDS through its
 images / Avram Finkelstein.
Description: Oakland, California : University of
 California Press, [2018] | Includes index.
Identifiers: LCCN 2017029451| ISBN 9780520295148
 (cloth : alk. paper) | ISBN 9780520968028 (ebook)
Subjects: LCSH: AIDS (Disease) and the arts—United
 States. | AIDS activists—United States. |
 Finkelstein, Avram, 1952- | Silence = Death
 Project (Artists' collective) | Gran Fury (Artists'
 collective) | ACT UP (Organization) | AIDS
 (Disease)—United States—History.
Classification: LCC NX180.A36 F56 2018 | DDC
 701/.03—dc23
LC record available at
https://lccn.loc.gov/2017029451

27 26 25 24 23 22 21 20 19 18
10 9 8 7 6 5 4 3 2 1

CONTENTS

PLATES

Color plates follow page 88.

Illustrations

Illustrations

It's commonly understood that the assassination of Archduke Ferdinand in 1914 set in motion the political events of the entire twentieth century. I've had my ear to the ground since the turn of the twenty-first, listening for a single incident that might trigger consequences for the century ahead. The 2016 American election was undoubtedly that moment. Our having joined the global march of protofascism will no doubt lead to myriad novel expressions of it, beginning with the shift away from the oligarchies of oil to joint American-Russian speculation in hackable information technologies, the spoils of our combined surveillance economies, a transition that has just been openly formalized.

On Inauguration Day, 2017, a day of noncompliance was called, the J-20 Art Strike. According to *The Guardian*, an art strike was futile. I'm surprised to hear myself say this, since I'm dubious of the art world and tend to thrown in with pitchforks and torches as a rule, but we can't predict the impact of a political action before we take it, so political agency can never be referred to as futile. Ever.

Besides, assessing political engagement as a success or a failure is to frame it in the language of capital—a mistake, I believe, given that capitalism

is in the chokehold of totalitarianism. Success, as a measure, imagines polit-ical resistance as a result, or a "thing" to acquire. Resistance is not a thing, or an object, or even an objective. It's a project, and it can't be acquired. It can only be activated, and while it dies the second we cease participation in it, it needs no endpoint to express its efficacy, because it's immediately reborn when someone else takes it up.

When I was sixteen, a student came into the common room of the Quaker school in my town, wanting to copy a poster he'd just brought back from the May 1968 Strikes in France. He asked me to help him, and that's how I learned to silk-screen. It's also what gave me the idea, eighteen years later and in a period of tremendous personal despair, to suggest making a poster to the Silence = Death collective, a year before the formation of ACT UP, the community of AIDS activists who would soon set to work defining its meaning.

So this book is for the sixteen-year-old in each of us, where the power resides to change our world, and who will hopefully be convinced by these pages that while there is suffering, political resistance is a project every one of us is responsible to take up.

ACKNOWLEDGMENTS

When curator Helen Molesworth first leafed through the journal I kept during the years surrounding the formation of ACT UP, she said, "I don't know what, but something needs to be done with this," and her cocurator Claire Grace said, without missing a beat, "It needs to be a book." So I want to thank them both for planting the seed.

In the same breath, I owe to my ACT UP comrade Debra Levine, who introduced me to Helen after interviewing me about Gran Fury's *The Four Questions* for her incisive work on that poster and ACT UP affinity groups, thanks for opening my eyes to the performative nature of my own work and for having written *How to Do Things with Dead Bodies*, a powerful account of the ACT UP political funerals.

I owe endless gratitude to the fireworks display that is Aaron Lecklider, at University of Massachusetts, for suggesting and organizing my first solo show as an artist after having hidden behind collective practices for decades, and for teaching me more about myself in the process than any curator ever has, and to his partner, Brian Halley, Senior Editor at University of Massachusetts Press, who was generous, insightful, thoughtful, and encouraging throughout the earliest iterations of this book, long before it finally found its way.

I need to thank Michelangelo Signorile, whose plain-spoken bravery I studied to help summon the power it took to finally say what I mean and stand by it, and Sarah Schulman, an early reader who also had the Jewish good sense to assemble the ACT UP Oral History Project, providing generations of students of social movements with primary source material that might otherwise have disappeared. I'd also like to thank my old partner in crime filmmaker Vincent Gagliostro and his producer Bryce Renninger, for allowing me to adapt the title of their documentary on my Flash Collective work for this book; Larry Kramer, who with all the directness of a Jewish uncle finally barked at me, "Stop *talking* about the book and *do the work*"; Charles Kreloff, for lending me his spine every time I needed it most; Hugh Ryan, one of the smartest people I know, for his generosity as a reader, his razor-sharp insights into all things queer, and his bottomless encouragement; Dan Fishback, for his patience, his wildly original emotional intelligence, human neighborliness, uncompromising grasp of how stories are told, unswerving belief in the meaning of my work, for lending me his brain in so many ways it would be pointless to list, and for framing the 2016 election as a single leitmotif; Ian Bradley-Perrin, for inviting me to do my very first skill-sharing workshop and opening a world to me in the process; Ted Kerr, the most ethical person I know, for naming it the Flash Collective and then forgetting he did it, for consistently challenging me in ways that are impossible to overlook, and for changing my life with one simple phrase, "You need to meet Amy Scholder"; Amy Scholder, who helped me find the perfect home for this project and then guided me through it with the rarest form of intellect, the kind I have unceasing admiration for, intellect that is soulful, inventive, searing, and entirely centered in humanity; and Niels Hooper, Executive Editor at the University of California Press, for his immediate grasp of what I am trying to accomplish in these pages.

But there never would have been a book—because I never would have survived the things I witnessed—without my lesbian sister, Maxine Wolfe,

who taught me everything I know about queer family and patiently held me together with spit and glue during the worst of times, and endured decades of my neurotic ruminations with heart, integrity, humor, loyalty, character, and smarts, all perfectly seasoned with haimish working-class candor; and my gay brother, Chris Lione, who never allowed his own frailties to prevent him from steeling me against the wilds of human mortality, and who has endured the worst of me with unflagging devotion and unreserved generosity of soul, managing it all with a deeply rooted queer irony that has kept me howling for decades.

And finally, to those I meant to say goodbye to but did not know how to, or thought I had but did it too quietly, or misread how much time was left for me to do it, or was not ready to or too selfish to: I'm sorry. And to those who said goodbye to me but I did not know that's what was happening, or I was too embarrassed by the intimacy of it, or I was crying instead of thanking you: thank you.

This book is my interpretation of my own experience of events as they unfolded around me, and I have tried to recount these events as accurately as I can, based on my recollection. Where events adhere to matters of public record, I have referred to public accounts, and so any remaining factual errors are unintentional. I trust readers will understand that while I share insights on these pages about some people I have known, these people have their own stories and so I have intentionally tried to avoid telling those, and focused on the ways our stories overlapped or had personal meaning to me. Where I am unclear about details, I have tried to indicate my lack of certainty. Where there is dialogue, it is reconstructed from my memory of those exchanges.

Introduction

AIDS 2.0

In 1981 there was a tempest on the horizon, and anyone with eyes could see it coming. In no time at all it was shaking the doors.

In spite of the fiercely swirling vortex, the outlines of its cultural meaning were still discernable. Playing out as it did, in the public sphere, it was impossible to overlook. So our assumptions about HIV/AIDS formed quickly in our shared spaces, from policy to pop culture, and almost as immediately they began to crystallize into a canon, one that has enveloped us ever since.

Now, after decades of shell-shocked reflection, those who survived this moment appear to be ready to speak about it again, and new canons are springing up, canons that have become the subject of contemplation for a new generation of historians, archivists, artists, and activists, who were born in the midst of HIV/AIDS and are struggling to make sense of the worlds they both inherited and missed. A growing number of narrative films, documentaries, archival projects, theater revivals, books, and gallery exhibitions have already been devoted to the topic, and these were just the first to the gate. There are many more major undertakings in the pipeline. We are in a second vortex, AIDS 2.0, and it is only just beginning.

Why now?

In cultural terms, it was kick-started by two corresponding anniversaries, the thirtieth anniversary of AIDS and the twenty-fifth anniversary of

the resistance coalition that helped foreground it in the American mind, ACT UP (AIDS Coalition to Unleash Power). But what does that mean if the thirtieth marker denotes the first *New York Times* article about AIDS, on July 3, 1981, and not the *New York Native* story that preceded it on May 18, or if it was a twenty-fifth anniversary that overlooked the Denver Principles of the 1983 AIDS Forum at the National Lesbian and Gay Health Conference, principles ACT UP was forged on?

It means that while academic consideration of our early responses to HIV/AIDS has been stacking into a fairly high wall, on the other side of this wall history is a process of generalization, an elevator pitch, and our media landscape privileges the stories that are easier to tell. Within our public spaces, complexities are frequently slipped beneath the shadows of our zeitgeists, and well-worn media tropes supplant more disorderly truths.

AIDS 2.0 is not the story of HIV/AIDS. It is its storytelling. It's the ferocity with which Internet mash-ups convert an AIDS past into memes, the evanescence of articles about chemsex by ravenous, multichannel media outlets like VICE, and the rapidity with which stories of HIV in trans communities get passed across the perpetual motion machine of social media. We live in a world of such accelerated content consumption that the historical synopsis offered in the Oscar-nominated *How to Survive a Plague* easily overshadowed the expansive granularity the ACT UP Oral History Project (AUOHP)—spanning fifteen-years of interviews—and a generation of feminist and queer scholarship mapping the counternarratives of AIDS held little sway over whether the mainstream media showed interest in the anemic representation of black artists in the *Art, AIDS, America* exhibition, or what that might actually tell us. Scholarly consideration of AIDS deepens our understanding immeasurably, but it simply cannot outpace how we talk about it in our cultural wilds. So the following pages are grounded in the popular storytelling of AIDS, not its theory, and this will not be a book about

the meaning made of Silence = Death within academia. It's about the ninety-five-foot video wall made of it by U2's production designer for the band's 2015 tour.

But the key dilemma presented by AIDS 2.0 is not simply how it talks about AIDS in the present. It is the fact of its having been built on speciously laid groundwork to begin with, the mediated storytelling that has thrown off every plumb line since we were first handed the phrase GRID (Gay-Related Immune Deficiency). The aggregate account we popularly accept as the "History of AIDS" is a saga that torques our understanding toward one appealing corner of it, the generational foundation of HIV manageability in a post-protease inhibitor world. It is a significant piece of the story, and untold lives were saved by it, but it has been problematically shaped through popular discourse and collective memory into a dominant narrative more supportive of political and economic power structures than of grassroots organizing, the use we believe this narrative serves. It's the heroic tale of an embattled community demanding the accelerated drug research that paved the way for pharmaceutical advances offering viral suppression to patients with access, a parable that "proves" the system works in a way so predicated on the presumptive neutrality of whiteness, male physiology, pharmaceutical intellectual property rights, and a deregulation-mad political landscape that it turns its back to the parts of the pandemic that continue to rage, offering a sense of resolution in its place. Resolution is fine for bedtime stories, but this particular synopsis has tipped activists born after 1987 who are doing work around HIV/AIDS into a historiographical tailspin, superimposing ethical quandaries of extreme proportions in the process. If HIV/AIDS is manageable, how do you convince people to care about the millions of lives beyond the reach of treatment access, or about decades of HIV criminalization case law? How do you reignite the will to fund research into a cure for HIV/AIDS, the only kind of pharmaceutical intervention that might finally eradicate stigma? And if AIDS only mattered where white people were

threatened by it, and if the only story that matters is how white people responded to it, what becomes of the majority of people still trapped in its furious spin?

This is not to deny that the struggle to expand access to life-saving drugs was essential: people were dying in hospital corridors, and there was no other choice. It is to say that here in the twenty-first century the *narrative* we have adopted to represent that struggle reinforces a social investment in the institutional systems of drug research and approval, with no mention of its continued repercussions, or acknowledgement that demands to speed the drug approval process was a benefit to the system, not a sacrifice. Unquestioning support of this narrative means the political uses outside the structures that profit from it remain ancillary. This book is an attempt to help widen this narrative for those of us who prefer to resist institutionalized power, using images by the two collectives responsible for the messaging most commonly associated with the early years of the pandemic in New York, the Silence = Death collective and Gran Fury. These images may already be familiar to you, though you might not be aware of where they came from. Journalists, historians, curators, critics, and scholars have been examining this work since the early days of the crisis, and it is universally deployed to represent it. It is also held up as an example of effective political communications, because it is so utterly concise.

The process of getting it there, however, was not. The Silence = Death poster is so saturated in codes, it took six months to finalize. And examining any Gran Fury image without the full context of the years of work by scores of activists absorbed in the issues it articulates completely unplugs it from its power source. These images are essential parts of our elevator pitch for this moment, yet concrete insights into what made these images tick can only come in long form. But I did not write this book to offer an analysis in support of the continued deployment of this work as fetishes of cultural productivity. That would serve no political purpose.

I wrote this book because I believe there is a particular problem with exhibitions and texts organized around the premise that the AIDS agitprop of ACT UP New York can be used as a model for how to mobilize communal responses during moments of crisis. It can be, but unlike the film and video from that period, which has context built into it, once these posters are isolated from the environment they were created for, they become oddly mute. When they are stripped of the native meanings that were activated in situ, their social proportion can't be approximated on a gallery wall with any degree of accuracy. Their "objectness" overtakes them, and no amount of didactic material adequately compensates for this effect. Work that easily sank its teeth into the scruff of your neck in a cluttered cityscape is immediately collared on a blank, white wall. After years of lecturing about this conundrum, I have become increasingly convinced that the best way to understand this work is to run loose inside its brain. This work becomes activated in its performance, in its doing. It was never meant to have use in a gallery setting, and as a consequence, it doesn't. So I will try to reattach this work to its political intentions within its social context, in the hope of recasting it in a corrected social proportion, as lived experience rather than as archival material, to enable readers who were not there to still encounter it "in the moment."

To adjust this proportionality, I need to first point to something easily overlooked. These posters were crafted for and within a unique constellation of social effects, a moment when a media corps on the brink of deregulated consolidation and experiencing the infancy of the $\frac{24}{7}$ cable news cycle flooded the airwaves with stories catering to a panicked public having nightmares about airborne HIV transmission, and it was lucrative to do so. If you were not there to see how this body of work played out in the late-twentieth-century commons it was designed for, when people thought you could "catch" HIV from a mosquito bite and journalists had no trouble pitching a story about it to their editors or producers, you would have no sense

that the efficacy of this work is located not solely in its ability to communicate but also in its ability to read social context. This analysis is an attempt to explore some of those gradations of context in a way that is centered in grassroots practice and that is granular enough to provide insight into the strategic thinking that drove this work into being.

I want to also point out that studying this agitprop as strictly determinative masks something else easily forgotten, something far more politically useful from an organizing perspective. This work is still trotted out to *tell* us something about ourselves, and for good reason: most of it is didactic to the point of flat-footedness, and it pilfers advertising vernaculars staged in the declarative. But the strategies behind it were not declarative. This work is wholly rooted in the question, and in the most easily overlooked subtext of the commons—the motivating principle behind the activation of social spaces: dialogue. It was an act of call and response, a request for participation, because lives were, and still are, at stake. The thinking behind it is as grounded in listening as it is in speech, and listening is essential to the intersectionality required to finally eradicate HIV/AIDS. So this book is intended to be a reminder that while we have a greater need for the resolution declarations imply, when it comes to HIV/AIDS, the struggles ahead of us still reside in the question mark. I hope to help situate some of those questions.

Images are funny things. They are the driving force in an image culture, and although we are inundated with them well past the point of familiarity, outside the professions that make or explain them to us, we actually have no place to consider them for ourselves. They surround us, so we may think we understand them. But they are really just the givens of a media landscape—the sky, rocks, and trees—and most of us barely think twice about them as they pass in front of us like the background in a cartoon.

Which might partially explain why we appear to have forgotten, or have adapted to, the many ways the story of HIV/AIDS has been absorbed,

colonized, and modified by institutional telling of it, an evolutionary process that has bent how we visualize the political, social, and cultural dimensions of it from its recognizable form. Institutional distortions have skewed our understanding of its many political meanings since the beginning, even for stakeholders in the moment, and that is especially true for the images associated with it, which have been reduced to passive body doubles for AIDS activism and been claimed in the name of cultural capital.

In 1992 Warner Brothers asked for permission to include the Silence = Death poster in *The Pelican Brief*. Even after a rather protracted set of conversations about the company's intentions for it, it did not surprise me to see it reduced to a visual code for AIDS activism in the opening protest sequence. In 2012 I had a far briefer exchange with the producers of *How to Survive a Plague* about the same image. *Plague* is a documentary that profiles activist stakeholders, yet the producers were satisfied to use this image in the same way Warner Brothers did, as a code that transports us to the center of an activist world, with little insight into the intricate political organizing that delivered its participants there. The use of Silence = Death in *Plague* exemplifies how decades of critical analysis of this particular image has had little impact on its functional meaning within our public narratives about AIDS. In this context the image is little more than the detritus of decades of institutional storytelling, a cryptogram flung into its midst to indicate the parts of the story it will not be committing to film. Silence = Death may have had a set of political meanings that represented critiques the subjects of the film rallied behind, but its use as a representation of political meaning has none.

Plague shows us aspects of the winding path to protease inhibitors, but neglects to look down at the intricate paving stones that led there. Those intricacies are the focus of this book, and I will walk you through the moments leading up to ACT UP, beginning with the surprisingly pervasive misapprehension—even among stakeholders—of the image most often used to indicate AIDS activism. For those who have not cited the most accurate

(and earliest) accounting of the cultural production of ACT UP—*AIDS Demo-graphics*, by Douglas Crimp and Adam Rolston—the blur of cultural storytell-ing has made it acceptable to say that Gran Fury designed the Silence = Death poster, collapsing these two collectives into one, making them barely dis-tinguishable in terms of intention, output, and affect. But a simple timeline reveals it could not have, since the entire output of the Silence = Death col-lective was completed before Gran Fury existed. I will explain how these two collectives came to be conflated, and then tease them apart for you, detail-ing the genesis of each and the conversations that led to them, their social and political differences, some of the arguments and accords that provide insights into each of their practices, and a family tree of the social connec-tions between them.

In terms of the voice and the structure of this book, scholars are likely to find my broad use of language confounding, but I am not a scholar myself, and I use words in their vernacular sense. Where I employ art references, I also favor the vernacular, for the benefit of readers not versed in art history. I also realize there will be scholarly readers who have already come to think of the work described here as belonging within art canons, but it was not intended to be art, as many of the individuals in Gran Fury have repeatedly stated on the record, and I will share my own perspective on that. And for readers who find my political perspective too doctrinaire, I ask your indul-gence. Those who know me know how easily I lapse into manifesto, and if you'd ever been to dinner with my family, you would understand it as both inherited and authentic. My political perspective was certainly not shared by every artist, curator, scholar, or activist I worked with, nor will it neces-sarily be shared by you, but I was far from the only one who read this politi-cal moment in this way, and it can't be discounted when considering any of the cultural production I had a hand in. This is a book based on the meaning I have made from my own analysis of the political events and cultural pro-duction that shaped my life. I acknowledge the decades of scholarly

interpretations of the same events and work product that have shed light on the questions of institutional power in meaningful ways, some that have actually deepened my own practice, and others that contradict it. What I offer here are my own interpretations, as a maker, not a scholar, and as a consequence they will be founded in practice, not theory.

I was raised in museums and schooled in the arts, and I have trafficked in cultural production my entire life, but my lineage is more largely a political one: my parents, both from Jewish, working-class backgrounds, met at an International Workers Order camp where my dad's mom was a cook, and they were members of the American Communist Party. I say this to explain why, having finally warmed up to calling myself an artist again, I primarily think of myself as a propagandist. Over a decade before Gran Fury existed, my art practice had been molded by the same *situationist* critiques the collective would come to deploy—the blend of Marxism, Dadaism, and Surrealism that explained "society" as an ongoing spectacle of social and political distractions staged by those who hold power in order to solidify the colonial supremacy of class, whiteness, and patriarchy—but I came to these critiques before I'd developed a theoretical understanding of them in art school. My personal political history led me to reason that even though the Situationist International had a hand in the riots in France in 1968 via its participation in the Sorbonne Occupation Committee in Paris, the factory workers who walked off the job during the strikes had likely never read *Society of the Spectacle* by Guy Debord. Their agency was rooted in the real-world implications of capital, not a theoretical consideration of it, and this has always served as a living example of the difference between theory and practice for me. So I may lean on critical theory from time to time, but the bulk of my arguments will be made from the factory floor. It is how I was raised, who I am, and how I see things.

As a result, I choose not to engage with scholarly theory. This is simply not a book about that. Rather, I am throwing my hat into the ring from

outside academia, hoping it lands in a useful way, with the goal of enriching our understanding of the making of this work for readers both inside and beyond its walls, by offering an honest appraisal of it from my own perspective: details of how it felt, *to me*, to produce it at the time, how it felt to be drawn into the art world through the back door as everyone I knew was dying, my impressions of how the art world reckoned with our work before, during, and after this moment, and how it feels to me now to be considered part of this landscape of cultural production once again, during AIDS 2.0.

Since I believe social context provides a means to understanding this work and this moment, I use the language of the day in some passages to explore the ideas some people were grappling with while imagining their own particular ideas of what "community" meant at the time. This book makes no attempt to tell every story in New York at the time, and I acknowledge these are stories that reflect the lens of my own privileges of gender and whiteness and that, without neutralizing the contributions of my collaborators who were not white or male, may reflect the privileges of other members of the collectives I was a part of. Where I appear to refer to the counternarratives of gender or race in a cursory way, it is a reflection of my sensitivity to the fine lines between gatekeeping or allyship and colonization, and it is my attempt to foreground their meaning without speaking on behalf of other activists, artists, writers, and thinkers who are doing defining work around these questions. Each chapter takes on a political or social issue as it raged through the circles I traveled in, and I hope to paint a picture vivid enough that you feel like a participant and perhaps draw conclusions, where they might be relevant, from the perspective of different lived experiences.

This book is not based solely on memory. Much of the source material I drew on has been in bins under my bed since its creation, material including original ACT UP backgrounders for actions (some of which I co-wrote), congressional bills (some based on research I helped assemble), eulogies, written confessions by dying colleagues to their infant children, press clippings,

a copy of Ed Meese's Civil Rights Commission's findings on AIDS slipped to us by a member of the commission itself, The ACT UP FBI files, meeting notes and flyers, and drafts of articles I wrote about ACT UP, as well as texts for talks and teach-ins, original sign-in sheets for general meetings and the subcommittees I served on, sketches for posters and ephemera from other collectives, a journal I kept that chronicles the nightmares I had right after Don's death, notes for the Silence = Death poster text and sketches for follow-up posters, production details like the contact info for the company that wheat-pasted it and the locations we chose, and my own ACT UP meeting notes from Larry Kramer's first talk at the Lesbian and Gay Community Services Center until after the formation of Gran Fury. This material was also cross-referenced with accounts in the ACT UP Oral History Project, the Bradley Ball Papers, the Gran Fury Archives, the ACT UP Papers at the New York Public Library Archives, and the Maxine Wolfe Papers at the Lesbian Herstory Archives.

I ask you to come to these pages with the understanding that I am not proposing them as a definitive account on behalf of others, nor refuting claims others may have made. As a person who had a hand in this work, I am simply reflecting the world as I saw it. I felt compelled to write this to offer a political perspective that might be relevant to current and future resistance struggles, provide primary source accounts to activists and queer folk who were born after the moment, and to help resituate the past for stakeholders who were so absorbed in saving lives, they may not have considered stories happening around them that fell outside their fields of vision.

Where it sounds as though I am critical of people I have known, worked alongside, or trusted with my life and the lives of those I loved most, I can only say I have come to realize that at times when right and wrong present themselves as painfully malleable, what we are left with are the terrors of the world as we make it, and the things we do to survive that. I have broken bread with enemies, had vitriolic battles with people I respect, and felt

betrayed by people I gave my heart to. But this is not a book about any of that.

It's about the spaces we have shared, whether lifelong or liminal, and the people I have known who raised their voices through a fog of fear and grief, people I still consider the "greatest generation" in a struggle against unspeakable cruelty and suffering. This book is about the commons and collectivity, which, for better or for worse, I have dedicated my life to and in which I still place my utter faith.

Silence = Death

The Immigrant

From the sofa I see the cup handle of the Maxwell House sign, just warming up as the sun drops behind it. High clouds are drawn into lavender wisps, and through them the planes circle Newark. Thirty stories below, the cars are inaudible, hidden beneath the abandoned ruins of the elevated West Side Highway. There's a lone jogger in the middle of it, with a Walkman clipped to his waistband, running over patches of wild grass pushing up through the concrete. The aluminum windows are pitted, and they cover the entire west wall of the apartment, a mingy frame on a fading diorama.

The piano over my shoulder rolls under Don's fingers, leading his voice, and then following it. At first it's somebody else's song, one he has made his, slower, and sadder. Then it's a song he's working on, a one-sided conversation, sung right at me. I'm eavesdropping, because he's asking me to. He's singing about sailing to the New World, and leaving the old one behind. Everything is a lullaby, as I lie in the fading light with my eyes closed, bathed in his perfect, dark tenor, never once guessing it would lead where it did, to the Land of the Permanently Brokenhearted.

There's a point when your story stops being yours, at least at the moment of its telling. Mine stopped being mine way before that, in 1981, when the first person to love me back started showing signs of immunosuppression, before AIDS even had its name. There was no test for it. We had to requisition drugs

directly from the Centers for Disease Control for the pneumonia he never made it past. By 1984, Don was dead.

The first time I took him to meet my folks, Don spiked a fever. It was a night he'd barely remember, and one I haven't forgotten. The next day I asked my mother what she thought, but it was nothing like the mother-son exchange most of us hope for. Instead, it was the kind you grow up with when your mom's a research biochemist, more of a consultation. I told her about the unrelenting sinusitis, the endless string of ear infections, the unexplained dermatological episodes, and of course, the fevers that came in the night and were gone the next day.

"There's something wrong with his immune system," she said. The windows may have rattled.

The first time we took Don to the hospital, he couldn't breathe and had a fever of 103. He had no admitting doctor, so the ambulance took us to Bellevue. They put him in the back of the ER, behind a thin curtain, shaking with fever. Over the oxygen mask his eyes brimmed with fear, begging us not to leave him there. His sister and I waited there all night, too far away to do any good, too terrified to leave. They finally found a bed for him, but there would be no doctor until morning.

Days went by before the orderlies would even enter the room, and it was only after I threatened them. They left his food in the hall, wearing masks and gloves while they did, and never returned for the trays. There was blood under the bed from the previous patient. We brought in supplies and cleaned the room ourselves.

They told us, finally, that he had AIDS, but I refused to believe it. We should monitor him, they said; they'd treat his symptoms as they arose, but they couldn't even say what those might be. When he could breathe on his own again, they sent him home with us. Dazed, we rode the elevator down, and the orderly held up his hand to prevent anyone else from getting on with us. People parted in our path.

The pneumonia returned. His first hospital stay was so harrowing, Don insisted he be taken this time to the safety of the suburbs, closer to his family. He eventually responded to the Pentamidine, but he was much weaker. The doctor was empathetic, but it was clear he was in over his head. "It's not a death sentence," he told me, but I got the feeling he wasn't really talking about Don.

The last time he went in, they barraged him with tests, all of them futile. Before Don was moved to the ICU, I spent the night with him in his room. I held his hand while he spasmed and gasped, but he had no idea I was even there. The night was terrible, and long. Over and over, I called the nurses in, even though it was clear there was nothing to be done. He rallied the next morning and we all assembled there, to say goodbye without really knowing it. "It's too much pressure," he told me, after everyone left. It was the last time I ever saw him.

They say weddings are when a couple's lives begin. Maybe. But they start all over with our deaths. We say "till death do us part" to testify to our devotion. Unless you're the one dying, everyone knows devotion lasts much longer than that. We cement our love when we marry the living. But we remarry the dead, and our love is then chiseled in stone. We become linked for eternity. Before I lost Don, I misread the Italian widow wearing black her whole life no matter how long her spouse has been gone. Now I see the wisdom in it. They wear black to remind themselves, and everybody else, what a broken heart looks like. Jews are far more baroque about this. We take all four seasons to drown in our loss before moving on. Then we try to forget, but don't, leaving family and friends to remember for us, while they pretend not to. I can't say why we make this elaborate pact, to walk away from our heartsickness when no one really plans to. But I worry that's exactly what I did. I wish I had just worn black all these years, clearing a path for my pain. Don's death was too much for me, so I eventually put it aside. But those who know me know I've never recovered from it. Those who know me can see the black dress.

The Immigrant

For Jews of my clan, memory is complicated, knotted, as it is, so tightly to survival. Sure, we're fixated on memory, just like everyone else, but memory of a very particular kind, one detached from a sense of place. Once you realize your village can be burned to the ground, you stop believing in place. No one remembers where my grandmother was born, because she refused to remember it herself. But none of us ever forgot why Lena left. She told me she fled the pogroms, long before I could even know what they were, and unless telling me they threw rocks at the Cossacks signified longing, her recounting was sapped of nostalgia. There was no trace of pleasure in it, anywhere. For her, memory was a lesson, not a luxury. After all, there would be no home for me to go back to, no survivors, no clan. They were gone, all of them, with no one to plant a commemorative tree in the town square. There was no town square. There was no town. My ancestral home is the genetic cellular memory of the meaning of cruelty.

Since we don't count on place, memory is what is left for us, memory without mooring. That's the secret we guard, that there is a special blend of memory that is Jewish. It is memory as the act of witnessing, of training the eye to look through a story rather than at it. Witnessing is the acknowledgement of what we do to one another, rather than what happened. Witnessing ignores the ship and studies what rides in the wake of it. It is the glow at the horizon, after the sun has left it and no one is looking anymore. Witnessing is the underbelly of memory. It also happens to be the utter gist of history. It is the entire human point.

And this is where you find me, peering out through an intricate mix. My Jew bears witness and pretends to forget, but my Italian widow just won't. I act like I've forgotten, but I haven't, because forgetting is the final price of the hardened heart, the sad cost of coping with the worst of what we get to see.

I refuse.

Silence = Death

Perhaps I'm about to, but if I find it hard to describe why I loved Don so deeply, it's harder still to explain why that might be. Like everyone else, I suppose, I simply expected love to come to me, whether or not I was ready for it. But it came to me long after I'd already decided it was a myth. Luckily, love is strongest when it's a surprise, and although I was far from a teenager, I fell in love as if I were. I realize now I was too old to have done it, but I worshipped everything about him.

You might say Don was funny looking, though I certainly didn't think so, and if he was, it never mattered. Everyone was drawn to him anyway. His ears would've made perfect coffee mug handles, and his front teeth might be the first things you notice. He was short, but I saw it as sturdy. He had a long face and I used to say he had a bean-shaped nose, though it looked nothing like a bean. His eyes were obsidian, so you could see the entire world bouncing off them, and they turned to half-moons when he was amused, which was most of the time. When he smiled, his mouth was shaped like a gull about to land, and when he sang, it became a tall oval. I'd never met anyone who spoke with his hands that much. If he mimicked someone—which he did with precision—his face turned into a rubber mask. Don was profoundly funny, as only a depressive can be, and he was the first person to ever make me guffaw.

He was painfully empathetic, and saw himself in the flaws of every stranger. He was tireless when it came to big themes, but still noticed everything, and surrendered freely to his curiosity about what was under the surface. If you showed him your coat, he grabbed to see the lining. His appetite for the least obvious thing extended beyond his hunger for every genre of experimental performance and art to quixotic fixations on spirituality and the remotest expressions of human frailty. He was charismatic if you noticed him casually, and compelling if you paid him the slightest attention. Don was the perfect fit for someone who was looking for a limitless sense of connection, and loving him meant submitting to an all-consuming eddy of magic and sadness.

For me, Don was perfect.

After he was diagnosed, I was sworn to secrecy about it. He asked me not to tell anyone, and until it was too late, I didn't. I went through it alone, though that wasn't as hard as it sounds. I had persuaded myself he wasn't dying. We decided, or I'd convinced us, that we could easily have a long life together and should proceed as if we would. We should each do what we had set out to, I maintained, so when we sat in our rocking chairs, we wouldn't blame each other for the things we gave up. Don got a manager and continued to record and perform, even after he'd gotten too fragile for it. And I decided to continue traveling for work, the part of my job I hated most. More than ever, I hated leaving him, even though I'd made the case that I should. So I left and never really went anywhere, because there is only travel in this world, travel, and no escape.

Don, who'd never been anywhere but LA, was obsessed with ocean voyages. I can't say why for sure, but he was. It was the romance, he said, but I think it was really the long goodbye from the high railing, the slow-motion decisiveness of it, and the surrender to uncertainty. It is freedom from the past if you need it to be, and second chances. But it can also mean irrevocable despair, the kind that waits on the horizon without your knowing it, and that you sail to but never quite choose.

Before its facelift, when it was close to demolition, Don insisted we visit Ellis Island, which he could see from his window during the many hours he surveyed the harbor as he wrote. The tour group was small, and the place was so littered, the guide asked us to stick close. There were papers thrown everywhere, and broken boards with nails. Some of the floors were split through to the ones below, and a hard light streamed in through bare windows. There was nothing there, really. Just rubble, and the stories he told us.

The trip over was terrible, the guide said. People borrowed the fare, or traded everything for it, often leaving nothing for food. Families might be scattered at the dock before they even boarded, with no recourse. Parents were forced to send their children on alone, or to leave them and promise to

Silence = Death

come back for them. Steerage was rough and the deck was cold. The sea could be nauseating, so you might not want to eat, and if you did, there might be nothing for you. After weeks of these hardships the immigrants disembarked on the island, disoriented. If they stumbled or wove, the immigration officers noticed it. If they were confused by the questions in this brand-new language, or they hesitated to answer, the back of their coats would be chalked with a code, often without their knowing it, sometimes with no interview at all. Their destiny was marked there and they'd be separated into holding cells, only to be sent back.

After that visit Don became even more preoccupied with the dispossessed, and it turned up in his writing in the form of an operatic song cycle, the last music he would ever write, an ode to the displaced. He saw himself in the immigrant, and I came to see it myself. I fought admitting it, but he and I were being chased from our homes and forced out to sea. There at the dock AIDS was separating us, from our friends and our families, and as we got nearer to the other shore, from each other as well.

It surprised me every time, but Don knew the schedule of the *Queen Elizabeth II* (*QEII*) by heart. If it worked out that way, everything would come to a halt and we'd watch it set sail from his window, with plates on our laps. Once, when we couldn't make it home in time, he made us run to the river to catch its departure. We stood on the banks of the abandoned West Side, close enough for me to see how big it was, big as a floating skyscraper. I can't tell you how much it frightened me. Many are fascinated by the sea, feel safe in it, and find water soothing. I panic when I wash my face. The ocean terrifies me, even watching it on film. I find it nightmarish, the ceaselessness, the enormity, the crushing power of it, and its irrational cruelty. But when I glanced over at him, I felt the electricity of his yearning. We stood there in silence, craning our necks, both tearing up, but for completely different reasons.

On its world cruise the *QEII* has long stretches of ocean voyage when the passengers are ship-bound. The liner books lecturers to distract the stir

The Immigrant

crazy. After Don's first hospitalization, I was recommended to speak onboard. Without missing a beat, I said no. Thank you, I said, I can't be in the middle of the ocean. You can bring a guest, was the reply. Thanks, I said, but it's out of the question, and I hung up.

After I put the phone down, I flushed, as if I'd had a narrow brush with death. Then, almost as quickly, I realized Don was the one confronting it. He was wasting, and weak. His hair was falling out, and he had a Herpes sore on his lip that never went away. We'd be trapped out at sea if he got any worse. But he might die at home and never sleep in its vastness. He was sick, maybe too sick to travel. But he might also be too sick not to. And then I thought he would never forgive me for what I'd just done. I might never forgive myself. A half hour later I called back.

Don was euphoric. I was scared. Scared of everything that lay ahead, scared of the sea and of what might happen out in the middle of it. But I shared none of that with him. Don's death was a subject we kept to ourselves, or I did anyway. If he tried to talk about it, I wouldn't let him. I was too young to face it, and I needed him to live. But now I know that holding off death is like putting on a girdle. The pounds don't go anywhere; you're simply moving them somewhere else. I'm ashamed that I fought it, sharing the truest meanings of my journey with Don, but I agreed to confront my terror of the sea for him. I kept it all to myself, and decided the sea might free him.

He'd never been out of the country, so I stood in line for hours with him for his passport. He bought Japanese language books and studied them diligently. On the *QEII*, dinner would be formal every night, and I bought him a shaving kit and cufflinks and shirts and a cheap tux. I splurged on fancy cummerbunds and good bow ties, and we practiced tying them on each other.

"Just like *Brideshead Revisited*," Don insisted, and I went along with it. "It will be so glamorous," he kept repeating. I went along with that as well, but I knew we weren't taking the cruise like the other passengers. I was working on it. We could never afford it, or the time off to do it. I was a hired hand, just

like the rest of the crew. But we learned to tie real bow ties as if we were gentry.

The *Brideshead* fantasy evaporated as soon as I walked into the ship's entry lounge, which had more in common with Raquel Welch's *Fantastic Voyage*. The seating was white and circular, and sunken. The hall carpets clashed where they collided with each other, and the ceilings were extremely low. It looked like a high-end sixties drug den. This is going to be a long two weeks, I thought. But Don's delight was overpowering. He was hilarious and made fun of everything. He became best friends with our hall porter, and our waiters, and every dowager he crossed paths with. People adored him, and I was reminded why.

To sail the ocean seems a long way to go to see a thing that already sits in your lap. Don loved the voyage, as I hoped he would, but sadness had also stowed away with him. The air was stinging on the Pacific that February in 1984, but he sat on deck all day in the blistering cold under layers of blankets and coats. He was frail everywhere else, but there he was resolute. Don stared out at the grey horizon through his blackout glasses, in the deafening winter wind. I love the cold, and I wanted desperately to sit with him, but I never lasted more than an hour. He might manage a smile, through his cracked, lilac lips, but then he'd turn his attention back to the dark, churning waters, flecked with whitecaps as solid as snow mounds. There were days it was like he was alone out at sea, adrift. I stared at the horizon because it was far less terrifying than the waters just over the railing. It was my bid for abstraction, and the only way I could come to terms with the fear of where we'd found ourselves. He focused on the horizon too, but all these years later I can only guess at what he saw when he looked at it.

At tea, he met a group of Japanese students and struck a bargain with them. Every day they traded language lessons. By the time we reached Yokohama, Don thought he had learned enough Japanese to manage, and with his musical ear, he actually had. While we were waiting for the notoriously mean Japanese customs to allow us to officially disembark, he decided

we should go on a day trip to a temple on the outskirts of the city, and he wanted to take the bus. We did, and managed pretty well until we got off. He could ask where the temple was and be understood, but neither of us had any idea what the answers meant. In no time at all we were lost.

All of us were lost, I should say. He'd befriended an elderly woman onboard. The trip was her husband's idea, but he hadn't lived to join her. She'd confided she didn't know why she came, and was sorry she had. Her husband always arranged for everything, she said, and she was afraid to leave the ship. Her loneliness broke Don's heart, and his empathy broke mine. He wanted to draw her out of it, and insisted she join us. She was reluctant, but Don had no regard for refusal.

He pulled this stranger close to him, as if she was family, and we wandered through the icy streets. She clutched him back, in her long, pleated silk dress. He made her put his black leg warmers underneath, and they bunched over her low, tan heels. His Peruvian gloves peeked out from the cuffs of her blonde mink coat, the ones he'd bought from a street vendor back home and had cut the fingers off of, and her pale, polished nails were blue in the cold. His hand-me-downs made her own frailties that much more apparent, but Don was frail himself, and the two may have shared much more than his clothing. Don was incapable of being covert, and who knows what he confided during our week onboard. In a way I never came to know, their bond may have been deeper than ours at that point.

I can't say who was happier—Don, on foreign soil with this surrogate grandmother, or me, totally lost in this strange city with him. I'd traveled a lot, but this was the first time I'd felt like an outsider. It wasn't because of the talking traffic lights or the building-sized LCDs. It wasn't the zero percent crime rate. It wasn't the shopkeeper who placed a pack of gum on the edge of a huge piece of wrapping paper, then folded it into a perfect parcel without one piece of tape and presented it to us as if it were a gemstone. It wasn't the street signs in letters I had no way to read.

Silence = Death

It was because death and discovery were out walking with us. As his life was waning, Don was just exploring the world. I'd seen much of it, but understanding what love meant was still uncharted, and without realizing it, I'd just sailed the Pacific to begin saying goodbye to it. So there we were, freezing in Japan, being filled and emptied at the same time, and it made me feel like an alien. I was saying goodbye, and not just to Don, who would be dead by November. I was saying goodbye to the world as we knew it, unaware an entire generation was doing exactly the same thing. Everything was changing, never to be the same again, and I had no idea what it meant yet.

The immigrant knows that when you flee, you're hollowing out the past. A skeleton might remain, but life has vacated it. No words can breathe life back into what you've left behind, can depict how warm the lake water was, as warm as your palm when you cupped it, or the exact shade of chartreuse as the trees leafed in, and the way that color vibrated against the damp, black branches of spring. People nod politely when you try to describe the old country, but they have no way to know what you're telling them. So, eventually, you give up trying.

By the time I'd met the people this book is about—the activists and artists, the as-yet-unnamed queers, the stalwarts and outcasts and policy wonks, the intrepid, the ambushed, and the abandoned—I'd stopped talking about Don altogether. As Lena had with her town in Russia, I'd given it up. It seemed pointless. They were fighting for their lives, and I was afraid talking about him might pierce any hope they had. They never knew him, and I didn't know how to change that. But now, all these years later, I've finally figured out how.

This book is dedicated to the AIDS immigrant, wherever they may have landed, and to Don Paul Yowell.

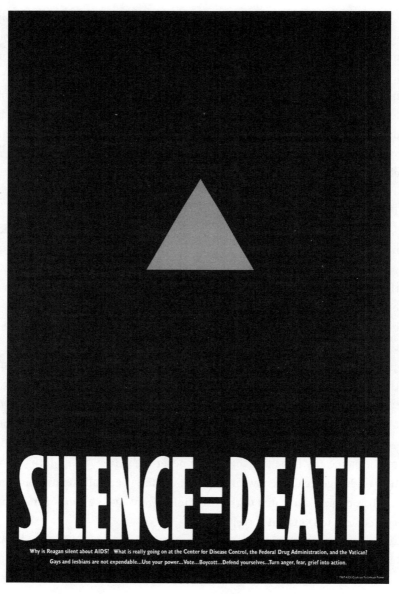

Figure 1. *Silence = Death*, The Silence = Death Project, 1987, poster, offset lithography, $33\frac{1}{2}$ × 22 in.

The Political Poster

Before Don introduced me to Peter Lione and his brother Chris, he gave me a lengthy caveat about their eccentricity. They're like lunatic nuns, he said, only hilarious, and they fight bitterly, like spouses. They lived together, bought furniture together, and shared everything but their friends, whom they each disapproved of with what can only be described as a fraternal vehemence. Don was Peter's best friend, so we rarely socialized with Chris. I was never meant to be close with him. In fact, I was carefully instructed by both Peter and Don to view him as a kind of specimen. But I was something of a specimen myself, and was more drawn to Chris than to Peter from the start.

Shortly after I met the brothers, I had the chance to witness them in full array, at a private unveiling of their Christmas tree. "You're not going to believe this," Don said with too much of a glint as he struggled to ring the stuck bell to their apartment. Half German, half Italian, the Liones had that double-whammy Christmas obsession. Martha Stewart has long since made this sort of fixation a ritual for all kinds of aficionados of tradition, but back then, and as a lefty Jew born just after the Holocaust who was denied any acknowledgment of Christmas, I was unprepared for what I was about to see.

Just inside the foyer was a tree so large you had to step around it. It practically blocked access to the kitchen. It scraped the ceiling, and was so

weighted with antique ornaments, near-lethal spun-glass angel hair, and contraband lead tinsel—hand-smuggled in suitcases from Germany—it had to be wired to the walls. They'd added branches, also wired, suspended in place to fill the bald patches tree-lovers apparently loathe. Here was Teutonic perfection, trussed and tortured, as unnatural as the holiday itself. The tree glowed from the inside, pavéd with tiny lights tucked deep in the crooks of its branches so as not to destabilize the nineteenth-century effects with any harsh traces of modernism. It was draped in faded glass garland from the thirties, and there were Victorian die cuts nestled everywhere. The treetop angel had a name, a German one, and she was carved out of wax and outfitted by Chris. Antique toys sat under the tree, playing to some imaginary childhood from days long gone.

I practically lost my balance.

Beyond the tree, if there could be a beyond, was an equally staged apartment, with boxwood vignettes on every surface. The apartment was secretly wallpapered, a thing forbidden by New York landlords, and the cottage-cheese ceiling had been scraped. It was furnished in a mix of thirties reproduction antiques and Empire Revival, which served as a backdrop for small collections of decorative arts: Staffordshire figurines, Edwardian tabletop, and Victorian hair weavings. It was only a block from Don's building, but it might as well have been over the river and through the woods. It was Christmas at grandmas, right down to the wing chairs, and I had never seen anything like it. If there were holidays at all in the circles I traveled in, it involved forests of aluminum tress with nothing on them, or trees made of black garbage bags. My crowd was No Wave rockers, artists, and junkies. They lived in tenements with tubs in their kitchens. They were out all night and barely cooked. If there was money, it was used for drugs or thrift, and they were all minimalists. No one had legacy ornaments waiting all year in their closets.

While they conducted our tour of their art-directed tree, Don would shoot me glances. "What did I tell you?" he said in a stage whisper, as if he

were there doing socio-anthropological fieldwork on a tribe with congenital hearing loss.

After we'd marveled long enough, Chris finally said, "Well, now that we're all here." He had a matchbox in his hand.

I'd never seen a tree with candles on it, had never even heard of one, but here it was. The air tensed as they lit each one, as if the tree might explode, which I now know it could have. They dimmed the lights, and we watched for a very short moment. Then they cupped a hand behind each flame and carefully blew them all out. It was so strange, this antiquarian ritual too dangerous to be sustained, and *all* of it felt alien to me. In front of the Lione tree, I wondered if I would ever suit such a tightly knit clan, with such extremely particular ways. I was uncertain that Don's gay family could ever become mine as well, and didn't consider the ways this episode might foreshadow what lay ahead.

If you've never experienced this misfortune, there is a particular quiet that first morning after someone dies. The world continues, but under constraint, as if your foot is on that pedal on a piano, the one that sits on the strings as you play them. The sun, if it shines, is deferential, or a little bit paler. And if you pass anyone too gleeful to notice you're drenched in loss, they are gleeful through a layer of gauze. It's what it feels like to be wrapped in the distinctive haze of a world in motion in spite of itself, to be fully aware of the hum we all pretend not to notice, the white noise of our own mortality. It's always there, but we give it our backs until we're forced to face it, which each of us is eventually called on to do.

I was too dazed to return to our apartment the morning Don died, and although I barely knew him, Chris insisted I come home with him instead. I went straight from the hospital to his couch, where I camped out for the weeks between Thanksgiving and Christmas and became inducted into the Lione Christmas finishing school with the sort of exaggerated ferocity that is

frequently the by-product of a loss around the holidays. He took me in during the most fraught time of the year, the way any real family member might, to stand by me when I needed it most. It solidified our connection during a shared moment of desolation, but not simply because it was the holidays and we didn't know how to have them without Don, or because we were both gay men facing the terror of AIDS. It was because Chris was the only firsthand witness to the change in Don's family surrounding his death, and he refused to stand for what was happening.

When I first met Don, the embrace of his family was almost eerie. They seemed to clamor for me, as if they'd been waiting for me their entire lives. They invited me into every intimate family moment, and I became immediately lost in their world. As soon as he was diagnosed, however, I was recast. Month by month my identity as Don's soul mate drained away with his health, and I became a stand-in for the illness that had entered our lives or, worse, was considered the cause of it. If it occurred to them I might also be at risk, no one thought to articulate any concern about that. The life that had centered on the glow of his family was fading, replaced by the power struggle over who knew best what Don needed or wanted. I was shifted squarely onto his mother's turf, and within months I went from the inner circle to being the sole focus of waiting room shouting matches. Toward the end, I was told I was no longer welcome in their house. I had to take the bus back and forth to New Jersey after work.

There is never an easy way to learn what is frequently true for queer spouses: when things are fine, you might feel welcome, if you're lucky, or possibly even loved. But there is also a dividing line, one you may not see until you need it most not to be there, one I never noticed until I was booted across it. People may disagree with me, but I have come to think that this line is always there, whether or not anyone falls ill. You never know how or where it will present itself, and it's only a matter of time before it does. Yes, some of the tensions I experienced surrounding Don's health care also exist

for heterosexual spouses, but that is not what I'm talking about here. I'm referring to a cordoning off peculiar to HIV/AIDS before 1984, the stigma constellation that separated gay men from the rest of the world, the set of social exercises that flattened the landscape for the lesbian and gay community before AIDS was a word people said out loud. The line I'm referring to is not the line that divides the sick from the well, or families from each other when they're confronting mortality. It's the one that calls into question not only your right to participate in the health care of a loved one but your right to all claims to the life you built when they were well. It's the line tracing along centuries of unspoken pacts that cater to the portions of the world with unchallenged veins of hatred, the line drawn around queer existence and any articulation of it, the line marriage rights don't actually remove, the line that can separate you from everything, even your own humanity. I'm talking about homophobia, and if AIDS had any cultural meaning at that point in time, a large portion of it was situated there, even for people who would never have characterized themselves that way.

Right after the funeral, Don's family swept through our apartment and removed every trace of him. They took all his music cassettes and his demo tapes, every picture of him and all of his clothes. They took things I had made for him, things he had given to me, and clothes that were mine but he loved to wear. They removed all evidence of him, without asking what was his or mine, without offering to leave a single keepsake of our lives together. Chris insisted he be there, to protect my interests, a thing I never imagined I would need. But in the end, he was as powerless as I was. There was no protection to be had for the man who had loved their son with all his heart, no deference, no regard, and no love. If I was ever actually a member of their family, I was escorted to its edge. Now that Don was ash, I was too, and Chris had no authority over any of it.

So he held my head and I cried on the stairway, at the border I had just been taken to. Then and there, any connections to the world I was taught to

count on evaporated, and another set of bonds began taking their place, bonds that would be defining, and not just for me. That night I locked elbows with everyone who'd already experienced what I just had, and my story with Don became part of the story of the world. I sat on the stairway with Chris as my story turned into *our* story, and the story of the millions who would come to experience this very same moment, stretching endlessly out into the horizon.

Politicization is a process of continually taking your own next step. My politics were molded long before this moment. Throw a dart at any story of the American Left, and my folks were probably there. They went to see *The Cradle Will Rock* the night the Federal Theater Project shuttered it, and brought my sister to hear Paul Robeson sing the day of the Peekskill Riots. They were regulars at an upstate utopian colony the summer the Rosenbergs were there, and their closest friends worked for the Works Projects Administration (WPA). We went on workers' retreats. Name it, and they were there. I never got a straight answer from my dad about his Communist Party ties, so I stopped asking him when I was in college. That was when he told me he was "in the Civil Defense" with Ethel Rosenberg, but he delivered this with a smirk and the whole premise was, well, ridiculous. Until the day she died, my mother never admitted to being a party member either, but during the McCarthy years she instructed my sister, "If they come for us, tell them you don't know anything about the copies of the *Daily Worker* in the closet." My sister sent me Free Speech Movement buttons from Berkeley, my grandmother came to peace marches with me, and my brother gave me a Baby Lenin pin when I entered middle school. As surely as a child can express a genetic predisposition for familial Republicanism, I was a child of the Left. When I was sixteen I stuffed envelopes for the Poor People's Campaign. The following year I canvassed for the Student Mobilization Committee to End the War in Vietnam. My first job was making strike T-shirts. I used to joke with friends that when I rebelled, I'd have to become a stockbroker.

The politics I inherited, however, had been formatted long before the idea of a queer identity ever was, and in the pre-Stonewall Left no accommodations were ever made for it. I had been out for over a decade, and politically engaged for much longer. But the stripping away of my claims to my life with Don was the moment when the politics I was raised with became my own. I was already political, but AIDS politicized me anyway, as surely as it did the men I would come to know who'd voted for Reagan before their boyfriends got sick. This was the moment I became politicized as a gay man, watching Don's family effectively scrub him from my life.

It was also the moment that would forever link me to Chris Lione.

I was inconsolable after Don was gone, and I resented the centrifugal force that is mourning. At first, as it goes, I was never alone: I was distracted, tucked in, watched over, and cared for. Then, almost as quickly, the periphery started to spin away and people peeled off layer by layer, while I was still stuck at the core. It was doubly cruel because I wasn't just experiencing loss. There was also the unspoken presumption that I was next. The silent headshakes, the lowered eyes, and the "I'm *so* sorry" that hung over every condolence like a premonition of a second funeral. Any casual relationships seemed to take place through a scrim of stumped knowingness, but mostly, people seemed to want distance from me. Hardly anyone wanted to talk about any of it, and those who did refused to use the word *AIDS*. No one needed to. There were too many euphemisms.

"Did you lose weight?" was code for "Are you sick?" and people looked you right in the eye when they asked you. I started eating six meals a day.

"I hear he's sick" became code for "He's dying," and "It's not a death sentence, you know" meant "God, I hope not."

Some of us called old boyfriends to warn them or to say goodbye, but backed away from the subject if they answered. "I've had a full life," Kevin

said, hunting me down at work, after years. He simply repeated it when I asked if he was telling me he had AIDS.

All my friends still did drugs, but they were also becoming macrobiotic, and brown rice started showing up on every downtown menu. The clubs were packed, but sex was another story entirely. Some gay men started dating women, as if a sexual makeover would save them, and women weren't also at risk. Others moved back home, pretending gay men in Phoenix couldn't possibly expose them to HIV. The personals were deemed somehow safe, and friends who'd never seen one started combing through them. Blind dates were suddenly acceptable, and everyone started talking about relationships. It was like the fifties all over again, even though the horse was already out of the barn. All of it made me angry. But when Rock Hudson was outed by the disease in 1985, I snapped. The year before, Don had died along with thousands of others, and no one even lifted their heads. Now, all the media handwringing was revolting, along with the agonizing over whether his on-screen kiss with Linda Evans put her at risk. It scorched through me, until I was sputtering like a kettle. Overnight I went from impossible-to-be-with to why-are-the-veins-sticking-out-of-your-neck?

When I first fell for Don, I'd introduced him to a musician friend from San Francisco, Jorge Socarrás. In a late-seventies, New York sense-of-the-day he was a self-professed vampire: alienated, enigmatic, romantic, and intense. Jorge and Don never became close, but they did try their hand at co-writing. Don was terrified he'd never find work if industry colleagues knew he had AIDS, and so Jorge was one of the people I avoided after he was diagnosed. He was a permanent fixture on the New York scene, and he worked at Area and his band sometimes played at Danceteria. He knew everyone.

He was vague about it at the time, but Jorge's musical collaborator Patrick Cowley had also died of AIDS. When word was out about Don, Jorge wanted to see how I was. We got together several times, but at a dinner in late 1985, for reasons he himself can't reconstruct, he invited Oliver Johnston without

telling me, a skinny dandy with a very thick southern drawl, who showed up in candy-apple-red glasses, a bowtie, and statement socks. I had no idea what to make of him. He was every bit as stylized as Jorge was, in ways I read as somewhat straight, but the two were opposites in every other way. By my standards he was as southern as they come: solicitous, blonde, goyishe. Compared to Jorge, however, he might as well have been from Alaska. Jorge was *southern hemisphere*: sophisticated, insistent, and entirely Latin. Watching them together across the table stripped my gears a little. To this day I can't even figure them as friends, and Jorge can't account for it either. The friendship, however, was not the real surprise of the evening.

No one knew what to say about AIDS, and when they did say something, it was rarely in the company of strangers. But it was all we talked about that night, and I quickly came to see that the thing they shared was a surefootedness that I associate with having been adored by your family. They both seemed utterly free from any conflict about speaking about AIDS, which I found exhilarating after so many years of secrecy. And this conversation wasn't simply focused on loss and fear, although we certainly covered that. What we mostly talked about was our anger and how freaked out our straight friends were by it. I had been marinating in the exact same feelings and pretending it was all just me. I hadn't considered that I wasn't the only one who woke up on the other side of a divide, and it was becoming too wide to reach across. Loss, death, and isolation, they're universal. But this was not a moment of universality. To face those things and to be gay, right then, was not universal. As we now know, it was a distinct moment in history, unlike any before it or since. Over the course of the evening something began to shift for me, and I realized death was not the only thing happening here. Rage was happening too. My own was so pervasive, I could not be deterred from it, and it was liberating to not have to hide it. It was awakening a need in me: without knowing it, I had been longing for a gay-only space, one that not only allowed me to be furious but embraced that fury. They'd tapped into

The Political Poster

something deep, and even though Jorge sometimes made me nervous and I didn't expect to see eye-to-eye with Oliver on anything else, their anger made me feel safe, and completely connected to them.

I was not the only one who felt the power in this discussion, and as the evening progressed, we started talking about forming a group. Not a support group, which none of us had any experience with. I suggested that we base it on feminist consciousness-raising principles, a men's group to explore what being gay in the age of AIDS might mean, and that it would be more productive if our members weren't all friends. I went on to say that while we might eventually decide to expand the group, we should begin by each inviting one more person, someone the other two didn't know. They agreed and within minutes it was decided. Apparently, we all had a growing determination to lean into this terrible moment and had been searching for someone to do it with. It was immediately clear to me how much I needed it, but frankly, it also surprised me. I had a close-knit circle of friends who had helped me through losing Don, and up until that evening I thought it had been enough. Even though the connection between my political life and my life as a gay man was becoming clearer to me, I hadn't yet realized I needed a communal way to process what had felt like a personal struggle. I was missing the sense of collectivity that had defined my own coming of age, and I needed it to be gay.

As soon as I left the restaurant, I called Chris to invite him. I couldn't imagine doing it without him. He said yes without hesitation.

Oliver brought in Charles Kreloff, the son of Bea Kreloff, a lefty dyke well known in feminist organizing circles. He was raised in a lesbian separatist household, which impressed me no end. Charles was haimish and compact, with a slanted, toothy grin, and he even lived in Don's building. He was extremely direct, the antithesis of Oliver, who practically had an emotional stammer: it took him forever to say what he meant, and even then, it felt like he was keeping something from you. I was relieved when I met Charles and liked him immediately. Jorge invited Brian Howard, the youngest

member of the group. Brian was funny, wide-eyed, self-effacing, and warm, but also somewhat tightly wound. He was jockier than anyone in my circles: you know, white turtlenecks under crew neck sweaters. He was also so effusive, I swore I saw sparks coming off him, and he interrupted himself all the time.

It was an odd assembly of eggheads and nerds, but as collectives go, we were not exactly diverse. Half of the group was Jewish. Counting Chris's Italian side, which I always have, and Jorge's Cuban lineage, the group was decidedly ethnic in temperament. Oliver was the odd man out in this crowd, but he was so passively controlling, there was always a level of WASPiness at the table. Chris was the art director of *Art and Antiques* magazine, Oliver had his own graphic design studio, and it turned out they had both gone to Parsons together. Charles had been an art director at Henri Bendel and was breaking into book design, and Jorge was a musician and writer. Brian studied photography at the School of Visual Arts and was transitioning into a career as a photo editor, and I was a senior art director at Vidal Sassoon. No one in this group was shy, and we all shared a level of neurosis that helped us bond immediately, swapping anxieties as if we were all old friends. It made for an accelerated chemistry that was extremely unguarded, and even though it was not intended to be group therapy or a support group, it felt like both right away. Initially we met at restaurants, but it interfered with our intimacy, and Charles quickly suggested we shift to potlucks, but not the hippie kind. Sometimes the focus on what we would each bring got so fussy that the only way to pierce it was through self-ridicule.

It would be reductive to say our conversations centered solely on sex, but we were all at risk, so that was a big part of the discussion. Those of us who had already lost sex partners were grappling with our fears about it. For the others who were uncertain whether we had, anxieties about sex were equally pervasive. All of us felt isolated, and none of us knew how to navigate sex anymore. Even those of us who were less relationship-focused were

afraid we'd never be able to retrieve the connectedness that can accompany sexual intimacy, or were afraid of facing death alone.

A group dynamic formed quickly, one that was likeminded but that was also the opposite of groupthink. There were animated conversations, always, and there was often hilarity. We were almost never mean, but we frequently fought. There was shouting, there was fist pounding, and occasionally tears. I lunged across the table at Oliver more than once, when he was being indirect. I hated that. Charles could be as emphatic as I was, and occasionally he was even more doctrinaire. Jorge tensed every muscle around his eyes when he needed to be heard, and when his mind was in overdrive—which was often— he almost seemed to gasp for air. Brian and I had no problem talking over any-one, and although Chris refused to interrupt, he was stubborn and never backed down when he thought he was right. Every one of us boiled over from time to time, and there were moments when things got very intense. Fear may have been the canvas for our conversations. But anger was definitely the paint.

We were a consciousness-raising group, but as our meetings dug deeper, I felt we were bordering on a political collective, and within the constraints of our own uniformity of privilege, we spent a lot of time exploring how race and gender were being foregrounded or ignored in media depictions of AIDS and in public policy. I began to sense there was an enemy out there, and it wasn't simply the disease. I couldn't help but notice that regardless of the weekly topic, we ended up talking about its political subtext. Sometimes we even brought in press clippings and pored over them for hours. Week in and week out, the situation was becoming less and less abstract to me. We were in the midst of a political crisis, and outside of our group, hardly anyone seemed to be talking about it.

In 1968 one of the students at the Quaker school in my town had brought back posters from the French student strikes to reproduce for the demonstrations in New York. I assisted him and that was how I learned

to silkscreen. Later that summer when I was visiting colleges, I went to the Museum School in Boston. The school looked like an old factory, as art schools frequently do. You entered directly into a student gallery with abused, low-pile carpeting. The whiff of linseed oil dropped down the stairwell from the painting studios, but there was something else in the air. Past the empty gallery was a long, narrow corridor, and on the floor, lining both walls, silk-screened posters had been set out to dry. At the tables inside the adjacent studios, students stood in groups: one with a squeegee, one to pass the paper, one to carry them away. The school was cranking out demonstration posters for the student strikes in the area. Between shifts, people crashed on the lobby floor. I went straight to admissions.

In essence and intention, the political poster is a public thing. It comes to life in public spaces, and outside them, is academic. Individuals design it, or agencies or governments, but it belongs to those who respond to its call. Once it hits the street, if it manages to tap into the zeitgeist, it may have its "moment," and when it does, it's the audience that determines that rare cultural nanosecond. Authorship takes a back seat, and the public sphere resembles the exercise in collectivity we hope it to be.

For public discourse to pierce through the churning perpetual motion machine of the American commons, it needs to come in bursts. Manifestos don't work. Sentences barely do. You need sound bites, catchphrases, crafted in plain language. The poster is exactly that, a sound bite, and vernacular to the core. The poster perfectly suits the American ear. It has a power. If you've ever stopped in front of one or turned your head for a second look, that power was at work. You may barely have been aware of it because of its hammer-and-nails simplicity, but you were caught up in it just the same. It's not art, if art is for museums. It's far more robust than that. It comes for you in ways art simply can't. The poster comes for you where you live.

Because of my upbringing, the political poster had always played a role in my understanding of social change. But by the time I was seventeen,

posters, demonstration flyers, and meeting announcements papered Eighth Street between the East and West Villages. It was how we found out what we needed to know, the things no media outlets would cover. Before smartphones, when young people needed to communicate with each other, we used the streets. AIDS didn't feel at all different to me. People's lives hung in the balance, as they had in Vietnam. Something needed to be done, and I could see we'd have to circumnavigate existing channels to do it. It felt completely familiar. When people need to communicate with one another, I reminded myself, there is always the street.

So I proposed to the collective that we design a poster about AIDS, to try to push the community into political action. We had constituted ourselves through political tenets and were not an art collective, but five of us came out of art school, four were graphic designers, and two were art directors. No one was remotely perplexed by the suggestion; no one spoke against it. It was instantly and unanimously agreed on.

I had one very clear political objective in mind, and posed it to the collective in the form of a marketing problem. The poster needed to simultaneously address two distinctly different audiences, with a bifurcated goal: to stimulate political organizing in the lesbian and gay community, and to simultaneously imply to anyone outside the community that we were already fully mobilized. Everything, from the paper we chose to the walls it would be hung on, took into account these seemingly opposite strategic ends.

Charles, who was raised in the Village and also remembered how the streets were used as a means for communication, cautioned us that the sixties were an intensely political moment, and the eighties were not, so a text-heavy manifesto might be easily disregarded. Chris agreed and felt there should be very little text at all. To "sell" activism in an apolitical moment, the poster needed to be cool and to intone "knowing." It needed to be both rarified and vernacular at the same time. It needed to give the impression of

ubiquity, and to create its own literacy. It needed to insinuate itself into being.

It needed to be advertising.

To support the illusion of an organized community, we decided the posters should be hung alongside advertising posters, in the spaces reserved for commercial enterprises. We chose this context to signify an "authorized voice" and to hint at resources and a level of organizing that were nonexistent. Since I had suggested the project, I thought it only fair to offer to pay to have the posters mounted by a professional service, if the collective would split the cost for printing them.

At the time in New York, commercial posters were professionally wheatpasted by local, family-owned companies—called snipers—who made "official" arrangements to post on construction sites it was otherwise illegal to use. Deregulation by the Reagan administration had resulted in tax abatements for new construction in New York City, resulting in a radical spike in the number of poster sites. These services worked strictly by referral, through word of mouth. Only two services put up posters at the time, and each had well-defined turf. A designer friend who did the posters for the Brooklyn Academy of Music's Next Wave Festival turned me on to their sniper. We weren't sure they'd be open to our project, but it turned out they were completely indifferent to content.

Sniper turf is divided into neighborhoods and districts, so targeting an audience in commercial spaces means analyzing the neighborhood demographics. To maximize visibility within our budget, we looked at art, entertainment, and media centers that offered general reach, cross-class business districts, areas with nightlife that drew people from the outer boroughs, residential areas where gay men predominated, and neighborhoods people in publishing either lived in or frequented. Within the constraints of our budget we settled on the East Village, Lower Broadway, SoHo, the West Village, Chelsea, Hell's Kitchen, and parts of the Upper West Side. For a

three-week presence in these neighborhoods, we were told, we'd need nine hundred posters, plus another nine hundred replacement posters. The number of posters for adequate coverage is determined by factors such as seasonal weather, size of available turf, and location. At the time, a poster cost more to snipe than to print. The company quoted us $1.50 per poster, and made such a point of guaranteeing coverage, I decided to covertly follow one of their crews around one night to see for myself. They worked in pairs, traveling on the back of an open pickup truck so they could reach the upper construction scaffolding for more coverage. If a poster on their turf was damaged, torn down, washed out, or pasted over by a competitor or individual, it was replaced.

Exposure to printed matter in New York is serendipitous, so we knew the poster had to be gripping. And the streets of New York are some of the most diverse public spaces in the world, so the poster's message needed to be broad enough to bridge wide gaps between audiences, and also leave room for unintended viewers. The dollar was strong, so Manhattan was not flooded with European tourists yet, Lower Broadway was not yet a developed commercial center, the East Village was still rough, the Meatpacking District was still mostly artists, sex clubs, and wholesale purveyors, and the redevelopment of Times Square had not been completed. Street life in Manhattan is also class stratified by transportation means, so audiences can differ wildly. Most locals traveled by subway or on foot, and very few Manhattanites in those neighborhoods kept cars at the time. Still, many took cabs, car services, or buses, and people from the outer boroughs and suburbs frequently traveled by car. Most New Yorkers commute to work, but tend to prefer neighborhood leisure and support services, and they also walk a great deal. So we surmised it would mostly be local audiences who encountered the poster up close if they lived or worked near a poster site, and everyone else would come across it through a vehicle window. As a result, I insisted we apply a "Can you read it from a moving vehicle?" test for the font, and we

tiered the messages to both points of discovery. In addition, some levels of meaning would need to be explicit, and others distinctly coded.

Like all messages in the public sphere, "Silence = Death" was context driven. The subsequent formation of ACT UP is the primary modifying factor in our understanding of this image, and it can now barely be imagined without it. But it was conceived a year before ACT UP's inception, and since one of the areas targeted was Times Square, we knew many viewers would not be local and might have limited exposure to the issues. The tagline was crafted to be provocative and alarming and to stimulate a political response in a setting that was not necessarily political. It was also intended to imply authorization. It was the voice of the insider and, by surface appearances, was declarative. But it was meant to stimulate curiosity, and questions. In that regard it was a Trojan horse.

While considering the content, we talked about other political poster campaigns, like the Art Workers Coalition *And Babies* poster from 1969. Charles also suggested we study the Guerrilla Girls, who managed to stage complex gender critiques on the sidewalks of New York in the vernacular. We tossed around the pluses and minuses of text versus image. We debated which issues to tackle and how to depict them.

Our first poster concept was an attack on William F. Buckley's 1986 call for the surveillance tattooing of all HIV-positive people, but as we considered using a tattooed body as an image, Chris warned us about how inherently exclusionary it would be. We tried, but couldn't conquer the questions of representation. Would a black-and-white image successfully obfuscate the subject's race? Could an extreme close-up of a tattoo make the subject's gender ambiguous enough? This exercise convinced us that any image we chose would need to be pictographic, so we moved to a discussion of what that might look like, thinking that what it should say might naturally follow.

In advertising, all images are coded, but the image we sought needed to act as a signal beacon to its lesbian and gay audience without excluding other

audiences. An icon would not only liberate us from the complexities of representation but also enable us to draw on existing queer codes. In some ways, this might have been easy, since to be queer is in many ways to coexist with codes. But it was not easy at all. We tore through, debated, and rejected every agreed-on symbol for the lesbian and gay community: the rainbow, the labrys, the lambda, and the triangle. All of them had baggage, and on some level we were uncomfortable with each of them.

The pink triangle seemed an obvious way to connect Buckley's suggestion of tattooing to the concept of genocide, but to the extent it might be a signifier of victimhood, it felt potentially disempowering to us. In the context of fears about segregation, quarantine, and internment of HIV-positive people, even a strategic appropriation could become a double-edged sword. We were uncomfortable with this aspect of the pink triangle.

We liked the inclusiveness of the rainbow. But it also had a little hippie baggage, and its brightness seemed inappropriate and somehow lacking in gravitas. Ultimately, however, it was the graphics that disqualified it. We decided it would make an ugly poster. We preferred the feminist empowerment tonalities of the labrys, but we knew many men would be unacquainted with it, and it would be hard to connect to some of the issues at hand. We felt the lambda was not known well enough to younger lesbians and gay men. During this process, we became somewhat rattled by the lack of an agreed-on symbol for the lesbian and gay community. It seemed, in a way, as if this might be one of the roots of the issue. We even debated designing a new symbol, but became immediately lost in it and realized we'd be embarking on a separate campaign before we could even get to the more pressing issues we were trying to address.

So we resigned ourselves to the use of the pink triangle, convincing ourselves that the codes activated by the triangle were open-ended enough to be useful, signifying lesbian and gay identity to some audience members, maleness to others, and referencing the historical meanings of genocide to

audiences familiar with that history. But we gave the familiar symbol a makeover. Changing its color from pale pink to a more vivid fuchsia, Pantone 212 C, seemed an acceptable reinvention that reflected graphic trends and suited the poster's aggressive tone. Turning it upside down was another gesture of reinvention that was inadvertent but worked out in our favor. Chris, who had recently visited Dachau, was certain it pointed upward. Oliver volunteered to "research" it and later confirmed the direction without actually checking it. We discovered it was incorrect after the printing, but decided it answered one of our concerns, superimposing an activist stance by borrowing the "power" intonations of the upward triangle in New Age spirituality, further skewing its relationship to the death camps.

We had settled on that icon, but we didn't have our tagline. After weeks of debating the holocaust analogy, the volley that led to the final turn of phrase and the key component of the poster, the equal sign, took barely sixty seconds, and it played out at our holiday dinner in December 1986 at Jorge's apartment as he heated his vegetarian entrée. It went like this:

"What about 'Gay silence is deafening?'" I said, reading a note I had made in my journal. The *New York Times* had used the phrase "deafening silence" in a news article about a different political question, and I'd written it down.

"How about 'Silence *is* death?'" Oliver immediately called out. I remember how this phrase sounded in his southern accent.

"No, no, it should be 'silence *equals* death,'," I believe either Charles or Chris blurted out.

"Wait! Wait! What about an equal sign, 'silence = death?'" Everyone jumped up at the same time in such an instantaneous clamor of agreement, I can't say for sure who shouted that out, but I am positive you could hear the ruckus from Jorge's living room window all the down to Avenue A. It was the exact shorthand we had been hoping for during the months we spent scrounging for an iconographic visual. It signaled the inevitability and

certainty of calculus and was perfect branding shorthand. I dubbed the equation "New Math for the Age of AIDS."

There was no doubt about the line, but we still broke into debates about the positive and negative uses of moral equivalencies and about instances when disagreements about political certainty can be rendered moot by catastrophe, such as times of war. We talked about the deadly effects of passivity in crises, communal silence and the nature of political silencing, silence as complicity, and scenarios where bystanders became participants without intending to be. We debated whether the equation was clear enough without offering more context, and decided a rejoinder to the tagline would be needed for that reason. And there was a conversation about the neutralization of deeper meanings that might accompany our use of advertising shorthand. But the phrase was too good to pass up. We immediately downshifted into design mode.

We wanted to mimic the standard dimensions of commercial posters and to use the coated paper stock generally employed for visual slickness and weather durability. I suggested that, to carve a contemplative space in the visually packed environment of commercial advertising, the poster needed a blank and expansive background, to create a "meditation zone" and serve as a visual palate cleanser. Since we were consciously mimicking design trends in an attempt to "influence influencers"—yuppie graphics, I called it—Chris thought a black background served this purpose better than any other color. The color black was, in every design field, firmly associated with the style of the day. It was the fashion color of choice, the color of the urban uniform, the preferred color within multiple music scenes, and a staple in interior design. It was sexy, authoritative, and above all, to be taken seriously. Black helped mediate the poster's presence in a gray urban universe, would allow the white and fuchsia graphics to "separate" against it for long-range visibility, and intoned a seizure of power through its arrogant disregard for the maximum use of purchased advertising real estate. It implied a foreboding storm of political action, and of course, it directly

referred to death. The following year when I was wearing a Silence = Death button at a restaurant, our waiter was disturbed by "such a violent image." "These are violent times," was my immediate response, but in truth we meant the image more coolly. It was calculated in every sense, especially where it levied threat. ACT UP was still months away.

Chris convinced us that, based on formal usage of negative space, the black field surrounding the triangle would be better resolved if the rows of modifying text sat outside that field, making the poster taller than standard stock dimensions, a design caveat that added costs for larger paper stock and the extra trim that would be necessary. In the second printing, after the formation of ACT UP, the poster's function shifted radically. It had outlived its original street life, and the lines of modifying text had no function when held over somebody's head at a demonstration. Chris suggested we redesign the poster, removing the rejoinder and changing the poster's dimensions to become squarer.

Charles suggested the font, Gill Sans Serif Extra Condensed, which Oliver wholeheartedly seconded, after a short graphics geek-fest about whether condensed or extra condensed would be wiser. It was graphically on-trend at the time, but more important, it was chosen for its ability to maximize point size within the narrowness of the poster's topography. The condensed font allowed for increased vertical scale, giving maximum readability from a distance. It did, however, have kerning pitfalls. The space between the condensed letters made for a very hard read. After the poster hit the streets, a few people asked us why *science* equaled death. In the subsequent printing, we opened up the spaces between the *I*, *L*, and *E*.

We sketched out the poster's proportions and continued to argue about colors, then toasted each other, and the poster, and exchanged gifts. Over the following weeks we worked out the details. Chris cut triangles for a comprehensive layout of the proportions, and Oliver kept pushing for versions with brightly colored backgrounds. Oliver and Chris tested the font

before sending it for typesetting. We compared printing quotes and decided on Chris's printer. We finalized the choice of paper stock.

Jorge and I worked on the rejoinder text, aimed at the lesbian and gay community. I'm didactic by nature, and Jorge came from a performance background, so the text is exceedingly packed. We had some back-and-forth while we hammered it into shape, culminating in one very long session on a pay phone at work the day before our typesetting deadline. The point size of the font would be much smaller, forcing more intimate contact on the part of the reader and potentially creating a self-reinforcing performative dynamic of presumed engagement. The poster was about complicity, at all levels, but it also needed to inspire action. So this part of the text was staged in the interrogative to force the audience into dialogue with it, and we chose to be politically broad in order to empower audiences at varying levels of politicization and of indeterminate race, gender, and class. The primary goal was to superimpose a presumption of solidarity and potentially set the stage for a collective response, so the text below was intentionally less concerned with specifics than with priming the pump for activist engagement.

We conjoined the government, public health services, and religious organizations with the same leading question, "What is really going on at . . . ?" We chose the Vatican as a stand-in for religious leadership because the Archdiocese of New York was highly influential in local politics, and selected Ronald Reagan as an easily understood surrogate for national leadership. The opening rhetorical question, "Why is Reagan silent about AIDS?" simultaneously signified the conservative political climate, coupled him to the word *death* in the slogan, and gave readers temporary distance from their own culpability, allowing them to internally pivot in resistance to the lethality of government silence. Since we could not count on a general familiarity with the intricacies of American public health research and policy, we chose to refer to it in broad strokes with the acronyms for the drug approval and epidemiological surveillance agencies. When I read the text over the

phone to Oliver, he suggested spelling the acronyms out. I agreed, and he forwarded what he misunderstood them to mean to the typesetter (*Federal* Drug Administration, rather than *Food* and Drug Administration, and Center for Disease Control, instead of Center*s*).

Since the politics of the audience were undefined, the solutions in the second line of text were also purposefully broad. The political responses being suggested there were stratified for multiple audiences and included electoral politics and boycotts as solutions. The phrase "Defend yourselves," however, makes another pivot, this time toward potentially radical responses, and the final line, "Turn Anger, Fear, Grief into Action," was designed as a stage-setter for subsequent posters in which "action" would gradually become more defined. *Silence = Death* was meant as a conversation starter, the first in a series calling for escalating political responses. From its inception, it was part of a campaign intended to propose violent resistance: I wanted to call for riots during the 1988 election year. There is a preliminary sketch of that poster in my journal notes, and I insisted we work anonymously to leave open the possibility of more radical types of resistance.

The poster was by no means the entire reason behind our collective. In fact, we reserved only a short amount of time each week to talk about it. But, in my opinion, it still took us six months to design for the following reason. I believe every conversation we had was in some way woven into the final work: Brian's loneliness, Jorge's obsession with his boyfriend's blue-grey-green eyes, Chris's rages over the role race was playing in the government response, my rages over Don, and Charles's rage at Oliver for keeping his HIV diagnosis from the collective for months. In some way, it's all in there. We were on a journey, as individuals and as a collective, and that is how long it took us to figure out how we saw ourselves in the Age of AIDS, as gay men, who feared for our lives and had come to lean on one another. The text of that poster is a few, short sentences, but it took us that long to discover what we needed to understand about this new world before we could boil it all down.

The Political Poster

Every conflict, every accord, every tear-filled moment, reduced to a simple equation. We weren't really attempting to articulate what a community was experiencing. As far as we knew, there was no community to give voice to at all. We were talking about ourselves. Since only six of us shared this set of backstories before I put it down in this chapter, it's easy to overlook the severity of the doubt that surrounded everyone who was thinking about these things before there was an activist moment to help us all climb out of it. The world that *Silence = Death* has since come to symbolize bore little resemblance to the world that existed in the moments just before it, and if there is a lesson here, it might be this: the world can change overnight, and while a communal voice has tremendous power, so do individual ones.

Oliver dealt with the typesetter and Chris finalized the mechanical for the printer. We researched the neighborhoods and I negotiated with the snipers. Manhattan street life dies between New Year's and early spring, and the weather is hostile for postering. Our aim was to hit New Yorkers during the transitional period when they came out of hibernation hungry for social interaction, but before the distractions of spring set in and people started leaving town on the weekends. We chose mid-March as the optimal peak time, with posters beginning to go up the last week in February. To support the campaign, I volunteered to contact LGBT media outlets and to approach bars and bookstores about placing posters there. Responses were varied, and I share them because they paint a fairly clear picture of the moment.

The men's bar Uncle Charlie's said yes without hesitation, giving us placement near the bathroom. Boots and Saddles also agreed. The others I approached declined, fearing conversations about AIDS in a gay bar would kill business. The Different Light Bookstore gave us the window right away, but because the triangle pointed in a direction that was ahistorical, the Oscar Wilde Bookstore said no.

Next, I met with Lou Maletta, a pioneer of gay cable programming in the early days of community access who had produced several shows on adult

Silence = Death

male entertainment and local politics. I did not know him, but Lou was extremely active in the community and eager to meet me. He asked me to his tiny production studio near the Meatpacking District. The set was lit, and the crew were between interviews. He took me to his office, which was also the editing room, and he asked me what I was working on.

I launched into a high-concept description of the poster, and I could see he was immediately lost. Before ACT UP, people had very set ideas about what constituted a lesbian and gay politics, especially in New York, where most of the community activism was focused on New York civil rights legislation or service organizations. Lou wanted to know what group I was representing, or if there was a specific demonstration or political campaign the poster was promoting. There were small local affinity groups that staged political zaps, like the Lavender Hill Mob, but we didn't appear to be one of those. We had no name, no public meetings, and no demonstration to promote. Instead, we were advocating a political sea change, a kind of unnamed underground, and had a campaign of radical resistance in mind. To counter my assessment that there was inadequate community response to AIDS, he pointed to the Gay Men's Health Crisis (GMHC). When I complained there was no political voice in the epidemic, he mentioned Gay and Lesbian Alliance Against Defamation (GLAAD). The idea of giving airtime to such an amorphous project was outside both his orientation and his comfort zone. He needed a concrete thing to urge his audience to do. He wished me luck.

Maletta wasn't the only person with a negative response to the poster. An ex who was visiting from Seattle thought it was the stupidest thing he'd ever heard of, that no one would know what it was or what to make of it, and that if they did, nothing could possibly come out of it. Richard Goldstein at the *Village Voice* didn't believe a poster that vague could have a political use, even though he was raised in the same New York I grew up in and had seen the Village papered with posters and manifestos. He also felt covering it would in some way be tantamount to advocating it, and he couldn't sign on to the

poster's contentions about the political culpability of governmental institutions without applying strict journalistic standards to it. He rejected the claims in the rejoinder as impossible to substantiate and declined to write about it at all.

The overall response was underwhelming, but I was undeterred. I'd already seen major political change during my life, often long in coming: a war ended, government surveillance countered by whistleblowers, civil rights demanded through single acts of bravery and ingenuity. I believed to my core that change was possible, and refused to be told otherwise. Lives were at stake, and I thought even futile attempts were worth trying. I'd made up my mind that if the poster didn't lead anywhere, I'd just move on to something else, and was already attending GLAAD demonstrations and Coalition for Lesbian and Gay Rights meetings and was on the planning committee for the March on Washington for Lesbian and Gay Rights.

Mike Salinas at the *New York Native* was the only journalist I contacted who thought the poster was worth writing about. The *Native* was more radical than the other gay media outlets, and more controversial. It gave ink to every development in AIDS treatments, even specious ones. It was one of the few local papers with weekly AIDS reporting. Salinas had no trouble getting approval from his publisher, Chuck Ortleb. He interviewed me without skepticism and respected my request for anonymity: I still wanted to leave open the possibility for radical organizing. The piece was short, but included the image, and it described our strategic goals.

Within weeks of the interview I saw an announcement in the *Native* that Larry Kramer was speaking at the Lesbian and Gay Community Services Center in New York on March 10, 1987. The *Native* regularly covered Kramer—the only person I had seen talking about the lack of a communal response and the far-reaching political subtext. So, when I heard he was speaking, I suggested the collective skip our weekly meeting and go there instead.

The room was packed, and the atmosphere was somewhat tense. I didn't know Larry at all or travel in his circles, so I was unaware of his histrionics. I now know people were there that night who'd been on the receiving end of those tactics. We'd had a fair share of shouting in our own meetings, but it rarely reached the pitch of Larry's talk that night. He started by drawing an imaginary line down the middle of the room and asking everyone on one side to stand. He pointed at them. "You'll all be dead in a year," he began, with a frown so severe it seemed fake, though he might easily have been nervous.

"Powerful," I said to myself, making a mental note. He followed by saying we deserved to die if we didn't fight and then hammered away at why we should be storming Washington with pitchforks. He demanded that GMHC change its tax-exempt status in order to switch from services to advocacy, that it fight for more drugs to be released, confront the FDA, start lobbying Albany, and hire a PR team. When he was done ranting, he challenged the audience for ideas, shaking two outstretched hands at us, bellowing, "What are you going to do about it?!?"

Those who traveled in Larry's circles may have another take on this moment, and for all I know, that may have included everyone else in the room but the six of us, but here is how it looked to me: If he believed there was little urgency around AIDS, this audience certainly contradicted it, and it was clear we weren't the only ones ready for action. A storm had been brewing, and the people in this room were the rumbling right before a thunderclap. The silence was about to end.

Audience members were shouting out as if they knew one another, or at least they were very comfortable there, and they immediately began flinging ideas across the room. I don't remember the discussion being facilitated, and the level of activity was kinetic. People jumped out of their seats to throw out ideas, and interrupted each other with excitement. And, oh yeah, there was that rage. One person called for devising ways to acquire the illegal drug therapy AL721. Another wanted to draw attention to the potential for

transfusion dependency caused by AZT. Kramer wanted pickets, protests, or arrests at a local FDA office. Someone else proposed a demonstration at the Third International Conference on AIDS in Washington, D.C. Then someone suggested an 8 AM weekly meeting at the Community Center, like the early AIDS Action meetings during the formation of GMHC. After a short debate about dates and times, the room quickly decided to meet at the Center two days later, at 7:30 PM.

The first meeting of the "AIDS Action Committee"—it wasn't named ACT UP until the meeting before the first demonstration at City Hall, when we needed to have a name—began with a recap of the ideas that came out of Larry's speech and then immediately moved into brainstorming possible actions. There was no resistance whatsoever to direct action or civil disobedience as a strategy, and the room was not timid about targets. When I look through my journal notes, the most startling thing about that evening is the number of issues and ideas ACT UP later undertook that were all articulated on that very first night: a higher political profile for affected communities, the cost and inaccessibility of experimental drugs, the involuntary testing of women, and the impact on communities of color, on sex workers, and on IV drug users. The actions proposed that night were a virtual roadmap for the following years of ACT UP as well: a presence at the International AIDS Conferences, infiltrating the FDA, needle exchange, civil disobedience at the National Institutes of Health, pressuring the media, demonstrating at Sloan Kettering and the Statue of Liberty, blocking bridges and tunnels, seizing the Gay Pride March, coordinating a national day of actions, stopping *New York Times* delivery trucks.

During the beginning announcements at the following meeting Neil Broome stood up to ask if anyone had seen the *Silence = Death* posters or knew anything about who had done them. He then looked around the room for the answer. There was a general murmur, and "Yeah, who did those?" seemed to rise out of it. Chris, Oliver, and I were the only ones from the collective there that night, and we were a few rows behind Neil and off to the left. We looked

at each other, and then Oliver asked me if we should come out as a collective. While I was thinking, I shrugged.

Without hesitation Oliver jumped up and claimed credit. Since our group was so small, we'd agreed that two of us could constitute a quorum. And since anonymity had been my suggestion to begin with and I did not immediately object, I think he felt liberated by the lack of conflict. We were asked who we were, and I answered, still seated, "We're a small consciousness-raising collective," and that was all I said about it. We didn't even have a name at that point, and had no plan to take one. There was applause, enough to make me uncomfortable, and to make Oliver beam in that way of his. While he beamed, I looked across the room, and I felt flushed. I was happy for the acknowledgment, to be honest. This roomful of activists was more than I'd hoped for. But I had no way to gauge what they were capable of yet. It felt as if there was radical potential, but it was too soon to say for sure. The ramifications were unclear, but I saw what was happening, had seen it before, and the reason this room was full was not a mystery to me.

I have since come to learn that Larry personally called people he knew to come to his talk that first night, and that might in fact be the reason many had shown up there. But that would not explain why I was there. It would not explain why the rest of my collective was there, or anyone in any of the affinity groups I would soon come to work with, or in my other collectives, or the hundreds of other people who flooded into the room over the following months who had actually never heard of Larry Kramer, because we did not know him or his work, and he did not personally call any of us. He and I came from very different worlds, and very different generations, and although I knew many film and performance people, none of them traveled in his circles and he knew as little about The Contortions or Robert Fripp as I knew about Broadway. I was, however, there for the same set of reasons Larry was. I was there because I was not meant to see Don having a spinal tap just before he died, and his grimace of terror while they did it, but I saw it anyway

through a crack in his hospital room door, and now could not think of any other way to erase the agony of it from my mind but to take to the streets.

I believe that ideas can be universal and that many people may have the same idea at the same time, independently from one another, often on opposite sides of the globe. That's not to say there is no original thought. I believe in that too. But AIDS was not happening to one of us. It was happening to many of us, even though we had yet to meet one another. There are cultural "moments" that belong to everyone, and this was one of those. Such moments may be spurred on and guided, or hammered into shape, and appropriated or claimed, but there is also a wildfire aspect to them, and that part belongs to nature. Some of us can see a moment before it arrives, and have personal histories of this kind of tuning. Others might just feel something and have no idea what it is. But I believe that if you live with your eyes open, such moments are generally plain to see. This activist response we seek to quantify in hindsight by pinpointing direct causality was in fact the result of a crisis in slow motion, and was as multifactorial as immunosuppression can be. It took a long time for many of us to realize our personal hell was a shared one, and it has been my experience that the activation of social spaces, whether through activism or cultural production, can have as much do with Carl Jung and Joseph Campbell as with policies promoted by elected officials, or centuries of institutional oppression. From the perspective of the realpolitik of political organizing, it serves to acknowledge that political agency is as rooted in pop culture as it is in critical theory, and is as connected to the psychodynamics of desire as it is to the question of communal ethics.

It would be convenient to say that the moment in question was the result of one person's Rolodex. But similar calls had been previously made, both publicly and privately, and the result I refer to here hadn't occurred. The questions of how ACT UP began or how it dissolved are ones more suited to the institutional uses of history, and while history is one of the methods of

conceptualizing resistance, history is also capital, and capitalism has a way of unhinging history from the meaning of the political agency behind it. It would be far more accurate to say ACT UP was caused by a rolling collective realization promoted through a series of catalytic elements, events, and individuals, and while it suits the nature of storytelling to claim this as an instant, the fact is, it took half a decade to unfurl.

Wars are started by power structures. Sometimes uprisings might be as well, but rarely when they are authentic. In the aggregate, many of the people in the room may not have consciously come for this reason, but the impulse that drove ACT UP into being was a reflection of individuals finally finding one another, to stand in resistance to unthinkable hard-heartedness. I also believe the urge to create a queer "family" frequently extends outward, however tenuously, and can push communities into formation. It's simple, I suppose, as simple as any tribal impulse is, the impulse for reassurance, at least, but it goes far beyond that. When you are queer, it's also a matter of survival, and that was never truer than it was at this moment.

So, in a way, there was no choice but to give over, and give over fully. I had the same communal instinct Oliver had that night, and as Larry had been having, but for me, it was playing out differently. In my head, I was considering how to expand our tiny collective to include ACT UP, an idea of community that had been in my head since we first formed, and I did it without saying a word to anyone about it. We had delivered *Silence = Death* to the commons, and I realized, there and then, that ACT UP was the next phase of our consciousness-raising project, and we had just met the rest of our members.

We had designed *Silence = Death*. ACT UP was about to create it.

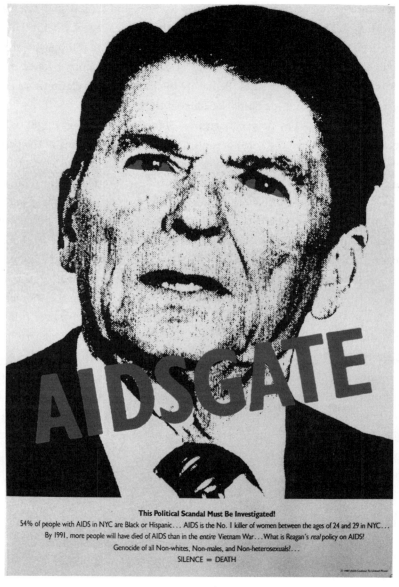

Figure 2. *AIDSGATE*, The Silence = Death Project, 1987, poster, offset lithography, 34 × 22 in.

War

If its mention is ever its glorification, war as a metaphor is troubling. For some of us, the mere language of war presents a moral dilemma.

But I'm not talking here about war as a metaphor for the eradication of disease. I'm talking about the burdens of war and the accommodations it forces on civilian life. War as a tear in the land. War as a political struggle, a holocaust, sprawling in slow motion. I saw it with my eyes, held its dead in my hands, watched the powerful jockey for its profits and its pain. Language is needed to describe what I saw and what it meant to be trapped in it. AIDS was a war, and it was no metaphor.

War, conveying power to the powerful, ownership to those who already profit, and pain to the rest of us. War, with its countless dead and its hobbled survivors, its displaced and its homeless, its rotating caregivers, endless triage, and rampant PTSD. War: destructive, but never final.

It was war, all right, with heroes, and midnight raids, headstones into the horizon for those who were loved enough, and being disposed of as medical waste for those who weren't. War, with its blanket of death laid over us, silent as nerve gas.

Yes, war, with the brave holding trenches and the rest of us tearing bandages, selling the possessions of the dead to provide care for the dying. War, with spies and traitors and enemies within, with prisoners, and the piling of bodies. War, with its call for camps, its funerals and wakes, memorials and

graveyards, hospital stays and hospital visits, written wills and wills contested, with its widows and its destitute. War, with its long, dull devastation, and salt-stained ankles in an ocean of tears, the beating of breasts and the tearing of hair.

War, with underground railways smuggling medicine in and people out, the sheltering of the wounded, the improvised clinics and the rotating caregivers. War, with infiltrators and volunteers, networks of advocates, and lawyers and proxies, with citizen journalists and ad hoc agencies, with research wings and guinea pigs, the thieving of resources, the begging for resources.

War. Because our government opposed our existence.

To say the ACT UP meetings at the Lesbian and Gay Community Services Center in New York crackled with a communal sense of discovery that bordered on the erotic only tells you how it felt if you made it through the clamorous, churning, ear-to-ear grin of its preamble to the restless, riptide anxiety of its ferocious possibility. The meeting space was a low-ceilinged cloister with the used-up feel of an industrial rec room. Even after the Center commissioned murals to cover the walls of the space, it never lost the working-class haphazardness of a Knights of Columbus hall. But it also felt like an enveloping cocoon, and as warm as an incubator. The striated, black-and-green linoleum floor tiles were cushioned enough to stand on all night, and oddly soft if you needed to sit on them.

Those who came early would arrange approximately eight rows of folding chairs, thirty across, dividing the room lengthwise, facing west during the early days, and east once the meetings became too big to enter into the front of them. The chairs were always filled, and there were three breaks in the rows if you needed to come and go, but almost as many people milled around the periphery of the room, often three and four deep, floating, cruising, schmoozing, gossiping, listening, kibitzing, and glad-handing. Fluted

iron pillars dotted the room, narrow enough to see around and looking far too spindly to support the hulking building above us. If you explored the outer edges of the space, you found a labyrinth of foyers, and back stairs with glass-doored vestibules, doors to courtyards, doors to cavelike corridors and loftlike anterooms, each of them populated with spin-off meetings or affinity group caucuses, and research team confabs that spontaneously sprang up around the multiple actions being negotiated on the floor on any given night.

At times the far wall of the room was lined with modular stage platforms, along with event speakers that some people perched on. The room pulsed like a nightclub, blaring with ideas instead of music, or a school you could teach at one minute and attend the next, an ever-expanding life raft for the disinherited, a dating service, an employment office, a health care facility, comedy club, performance space, research institute, company store, and meandering tutorial in world-making. There were teach-ins and shrieking fights, diatribes and rationales, tears and puppet shows, minichorales and meltdowns, all of it buttressed by the ongoing and well-proven certainty that any single person in that room would catch you if you fell. It was not for the fainthearted, but every one of us knew what was waiting outside those doors, and that was much, much worse. So we stayed—clung to it, more accurately—and new people joined us every week. I was there from the start and had watched it build, so I can only imagine how it might've felt walking into that room for the first time. There was an ongoing attempt at newcomer orientation, but no explanation could ever be offered for its intensity. There was simply the white-hot communal performance of it, every Monday night, for years on end.

The room seethed. Some found it terrifying, and the meetings could certainly be hazardous, but I found them reassuring. Many people have described the floor of ACT UP as electric. If it was, it was electric in *every* sense of the word. It was kinetic, shocking, forceful, activating, and

War

occasionally dangerous. But it was also the safest place I knew, offering the safety of knowing who was in the trench with you, of being able to weep in a crowd without being asked why. We trained one another as the need arose, to become experts within a communal pool of them, creating a school for activists, advocates, artists, policy makers, scientific researchers, journalists, and policy wonks. It was far from the only community dealing with HIV/AIDS in New York, but one that had discovered how the most rudimentary of commonalities, mortality, could be activated as a political bond.

A tension also accompanied this bond, and its rank and file pushed every boundary of individual identity, but ACT UP was also a collective, and as such, it functioned like an organism. There was no universal truth to it, and it was only as true as any activity staged at the Lesbian and Gay Community Services Center in New York could ever be. But it was not simply true to whoever showed up on any given night. It was true to every person those people had heard speak on any other night. It was an expanding, self-politicizing perpetual-motion machine, and even though its membership was in flux and it applied an inverted version of anger management, its heart could always be counted on. *The floor* was the term we used to loosely describe the organic democracy and the voting body that deliberated the impact each strategy might have on our shared fate, but it also referred to a collective temperament, which is an entirely separate thing. Many of us came to know the issues inside and out, while others were content to go by their gut. But no one was passive. If you were there, you were done with that. It's common to hear in firsthand accounts how completely consumed we all were. Many of us also attended working meetings every night of the week and still felt as though we weren't doing enough. It went on like that without rest. It was compulsive, but there was simply no choice. People were sliding through our fingers like sand.

Partly owing to a foundational maleness and whiteness that can't exactly be corrected once an organization has already formed, the unwavering

Silence = Death

certainty that room could muster was intoxicating. I also know it's possible to be at your most defined and, at the same time, feel lost. Certainly that was true for me, and it probably described a lot of other people who passed through those doors. It was a clubhouse for the misplaced and for those in freefall, and a space that couldn't be considered apart from the mythic or the primeval, or the psychodynamics of betrayal and rage. It was like coming in from the cold to a town hall for the dispossessed. And in those very first moments—before new members joined the group with experience in resistance work and it expanded in terms of its diversity—ACT UP often volleyed between a raging self-determination and seat-of-the-pants messiness. It was a month before a steering committee formed, only to be replaced by a coordinating committee the following month. There were loose organizing principles that were less structural than improvisational, and heated arguments erupted over guerilla actions versus mass civil disobedience, whether to resist institutional bureaucracies or change them from within, battles over conflicting messages from marshals during civil disobedience, and whether we should negotiate our demonstrations in advance with the cops. There were pitched shouting matches over how radical we could or should be, and our third meeting devolved into a painful slugfest over how true coalitions are formed. In the first few months, before the room became filled beyond its capacity, ACT UP was still finding its identity, and at times it even reassembled the organizations it was formed to slough off. People from GMHC facilitated the meetings, former Gay Activist Alliance (GAA) members held court, organizers from the Coalition for Lesbian and Gay Rights jockeyed for influence, the New Alliance Party attempted their customary minicoup, and power dykes from the East End stalked the room.

It has never been my nature to have a huge circle of friends, but I have always had a close-knit one, and every single one of them became involved in ACT UP in some way. So, woven among all these new strangers were many people from my past, making the experience even more transformative for

me. The Silence = Death collective continued to meet, but we were also becoming engulfed, either in separate orbits or in ones that overlapped. From the beginning, ACT UP focused on the intricacies of AIDS treatment, and some members of our collective had no appetite for it. We had varying stamina for that level of specificity, and a few of us were too conflict-averse to ever speak up at the meetings. In the end, Oliver and Chris became the most regular attenders, and I never missed a single meeting. The more involved I became the more apparent it was to me that our collective should combine forces with the group.

Oliver and Chris both joined the Outreach Committee, which was organized around coalition building. Chris was a tireless workhorse. After hours of painting the sprawling banners for the Women's Committee Action at Shea Stadium, when everyone else had gone home, he made me go back over them with him, with a ruler and a black Sharpie, to straighten out the edges of every four-foot letter. Oliver was behind the short-lived ACT UP palm card, which was essentially a business card, an idea I never fully understood. He freaked everyone out by adding the phrase "We liaise with PWAs" without consulting anyone, the sort of autonomous decision he was famous for in our own collective.

I was elected one of the first two at-large members to represent the floor in the Coordinating Committee, which organized the meeting agenda, and I was also on the Logistics Committee, which later turned into the short-lived Actions Committee. Logistics did the legwork for demonstrations and researched the locations to report back to the floor. I could always find a way into a building, and I was the king of the side door. When I was a kid, a friend taught me how to sneak into any concert: in a jumpsuit, holding a folding chair over your head and shouting "Coming through!" I was also great on a stakeout, and in my drug days, I always stood lookout.

I became swept up in the Fundraising Committee as well. I was sitting next to someone who suggested a need for one and who was instantly

"volunteered" to head it by the facilitator that night. "I have no idea what I'm doing," he shrugged, with a nervous grin and eyes full of fear. After the meeting, he asked me for ideas.

"Let's make a thousand 'Silence = Death' buttons to sell at the GMHC AIDS Walk in May," I said without hesitation. I had already decided we should do buttons and had done all the research. "They'll cost eighteen cents each and we'll sell them for a buck. We can use part of the proceeds to make T-shirts to sell at Pride the following month."

"I don't know." Again the eyes, this time without the grin. "What if nobody buys them?"

"I'll pay for the first run. Risk free." The suggestion was rhetorical, but he was still reluctant when he said yes.

I knew we would easily sell them, but fund-raising was not my motivation. Silence = Death was originally conceived of as a consciousness-raising project to get people to think about AIDS, and ACT UP had discussed "squatting" on the AIDS Walk to politicize it. People wearing the image would help us push the entire event in a more political direction. If the poster had opened a door to thinking about the politics of AIDS, the button could help more people cross the threshold. We did sell the buttons, every one of them, and the next day there were a thousand more activists on the streets of New York.

This sort of ubiquity had always been one of the goals of the Silence = Death project. Still, I wanted to be respectful about how we integrated the image into ACT UP. Simon Doonan, then display director at Barney's in New York, had a different timeline in mind. He was one of the first of ACT UP's many unofficial "art directors." After ACT UP's first demonstration on Wall Street, he prodded me to bring the posters to the next one, the Tax Day Action at the Post Office.

I pushed back. "I don't feel comfortable bringing posters without the floor's consent."

"Don't be ridiculous. Everyone brings their own posters to a demo."

"Yeah, but not a stack of them."

"Just give me a bunch. It'll be out of your hands. I'll take the blame."

I tried again to deter him. "But they're so big, and the paper is so thin. How's anyone gonna hold them up?"

"I'll have the kids at work mount them on foam core." Foam core is a staple for displays and signage, a rigid, lightweight, Styrofoam board sandwiched with paper. I'd never seen it used at a demonstration before.

"Genius," is what I thought, but "Okay" is what I said.

It was genius. Foam core is extremely lightweight and holds up in all kinds of weather, and we later discovered it was percussive. I remember the first time one of the East Village boys pounded on one, and his startled grin when he did it. He was surprised by how loud it was, and the pounding spread like a flash fire. The amplified drumming sounded like an army of timpani echoing off the buildings. It was intimidating, processional, powerful.

The next phase of the use of the image came in the form of stickers through the Outreach Committee, which Oliver and Chris worked on. They cost much less than the buttons and could be placed anywhere. In no time at all they were clustered all over the city in places everyone frequented: on every subway, inside the cash dispensers of every ATM, and in the hinged lids of every mailbox. A handful of activists with a few rolls of stickers were able to create a sense of ACT UP's omnipresence (even though there were only a few hundred members at the time), and in no time, it became a noticeable feature of the Manhattan landscape. As we began to have more demonstrations and meetings in Washington, D.C., every coin-toss tollbooth between the two cities became plastered with them, helping reinforce an exaggerated sense of our influence in the corridor connecting the media and government centers of America. The stickers even found their way into the Pentagon and the National Security Agency, owing to one fearless lesbian and her gay husband, both living with HIV,

who had security clearance. I was told that when they landed on the door of Oliver North's office, the Department of Defense circulated a stern warning memo.

I don't doubt that all the efforts on the part of the collective and ACT UP to expand the use of this consciousness-raising project within our community of activists played a part in the impression that it was the ACT UP logo. But the consistent framing by media outlets of the image as a logo effectively compacted the fuller dimensions of its creation and usage, which came out of an extremely fluid collective dynamic. The buttons were my idea, and the stickers came out of Outreach, with Oliver and Chris designing them. I suggested T-shirts to the Pride Subcommittee because I envisioned our presence as a sea of black delivering a single message, and Chris and I sold the shirts at D.C. Pride as a trial balloon before debuting them in New York. But the shirts were actually ushered through by the Fundraising Committee, and the dissemination of the stickers was completely spontaneous and decided on by the individuals who carried rolls of them wherever they went. There were suggestions to the floor when they were handed out, but no formal conversations or votes about how they should be used. The sticker project could best be described as a fugue of communal impulses, viral, before this sort of gesture became a marketing strategy, one that quickly evolved through its usage. Everyone who came across a sticker put another beside it, until they were clustered everywhere. It was a part of a collective dialogue, within the flux of a dynamic practice, a blossoming set of shared realizations that grew from individual impulses into a communal identity, eventually commandeering the city as an activated space. In the same way that ACT UP members with an aptitude for research or policy threw their hats into the ring, our collective contributed our own work-product to the larger group around us, and while I fanned the flames in ways that felt appropriate to me, Silence = Death was organically agreed upon over a four-month period with no formal conversations about it on the floor whatever, something that

might not have happened once the organization began to grow exponentially that summer.

There were two notable controversies about it, however. The first came when the head of Fundraising, Peter Staley, finally proposed the T-shirt idea to the floor. Larry Kramer had a notorious meltdown about it, screaming, "Sissies! People are dying and you're talking about T-shirts," before storming out of the meeting. He was not the only one who mistook this part of the project as a desire to open a swag boutique, but here is the reality about the image we later came to formally agree on in hindsight: not everyone has the ability to visualize things that haven't happened yet, and except for the collective, every time I ran any aspect of this image by anyone, from concept to dissemination, they thought it was nuts. If I had listened to any of it, we would never even have produced the poster. That the T-shirts might raise a lot of money didn't matter to me. I felt strongly about this fourth life for the image as a consciousness-raiser, and wanted to seize the opportunity the moment had presented. With prodding on my part, ACT UP was becoming the "newest member" of the Silence = Death collective, articulating the agency of the poster in ways I had never precisely imagined, and I saw the shirts as a new way to expand on it, further engendering a sense of belonging and solidarity. A T-shirt could also go where a placard can't, and was ideal for those not physically able to manage a sign. And finally, on a media landscape where repetition is essential, activists could define their own space in the same way the black posters had carved their own zones in the city landscape, becoming living agitprop in media coverage every time the cameras zoomed in for a close-up or sound bite.

Chris's neighbor was a fashion rep, and so was his brother. It was second nature for us to source cheap T-shirt blanks on the Lower East Side in New York. We negotiated a price, made the mechanical, and helped Peter Staley deliver the shirts to the printer. We sold the shirts at the Pride street fair, in a booth that in a moment of omnipotence I decided I could engineer,

but which barely made it through the day. We had great placement and sold most of them. ACT UP members staffed the booth in constant rotation. And Larry, who hated the idea when we proposed it, is said to have sold the most that day. Although it took a long time to plan, the shirt project became hugely successful, as both an organizing tool and a fund-raiser for ACT UP.

The second controversy was far briefer in comparison, but much more uncomfortable for me. It came when we proposed copyrighting *Silence = Death*.

I had been involved with the March on Washington (MOW) organizing committee before ACT UP formed, and was later sent as one of nine representatives from ACT UP to the civil disobedience organizing meeting in Boston right after Pride that first year, in 1987. Although I was unpopular for being openly hostile to the ideas considered at that meeting, I was nonetheless approached by the organizers of the march to use Silence = Death as a fund-raiser. We had no formal affiliation with ACT UP at that point, so I brought it to the collective, which unanimously agreed the march was something we wanted to support.

Just before the Boston meeting an intellectual property lawyer who was an ACT UP member approached me at the health club we both went to and advised me that if we didn't copyright *Silence = Death*, someone else actually could, preventing us, and ACT UP, from using it. With our shared gallows humor the collective had often joked that the image was the "smiley face" of the 1980s, and that is exactly what happened to the man who designed that image. The prospect scared me, so I brought this idea to the collective at the same time as I walked them through the MOW request.

We agreed we should probably copyright it, to ensure that we had rights to give it away, which seemed an idea people found very hard to grasp at that time. We decided to simultaneously tell ACT UP about this decision and request that we allow the march to use it as a national fund-raiser, with the

proviso that MOW not be allowed to sell it in New York or in D.C. during the actual march, and that the permission would be in exchange for march organizers to cosponsor an ACT UP event, which ACT UP had requested and they were reluctant to do. So I asked for time on the agenda to present this idea at a Monday night meeting as soon as I got back from Boston.

Friends who have heard me refer to it as a bloodbath have disagreed with that description, but they were not standing in front of the room that night. I can't remember ever feeling so alone in ACT UP, even though most of the collective was there with me. But it would've been Oliver and I who did most of the talking, and I was completely unprepared for the level of vitriol and distrust. It didn't help that it was one of the first meetings after Pride in New York, when the room was sweltering, and heaving with an expanded membership none of us had anticipated. It was the beginning of a transition that would become more and more noticeable, from a time when you knew all the people in the room and might even have heard some of them speak, to its being a sea of faces you didn't recognize. It was the first time I felt unsafe in ACT UP.

One by one people raised suspicions and objections, even though we were also proposing ACT UP hold the actual copyright (which we also explained had no legal meaning, since the room had rejected forming a board, filing taxes, having 501c3 status, or any other form of leadership hierarchy). The debate lasted no more than twenty minutes, but it seemed to go on for hours. Very few people spoke in favor of the idea or on behalf of the collective, and I felt it would be inappropriate for us to do it. The following week the floor voted in favor of the proposal anyway. But it left such a bad taste in our mouths, and since there was no real "ACT UP" to assign ownership to, the lawyer advising us decided not to file the paperwork. Instead, we added a © symbol on the poster to establish some form of usage. Over the following years I was pulled aside by ACT UP members who thought we should send cease-and-desist orders to the lone gay boot maker in Austin

who had a pair of Silence = Death boots in the store window, or to the gay novelty company that decided a Silence = Death watch would be a great seller. It was designed to be a consciousness-raising project, and we considered every use of the image an opportunity for people to think about AIDS, so we never sent any.

Well, we sent one.

I told our lawyer friend I had heard an unsubstantiated allegation that Nancy Regan had used the phrase in an antidrug public service announcement in Chicago. At three in the morning she had supposedly delivered the line, "Just say no to drugs . . . because silence equals death."

"Does it matter if it's true?" I asked him, at the gym.

"Not at all. Anyway, it's too good not to pursue."

The White House seemed genuinely puzzled, but it did respond with a denial.

In addition to the hive of activity surrounding the dissemination of *Silence = Death*, our collective was also planning our next poster, the first we would produce within ACT UP. In 1987 I was involved in the logistics for our first action at the Third International Conference on AIDS in D.C., and I proposed it to the collective as an opportunity to up the ante. The action would involve a series of strategic firsts for the fledgling organization: our first national demonstration, our first civil disobedience about AIDS at the White House, and our first demonstration at an AIDS conference. We were hoping for something that would live up to the potential of the moment and help set the tone for the rest of the year; above all, I wanted to highlight a war footing by tying the coded Holocaust references in Silence = Death to a charge of war crimes. I started toying with text that would triangulate American pride over the morality of our role in World War II (hinted at in the first poster) against our shame about our involvement in Vietnam, and the carnage of AIDS, while highlighting gender and race. The text across the bottom of the

AIDSGATE poster reads, "54% of people with AIDS in NYC are Black or Hispanic . . . AIDS is the No. 1 killer of women between the ages of 24 and 29 in NYC . . . By 1991, more people will have died of AIDS than in the entire Vietnam War. What is Reagan's *real* policy on AIDS? Genocide of all Non-Whites, Non-males, and Non-heterosexuals? . . . SILENCE = DEATH."

The tagline for the poster was tossed out during a brainstorming session for the second ACT UP demonstration at an April 7 meeting. It jumped out at me and I made working notes in my journal to share with the collective. The image for *AIDSGATE* was always a fait accompli: there was no controversy over whether to depict Reagan. We chose an image of him that would translate into a one-color graphic, flattening him into iconography that could be easily recognizable from a distance and on television B roll, the images used to illustrate voiceover news reports.

In truth, I remember spending more time debating the color of the poster. Originally, I thought yellow, black, and red would be graphically bold and signal caution and danger, but good arguments for staying with tertiary colors were made, and we wanted him to look monstrous, so we settled on green. There was much discussion about the possibility of fluorescent green—my longtime personal favorite—but it would have meant a spot color that required a "double pass" (printing the color two times to guarantee vividness, because the ink does not have a white pigment base). Fluorescent ink also quickly fades in the sunlight, so we would have needed to increase the run of posters to replace them over time. Each one of those ideas increased the poster's cost. So we went with the most saturated Pantone green we could agree on, knowing the same coated paper stock we had chosen for the *Silence = Death* poster would increase the saturation of the color. At the last minute, as Oliver was preparing the mechanical for the printer, he decided Reagan didn't look demonic enough and he made the eyes hot pink. True to his style, he did it without consulting anyone in the collective. It improved the poster, but the collective should have had a

chance to discuss the decision, and it infuriated me. It was not the first or last time Oliver and I would have a fight about what collectivity meant.

I proposed the text, which was based on several ACT UP fact sheets, and we had a fair amount of discussion about its content. Whereas *Silence = Death* was coded, in this poster we wanted to articulate the subtexts of gender and race that had factored so heavily into our decision to use an icon instead of an inherently exclusionary photographic image. Contrary to many characterizations of ACT UP the organization was also concerned with these issues—from its very first meeting, according to my journal notes—and we wanted to help foreground them. This poster needed to be explicit, and with the combined effect of a single word and single image, it was intended to be more flat-footed and to play to the cameras with more clarity than *Silence = Death*, which was never conceived of as a demonstration poster. Silence = Death was a manifesto disguised as an MTV poster. *AIDSGATE* was a political cartoon.

I still regret our decision not to go with fluorescent ink, but the green popped in the scorching D.C. sun. The poster was a production squeaker, so I don't believe we showed the poster to the floor before we went to D.C. Simon mounted them on foam core again, and this time he made at least a dozen. The poster was not consciously designed to imprint a graphic "style" on ACT UP, but the compatibility of the design with the *Silence = Death* poster was fully thought out. Everyone in our collective was a card-carrying member of the Taste Mafia, and we knew they would be seen side by side. At least ten of my old friends before ACT UP came down on the bus to D.C. for the action, forming a miniaffinity group to debut the poster.

Although I was acutely aware of the significance of the first national civil disobedience about AIDS in front of the White House, it was only our third action. It was also our first "away game," and it was negotiated between national leadership organizations and the D.C. police. The compact streets of Lower Manhattan telegraphed the urgency of our frenzied early meetings

during the first ACT UP action on Wall Street. That demonstration had also been negotiated, and was small, but the location created a natural bottleneck that was easily corked, so the demonstration felt kinetic. Our second action was not negotiated, and it turned into a shoving match with the cops, intense enough for someone to pickpocket a police radio without them even noticing. The White House event had more of a festival feel to it, and there were aspects that felt stripped of some meaning for me. I know it is not necessarily true, but negotiated actions feel inauthentic to me. And as it is with many municipal spaces, the scale of D.C. is purposefully intended to dwarf the individual. The openness of the avenue, the glaring sun, the lack of foot traffic—it all felt more like a Hollywood reenactment of dissent than the barely contained, raging machine I knew ACT UP to be. While I have a personal affinity for controlled optics, watching the leaders of the national LGBT organizations led away one by one in suits smacked a little too much of stagecraft.

The picket at the Third International Conference on AIDS was just as rarified, but it did not feel that way to me. It was our first picket, and it had an unexpected power for that type of intervention. It was at a hotel, so there was foot traffic that allowed for interaction. The conference-goers were surprised and engaged, even the ones who disagreed, and they were not shy about gawking from the glass windows above us. I felt a complete lack of aloofness, and had a sense that the lines between us might be permeable. It was ACT UP's first official encounter with the research community, and many attendees wanted *Silence = Death* stickers and buttons, making it our first activist infiltration of a conference. As we picketed outside, the stark unity of the *AIDSGATE* posters seemed all the more threatening against the knot of angry demonstrators, whose bodies were tangled in sticky red masking tape in the D.C. humidity to symbolize the red tape of the AIDS drug approval process. The tape was oddly visceral in comparison, and although people had registered an indictment of the administration with their bodies

earlier in the day, the symbolic arrests seemed relatively remote. I was still very much committed to symbols and agitprop, like Silence = Death, but that was the day I realized that the magic of ACT UP might actually be centered on performance.

Our next major action after D.C. was the ACT UP presence at the NYC Pride March. My journal notes indicate that commandeering the march was an idea proposed at the very first meeting. "Make it a Gay Rage Parade," "Fill the sky with black balloons," "All wear black," it says. As an opportunity for outreach it was clear: there would be hundreds of thousands of bystanders. After weeks of brainstorming about it on the floor, and again in the subcommittee tasked with forming those discussions into a proposal, we decided on a concentration camp theme. We talked about ways to engage the audience, making the threat of internment seem less an abstraction and more a political possibility. Someone suggested we arrest onlookers and actually detain them. We also discussed forcing the march to halt, and someone else suggested "stalling" the ACT UP float or using it to force the march to turn around.

We built the concentration camp on a rented flatbed truck under the direction of another old friend before ACT UP, Mark Simpson, at his studio in the Brooklyn neighborhood of Williamsburg, which was considered the wilds at the time. We added a guard tower to mount cutouts of Reagan from the *AIDSGATE* poster, and a high fence ringing the bed of the truck. Someone with set-building experience devised realistic barbed wire from flexible plastic tubing, and we painted banners to cover the tires. Mark was both stoned and drunk, so he laughed more than he hammered, but there were lots of us there and it did get built. It was exhausting, and fun, but from my perspective the overall effect was a little too art school.

As messy as it looked to me that day, during the march the concentration camp felt powerful, confrontational, and a little frightening. Over the years the Gay Pride March had morphed into a parade, and we were determined to change it back. On either side were uniformed guards in rubber gloves, the

sort that cops wore to our demos out of fear of infection. Everyone was deadly serious about remaining in character. Rows of *Silence = Death* and *AID-SGATE* posters marched behind the internment camp, and many wore the T-shirt versions as well. Teams of people had been out all night spray stenciling "Silence = Death" on the street corners along the march route. Our presence was extremely out of character for Pride in New York, and it projected the sort of political certainty that had been lost over the years. At first there weren't that many of us. By the time we reached the Village, we took up several city blocks. I was at Eleventh Street when the moment of silence the organizers had arranged to memorialize AIDS was signaled. We were silent for exactly one minute, before breaking into a spontaneous chant, one I hadn't heard before that: "We'll never be silent again! ACT UP!" Fists pumped in the air around me, and I heard voices cracking with tears. If you are able to imagine what it was like before the mobilization we associate with HIV/AIDS had begun, you can also imagine how intense this moment might have been, to be out on the streets of New York and see people joining us from behind the police barricades by the hundreds. There had been such a long silence, and for the very first time, I felt as if it might be behind us. Here we were, marching, at a time and in circumstances that were completely unprecedented. I felt an unexpected gratitude from the sidelines, and it resonated more loudly than our shouting. The world was pivoting again, right there in the streets of the Village, where activists who'd paved the way for our liberation once stood. It was emotional, in the way the simplest acknowledgment always feels after you've suffered too long in isolation.

Our very next meeting was packed to the rafters, and it marked a radical shift. We'd shown half a million New Yorkers what an alternative response to AIDS might look like, on one of the busiest streets in the world, with a rage that echoed off the buildings. We'd illustrated what power can feel like when you take the lid off it. The Pride March in New York is such a diverse outreach

forum that the new membership helped chip away at our homogeneity. We had already been in overdrive for four months, but ACT UP suddenly became the place to be, and it seemed to happen overnight. New Yorkers were beginning to take notice.

One of them was William Olander, a senior curator from the New Museum. Shortly after Pride, he contacted David Meieran from the Testing the Limits video collective, who then called me.

"Bill wants to offer the museum windows to ACT UP."

I knew the museum had a history of featuring political work, but I was surprised. "He knows ACT UP is a political organization, not an art collective, right?" I asked.

"Oh, definitely."

"How weird," I said. "So why are you calling me?"

"He asked to speak with someone involved with Silence = Death. Besides, I don't want to go near this thing. I have no idea how the floor will react, but they respect you." The floor was unpredictable, and he was nervous about it. They had recently feasted on me during the copyright debate, and I was too.

"I have no interest in it," I said. I had a political antipathy for the art world, based on my long-held belief that the sole function of Western European aesthetics is the consistent reinstatement of whiteness, patriarchy, and class, in support of colonization and hegemony. I had abandoned my art practice and wanted no part of a museum installation.

David was more conflicted. "But don't you think ACT UP should decide for itself? I don't feel comfortable just rejecting the offer."

I thought for a beat and then had to agree. "Of course, you're right," I said; "it's the floor's decision. Give me his number." I committed to doing the legwork, bringing it to the floor, and organizing the first meeting for the project if there was interest.

Bill was undeterred by my reservations when I called him. He reminded me the museum was in a transitional area, with diverse foot traffic of people

coming from the outer boroughs to work. I started to become more interested.

He mapped out the project. "I want to offer the museum windows to ACT UP to stage a 'demonstration' in, starting November 19th, for eight weeks. You'll need to consider the lack of climate control since the window isn't heated, and we have the capacity for multiple projections."

"So," I asked, "we can do anything we want?"

"Anything."

"No content restrictions?"

"None."

"We can be as confrontational as we want?"

"I'm counting on it."

"We can name corporations and use corporate logos, even if they're museum sponsors?" I knew artist Hans Haacke had just had an exhibition there and gotten into trouble in the past for it.

"Of course."

"Can we do street interventions that connect back to the museum, without restriction?"

"Yes, of course."

"What if we decided to wheat-paste the surrounding areas, or the museum window itself?"

"What a great idea."

I was certain he didn't understand what he was offering, and I paused. "You're sure about this? Once I bring it to the floor, anything can happen and there's no calling it off."

"Absolutely." Wow, I thought, he's obviously never been to an ACT UP meeting, though he apparently had.

I stood in front of the room that following Monday. "The New Museum has offered us their windows for eight weeks in the fall to stage a visual 'demo,'" I said. "There are no content restrictions whatsoever. The museum

Silence = Death

has good frontage in a neighborhood with diverse businesses that serve cross-class audiences from the outer boroughs, so there's outreach potential beyond the art audiences of SoHo. We can also use the streets around the museum any way we see fit without clearing it with them first—we can poster, we can demonstrate. Anyone who's interested, meet me, over there," I finished, pointing to the southwest corner of the room.

A group gathered there, and Mark Simpson was right in the middle of it. Mark was a permanent fixture in my circle of friends, having been unofficially "adopted" by Chris's next-door neighbor and her entire family. I had known him for years. He'd given Don work at his boyfriend's unfinished furniture store in the East Village after he became too sick to perform, a kindness I would never forget, and he was one of the people who helped patch me together after Don died. Chris adored Mark, and Mark had expressed interest in joining our collective, but we had yet to "officially" expand it. He had been chomping at the bit for a while now, and here was his chance to finally do something.

We chose a meeting time that Friday at an apartment on East Fourteenth Street. I went to that meeting to be sure the process was under way, and reported back to the floor before bowing out of the project. I was hostile to working within an art context, something I remained dogmatic about long after I'd eventually agreed to doing so, which anyone who worked with me will confirm. But Mark was there with a yellow legal pad, and after I gave a fuller report of my conversation with the curator, he quickly began steering the conversation.

Some weeks later I was drawn back into the project. Mark approached me on behalf of the working committee to ask the Silence = Death collective if we minded them making a neon version of the image for the installation. Someone in the committee who was teaching a neon course had volunteered to do the fabrication. The committee hoped we wouldn't feel it trivialized the image. Without any understanding of the context, the collective was puzzled as to why they wanted to do it. We thought it sounded kitschy, and

actually had a good laugh about it. But as a matter of our political practice we had come to consider any use of the image to be in line with our conscious-ness-raising objectives, even uses we disagreed with, and so we said yes. It wasn't until the opening of the installation that November that I paid any more attention to the window.

It was very cold that night on Lower Broadway, which can act like a fierce wind tunnel. There were refreshments at the gathering inside, but I mostly stood out in the cold, somewhat transfixed. I imagined the installation would be messy and a little bit DIY, like the Pride float, but the committee had steered this project in a serious direction. I was mesmerized by its slick-ness and singularity of vision. Although I had been hesitant about a museum project, after speaking to Bill Olander, I had seen how his suggestion could also be visionary. What I hadn't seen was how it might set the stage for a work that would be defining, for myself, my colleagues, my community, and for the art world, which he wanted to put on notice. I could tell he intended the ACT UP installation to be a shot across its bow, but I had no sense of how it would play out. As it happened, there were artists within ACT UP who'd decided to test the opportunity by creating something so formally resolved it could not be easily overlooked. It used the space in a way far more consid-ered than I imagined it would be. And the installation, *Let the Record Show,* was propelled by a concise historical absolutism, structured as it was around the Nuremberg trials. That surprised me as well.

It may sound ridiculous to say it, but I did not anticipate that the Holo-caust metaphor would be so agreed upon within ACT UP, when we had struggled with it in our tiny collective. We knew it was an apt analogy, espe-cially with Buckley's tattooing editorial. But it also had conceptual flaws. We were squeamish that it might be read as glib, and wary of interpretations that could be disempowering. Many aspects of the AIDS crisis were compa-rable, but the Holocaust was singular in others. So, while we were directly responsible for advancing the metaphor, I was surprised by the concentra-

tion camp float and, on its heels, this installation. I was also relieved by it, as if the burden of history had been shared, along with the responsibility for bearing witness. It was liberating to see ACT UP members cogently carry this metaphor to the next level, and continue to refine its potential meaning. It felt like someone finally had our backs.

And that was precisely the power of ACT UP.

Outside the museum, huddled with our drinks, I stood with Mark on the curb along with several other people who had worked on the window. It was cold, and we were all a little lit. We were joking and gossiping, mostly about people in ACT UP, and that's when Mark started in.

"No really, I think we should stay together and continue to make work," he said in that tone of his, which sounded low-key if your ear was tuned to New York, but excitable if you were listening to him back home in Texas. He wasn't the only one who thought it or who said it, but he was the most insistent and the most difficult to resist. Over the years we all came to agree that Mark willed Gran Fury into being. He needed it, perhaps more than any of us. Some version of it might've happened anyway, but Mark was like a stage mother who pushed for it, so he and Gran Fury became inextricably bound in all of our minds. And on that particular night no one took exception to his entreaty, myself included. Mark had been part of my intimate circle long before ACT UP came along, and while opinions might differ about whether we were good friends, he was part of my world and everyone I respected or adored respected and adored Mark. I didn't realize it yet, but I was about to begin feeling that way about him myself. So I listened, while I looked at the *Silence = Death* neon, which wasn't simply the commentary on branding I had presumed it might be. It echoed the signage in the surrounding sex shop windows, and as a result it thoughtfully articulated the questions of gender, race, class, and sexual othering situated at the core of the AIDS crisis. It was far more nuanced and so smartly considered in this context, it opened me to hearing about this new collective Mark was proposing.

In historical terms, it was barely a second. But on the ground, Silence =
Death had slowly morphed over a two-year period from an impulse, to a call
to arms, to a "logo," and now here it was, a trade sign. I thought to myself as
I looked up at it, "Silence = Death is officially open for business," and I was
trying to imagine what that might mean. From that moment on, the world
would think many things about Silence = Death and about the work of ACT
UP, and very soon it would have opinions about the work of Gran Fury as
well. From that moment on, a canon would begin to solidify that folded the
work of the tiny collective I'd started with five friends into the organization
that deployed it and, now, into the work of this new collective I'd helped
organize with another friend. In a culture fueled on images, the things that
can be seen—especially seen in neon—tend to be the things we consider to
be truer. In practically no time legend would have it that Gran Fury designed
Silence = Death, and a confluence of the many political and cultural ideas,
gestures, and legacies that would spring from this nascent community of
activists in lower Manhattan would also be transfused into its body.

Gran Fury

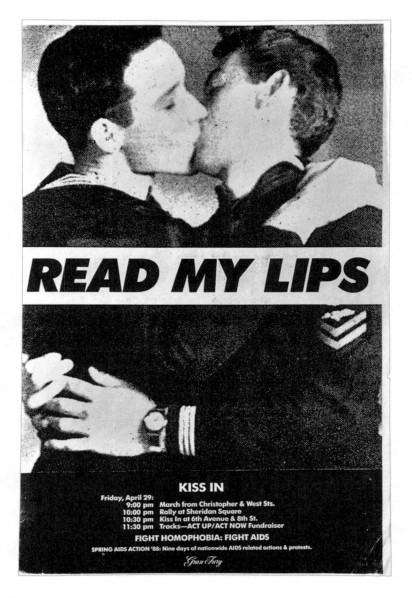

Figure 3. *Read My Lips* (men's version), Gran Fury, 1988, poster, photocopy on paper, $16\frac{3}{4} \times 10\frac{3}{4}$ in. ACT UP, Spring AIDS Action 1988.

Read My Lips

Regardless of the anxieties about sex approaching brushfire proportions in gay America, ACT UP managed to be sexual without restraint, a feature few of its participants are ever able to refrain from mentioning. Desire seeped out of every overpainted surface in the main hall of the Lesbian and Gay Community Services Center on Monday nights. It filled every poorly lit corner and hid under every rickety folding table. There were exceptional examples of every physical type and identity packed into that room, but most of us were not exceptional at all, and that's not what I'm talking about anyway. It would be entirely reductive to say surface appearances were where ACT UP's sexuality resided, and a mistake to decouple the erotic charge from the thing that drove most of us into that room in the first place. The group's sexuality was a direct result of having taken a stand, of seeing something in each other's eyes that runs deeper than desire. Connectedness is what percolated across the floor and bubbled over, and it was there fully clothed.

But the air also carried another very particular aphrodisiac, one most people fail to talk about. After years of isolation, suffering, and doubt, ACT UP was a place you could fall in love with *yourself* again, or at least see yourself as right or righteous or powerful, and in a world that preferred we be discarded or dead, possibly even see yourself as heroic. It is one of the most underplayed psychodynamics of that communal experience, and a large component of its erotic subtext.

Don and I never had safe sex. He was so covert about his diagnosis that even though the AIDS activist Michael Callen had covered several of Don's songs, we never socialized with him and I didn't read his seminal *How to Have Sex in an Epidemic* until Don was gone. After he died, I just presumed I was HIV-positive, and everyone else did as well, which had a chastening effect on every sexual encounter I had, and that's kind of how it was for a lot of us back then. The truth is I didn't understand safe behavior until much later, and by then I'd decided sex had gone the way of the dinosaur. That is, until I noticed Steve Webb at the fifth ACT UP meeting.

I became aware of him because of the friend he was sitting with, an otherworldly, Thor-like dude with white blonde hair. Steve was every bit as eye-catching, but in a way amplified by flaws. His upper lip was fuller on the left side, and it looked as if it was permanently snagged on his lower one. His hair was so wiry, a weekly haircut could never contain how round it wanted to be. His chest was a good one, but his shoulders, which were so bowed by poor posture it looked as if they might smother him, dwarfed it. He showed a fair amount of tooth when he laughed, but he was reserved with it, and his smile was more efforted than his pal's, whose face had entirely surrendered to some chronic sense of amusement. You could tell they were both accustomed to attention, since they'd seated themselves in such a way that no one in the room need deprive themselves of their every move. Still, he seemed retiring compared to Thor, who was epilated beyond any animal recognition and in permanent gym attire, slouching back in his chair with his legs open and fully extended, in a tank top slung so low it barely stayed on him. Steve's T-shirt was snug enough to prove he intended it, but his khakis did him no favors, and for the most part he looked down or was slouched forward with his chin buried deep in his fist. His eyes were pale, but squinted, and his brow was completely furrowed, except when his friend—who appeared hell-bent on having a good time in spite of the gravity of the floor conversation—said something funny. Steve appeared hell-bent on listening.

He stood up once to make a point. He was taller than his seated form hinted at, and it became a different body as he unfolded it. It seemed less broad and lither, and in profile he looked like another person. His shoulders still dominated and were still as round as a barrel, but the strength of his neck seemed to balance them, and so did the narrowness of his hips as he parked his left hand on them in a way that was studied. Both feet were firmly planted while he poked high in the air with one finger, three or four times, entirely propelled by his wrist while the rest of him barely moved. He was concise, and delivered an impassioned, political speech in a high tenor, as if he were speaking at the Continental Congress. And then, although I'm not sure why it would've been necessary, he suddenly pivoted before taking his seat. If he was nervous, he didn't act it, and he was articulate in a way that can come only from being unrehearsed. You could've heard a pin drop while he was speaking, and the room fizzed back into silence in his wake. I stopped looking at Thor. So did everyone else. I decided this was someone to be taken seriously. And almost as quickly as I'd first noticed him, I determined he was out of my league.

I pretty much flunked Fag. I've still never actually seen *The Sound of Music*. I could barely manage an hour of *Gypsy*, and then it was only because I felt as if I'd had an incomplete education. I would have walked out of *Dream Girls* if Don hadn't put his foot down. And I've never, *ever* been able to tell when someone is interested in me. If that weren't enough, I'd been so distracted by the whirlwind of meetings, research, production deadlines, and finalizing *AIDSGATE* that it had entirely escaped my notice that Steve was volunteering for every project I worked on. Over the following months we both joined the short-lived Logistics Committee and helped organize the D.C. demonstration together. He offered to help me construct the Pride booth and insisted I sit on his shoulders to build the top of it, rather than tilting the booth on its side to do it. And when I agreed to represent ACT UP at the Boston organizing meeting for the National March on Washington over the Fourth of July weekend, his hand shot up.

"I work the day before, so I'll have to fly up," I said after the meeting, a little embarrassed to be spending the money. "I'll just join you up there."

"Great," he said without missing a beat. "I'm flying, too. Let's go together."

"Uh . . . cool," I stammered. "I'll meet you at the shuttle." I didn't expect that at all, and then I said, "I used to know a cheap motel on the river out near Allston. Do you want me to see if they have an extra room for you?"

"Don't do that," he said, and he said it right away. "I have a really good friend in the North End who usually puts me up. Why don't you stay there too? She has lots of room, and I know you'd really like her."

I hesitated before saying yes. I'm a bad sleeper.

I did like her, a lot, and the mediocre Italian food we had in that neighborhood reminded me of my school days in Boston, when I shopped at Haymarket on Saturday and cooked for the week. She was funny, and very smart, and seemed to take a shine to me, but I still wasn't on to Steve's seduction scenario until she offered us her bedroom. I didn't see it coming, though I never do, and it wouldn't have mattered anyway. I'm certain no one ever said no to him. He had carefully constructed a world in which that was the case.

By the time we joined the other New Yorkers at the planning meeting the next morning, Steve was coiled tightly around me, and had already chosen a pet name for me. I was drawn in by him, but found it more confusing than it was exhilarating. His mind seemed completely made up about me, and I suppose it was; the people he attached himself to played a fairly big part in the world he'd constructed for himself. He was immediately at home with the idea of belonging to me, and making a public declaration of it. I, on the other hand, can take years to declare myself, and I'm famous for keeping my guard up. But I lowered it for him, right away. You'd have had to be made of stone not to.

Steve was smart and his ideas considered, with a vision of the world born of the sort of midwestern egalitarianism that's constructed on some

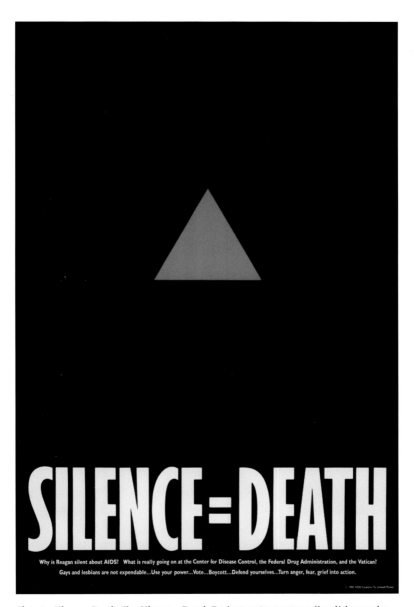

Plate 1. *Silence = Death*, The Silence = Death Project, 1987, poster, offset lithography, $33\frac{1}{2} \times 22$ in.

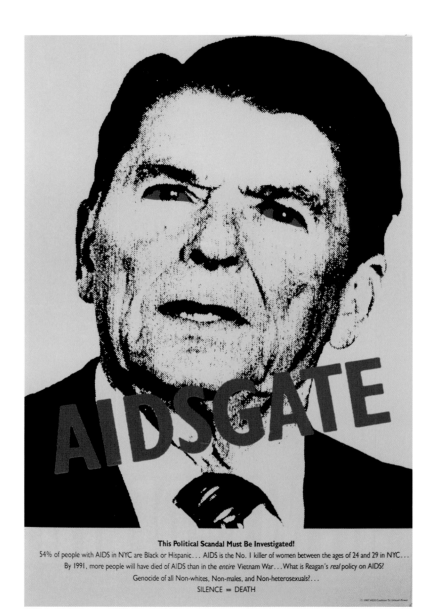

This Political Scandal Must Be Investigated!

54% of people with AIDS in NYC are Black or Hispanic... AIDS is the No. 1 killer of women between the ages of 24 and 29 in NYC... By 1991, more people will have died of AIDS than in the *entire* Vietnam War... What is Reagan's *real* policy on AIDS? Genocide of all Non-whites, Non-males, and Non-heterosexuals?...

SILENCE = DEATH

Plate 2. *AIDSGATE*, The Silence = Death Project, 1987, poster, offset lithography, 34 × 22 in.

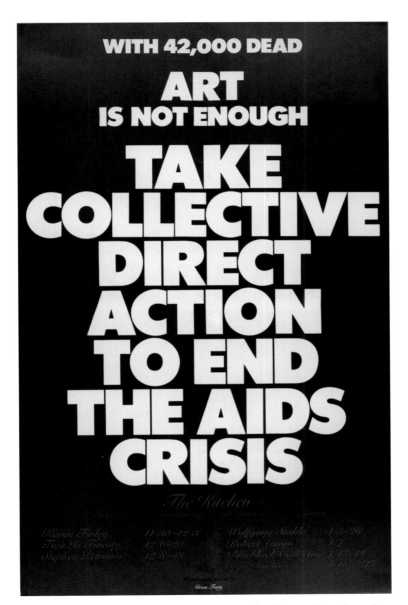

Plate 3. *Art Is Not Enough*, Gran Fury, 1988, poster, offset lithography, $21\frac{1}{2} \times 13\frac{1}{2}$ in. For The Kitchen, New York.

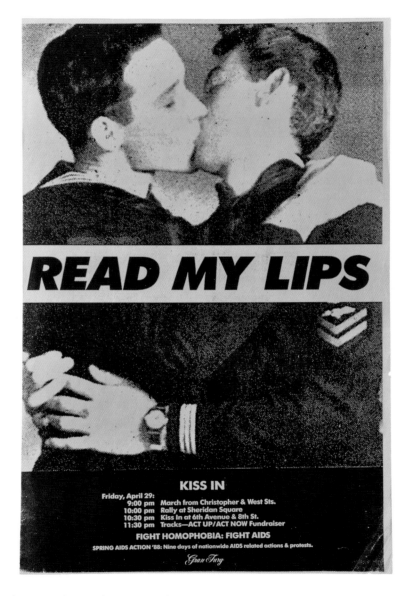

Plate 4. *Read My Lips* (men's version)s, Gran Fury, 1988, poster, photocopy on paper, $16\frac{3}{4} \times 10\frac{3}{4}$ in. ACT UP, Spring AIDS Action 1988.

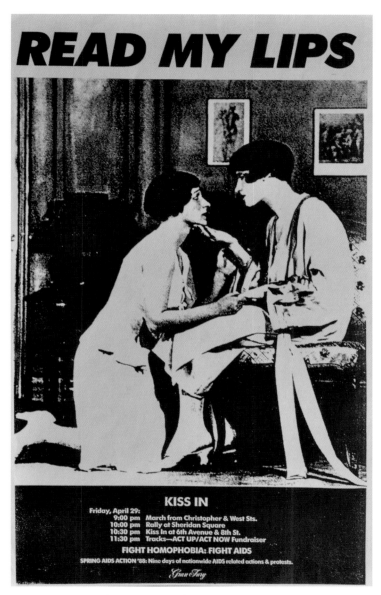

Plate 5. *Read My Lips* (women's version), Gran Fury, 1988, poster, photocopy on paper, $16\frac{3}{4} \times 10\frac{3}{4}$ in. ACT UP, Spring AIDS Action 1988.

KISSING DOESN'T KILL: GR

CORPORATE GREED, GOVERNMENT INACTION, AND I

Plate 6. *Kissing Doesn't Kill*, Gran Fury, 1989–1990, four-color bus-side poster, ink on PVC, 30 × 140 in. For Art Against AIDS On The Road.

ᴇᴅ AND INDIFFERENCE DO.

ᴄ INDIFFERENCE MAKE AIDS A POLITICAL CRISIS.

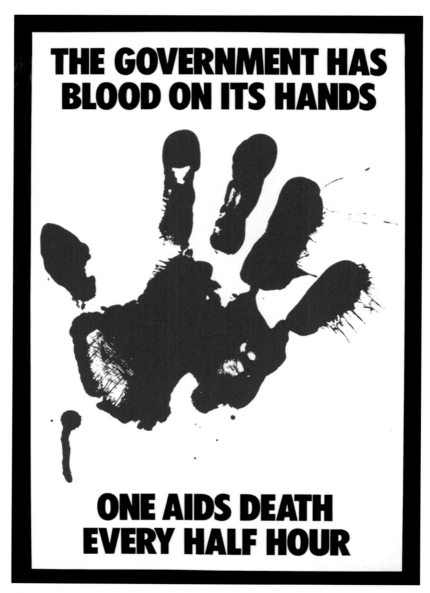

Plate 7. *The Government Has Blood On Its Hands*, Gran Fury, 1988, poster, offset lithography, $31\frac{3}{4} \times 21\frac{3}{8}$ in. ACT UP, FDA Action.

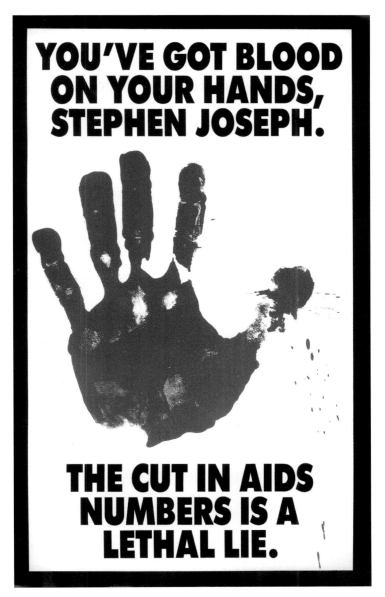

Plate 8. *You've Got Blood On Your Hands, Stephen Joseph*, Gran Fury, 1988, poster, offset lithography, $14 \times 8\frac{1}{2}$ in.

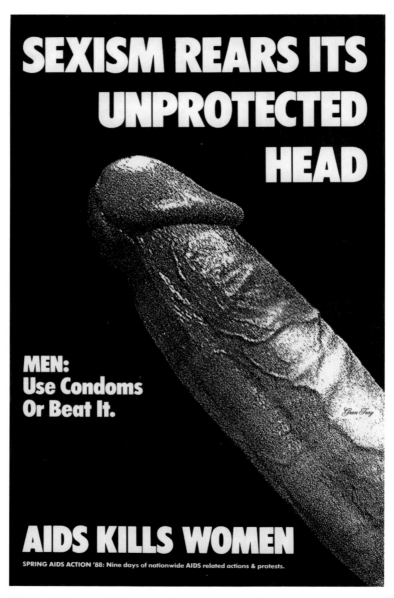

Plate 9. *Sexism Rears Its Unprotected Head*, Gran Fury, 1988, poster, photocopy on paper, $16\frac{3}{4} \times 10\frac{3}{4}$ in. ACT UP, Spring AIDS Action 1988. Courtesy Fales Library, New York University.

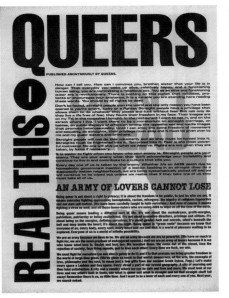

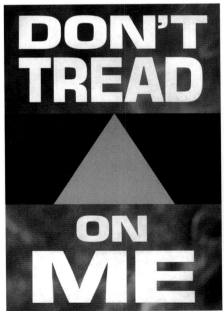
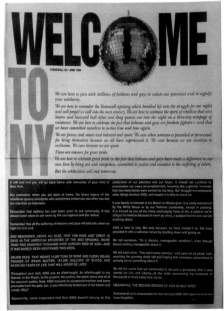

Plate 10. Clockwise, from top left: *Queers Read This*, Anonymous Queers, June 1990, front, offset lithography on newsprint, 15 × 22 $\frac{1}{2}$ in., folded newspaper; *Queers Read This*, Anonymous Queers, June 1990, back, offset lithography on newsprint, 15 × 22 $\frac{1}{2}$ in., folded; *Don't Tread On Me*, Anonymous Queers, June 1991, poster, offset lithography, 12 × 7 $\frac{3}{16}$ in.; *Welcome To New York*, Anonymous Queers, June 1994, front, offset lithography on newsprint, 15 × 22 in., folded.

SEXISM REARS ITS UNPROTECTED HEAD

MEN USE CONDOMS OR BEAT IT

AIDS KILLS WOMEN

Plate 11. *The Pope And The Penis* (second panel), Gran Fury, 1990, ink on PVC, 96 × 216 in. For Aperto 90, XLIV Venice Biennale, Italy. Courtesy of The New York Public Library.

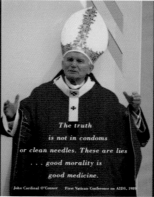

The Catholic Church has long taught men and women to loathe their bodies and to fear their sexual natures. This particular vision of good and evil continues to bring suffering and even death. By holding medicine hostage to Catholic morality and withholding information which allows people to protect themselves and each other from acquiring the Human Immunodeficiency Virus, the Church seeks

The truth is not in condoms or clean needles. These are lies . . . good morality is good medicine.

John Cardinal O'Connor First Vatican Conference on AIDS, 1989

to punish all who do not share in its peculiar version of human experience and makes clear its preference for living saints and dead sinners. It is immoral to practice bad medicine. It is bad medicine to deny people information that can help end the AIDS crisis. Condoms and clean needles save lives as surely as the earth revolves around the sun. AIDS is caused by a virus and a virus has no morals.

Plate 12. *The Pope And The Penis* (first panel), Gran Fury, 1990, ink on PVC, 96 × 216 in. For Aperto 90, XLIV Venice Biennale, Italy. Courtesy of The New York Public Library.

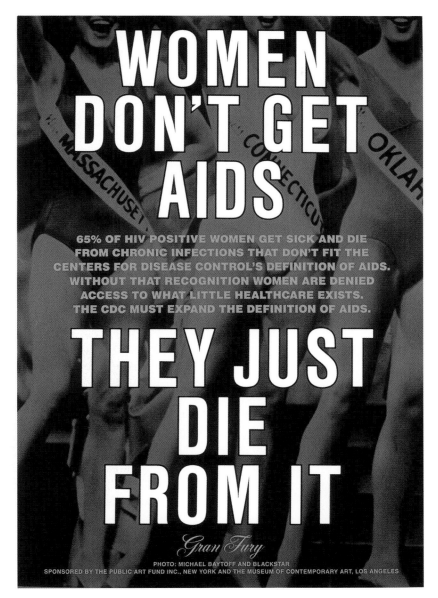

Plate 13. *Women Don't Get AIDS, They Just Die From It*, Gran Fury, 1991, bus-stop shelter sign, ink on acetate, 70 × 47 in. Public Art Fund, New York. The Museum of Contemporary Art, Los Angeles. Courtesy of The New York Public Library.

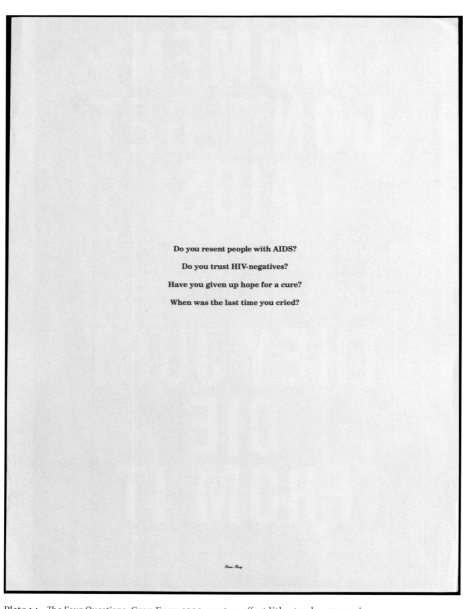

Plate 14. *The Four Questions*, Gran Fury, 1993, poster, offset lithography, 25 × 19 in.

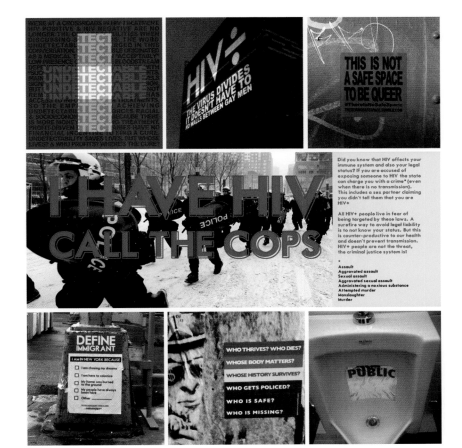

Plate 15. Public projects produced during Flash Collective workshops conducted by the author between 2014 and 2016. Left to right, top to bottom: *What Is Undetectable?* What Is Undetectable Flash Collective, 2014, lenticular postcards and lightboxes in four New York Public Library branches, workshop co-organized with Jason Baumann and Visual AIDS, sponsored by the New York Public Library; *HIV÷*, Viral Divide Flash Collective, 2016, projection on the Bronx Museum for *Art, AIDS, America*, projection by the Illuminator collective, workshop co-organized with Mark S. King, sponsored by Visual AIDS, Gay Men's Health Crisis, Broadway Cares/Equity Fights AIDS; *There Is No Safe Space*, Helix Queer Performance Network Flash Collective, 2014, sticker intervention at The New Museum, workshop co-organized with Dan Fishback, sponsored by the Helix Queer Performance Network and the Hemispheric Institute of Performance and Politics, New York; *I Have HIV, Call the Cops*, FUCKLAWS Flash Collective, 2014, projected billboard, buttons, and digital postcards, workshop co-organized with Ian Bradley-Perrin and Karen Herland, sponsored by Concordia University and the Centre for Exhibition and Research in the Aftermath of Violence, Montreal; *Define Immigrant*, Define Immigrant Flash Collective, 2015, digital posters, workshop co-organized by Dipti Desai, New York University (NYU) Steinhardt, New York; *Queer Crisis*, Queer Crisis Flash Collective, 2014, crack-and-peel stickers, workshop co-organized with Dan Fishback, sponsored by the Helix Queer Performance Network and the Hemispheric Institute of Performance and Politics, New York; *Untitled*, Public/Private Flash Collective, 2015, crack-and-peel stickers, workshop co-organized with Dipti Desai, NYU Steinhardt, New York.

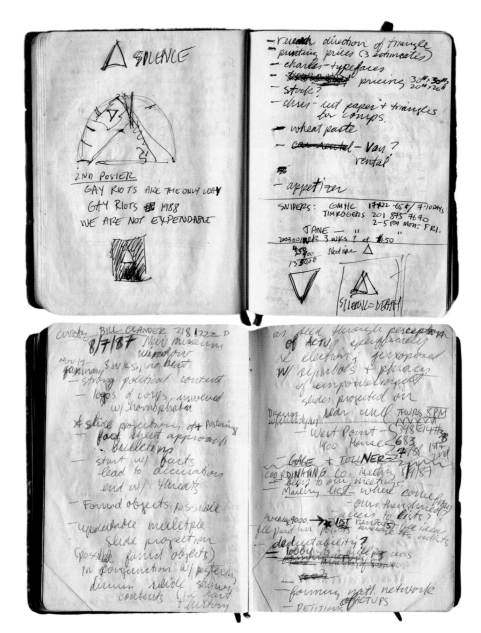

Plate 16. Journal notes, Avram Finkelstein, 1986–1987. Top: *Silence = Death* meeting notes with sketch of *Silence = Death* poster and follow-up riot poster, task assignments, and budgets. Bottom: notes from phone conversation with William R. Olander, senior curator at The New Museum about the ACT UP *Let The Record Show* window installation, which led to the formation of Gran Fury; notes for organizing the committee to produce it; and notes from an ACT UP Coordinating Committee meeting about direct-mail fund-raising. Courtesy Fales Library, New York University.

high-WASP notion of fair play. He was also lost and he knew it, though he barely complained about it. His financial needs were provided for by an older, married man who lived in the next building. But now, surrounded by sickness and death and with the news of his seroconversion, it was no longer enough for him. He wanted to see himself as necessary, though he didn't exactly know how to do it. So he went through the motions as he struggled to figure it out, a strategy he'd pretty much perfected. Steve needed to matter, and even in its infancy ACT UP helped locate the possibility of that. He dove headlong into it and started swimming, as many of us did, barely tilting his head for air. He joined the Coordinating Committee, and Logistics, and with Stephen Gendin, he coauthored the ACT UP Working Document, which created a structure for its participatory democracy.

I'm not sure how a person comes to subjugate other gifts to his looks, since I was never exactly presented with that option. In Steve's case, he seized it and worked hard to make himself desirable, though he was barely able to conceal an underlying self-deprecation. According to Steve his father had disowned him for having an affair with one of his dad's friends, Steve's high school coach. Sex came easy for him, and it became a means to survive, but he appeared to me to have no special love for it. It helped him carve his place in the world, and that had a power. But he wanted to stand out for other reasons, and long before he discovered he actually might, he had solidified this particular means to approximate it, as is true for many gay men.

If it sounds as though I'm trying to rationalize him, I am. I'm embarrassed to think that in one glance you might think you understood my attraction to him, which would've been fine with most of the men in his life. But I'd never had a relationship based solely on looks before, and even if that were all there was to it, it still wouldn't do justice to how it *felt* to me in the terrible world that had locked in around us, after the years of concessions I'd had to make to coexist with it. We couldn't have been more

different, and under other circumstances we would never have met, yet here we were: Steve, looking to be linked to someone who might reinforce his significance, and me, needing to feel wanted in a world that had withered away from me.

I was not looking for him. In fact, I'd originally given him my back. But there is nothing more irresistible than being pursued, and he became my first bond of war in this highly pitched world, where the terrifying was undergoing some miraculous form of communal metamorphosis. We were not the only ones coupling in ACT UP during those early moments, and connectedness felt radical in that context, like an extension of the support and care teams we were assembling to help one another survive, or the affinity group structure that constituted a large part of not only ACT UP's political structure but its social structure as well. In fact, coupling and polyamory often rose organically out of affinity groups, committees, and working groups. I'm not saying it was coupling that was necessarily definitive, but it was certainly as much a part of our landscape as sexuality was. Neither do I imply that ACT UP was a sort of sexual commune. It was simply a tightly knit community, one teetering on the brink of extinction, and intent on exploring any meaningful avenue for support, sharing, or nurturing.

Even though I wasn't 100 percent sure what my expectations were, I was in the process of falling for Steve and was undoubtedly banking on some semblance of the romantic permanence I had buried with Don. We spent every moment together and were linked in the minds of everyone in ACT UP, in a highly public way. We were part of a tightly knit circle that worked and socialized together, one with a swiftly evolving vernacular that frequently spun off into epic pranks and vast practical jokes. Our lives and our identities, in both meaning and ritual, became intertwined, and Steve was the driving force behind all of it. He even announced the end of the arrangement with the man who had been supporting him.

And so it was hard to square his sudden change in behavior when he told me it was over between us, just before the holidays in 1987. Casual bonds often end quickly, but there was nothing casual about the world we inhabited, the one Steve had called into play between us. There was no trace of disinterest, no tension, no cooling-off period, no slow walk away from it. There was just the deepest kind of connection and communal urgency, and then its sudden disappearance.

When I obsess on something—which is likely too often—you do not want to be in the vicinity. I'm far from the only person who indulges in this, but it has become clear to me that this particular practice can stretch any relationship beyond customary strain. When I feel something to be unresolved, it's hard for me to let go of it. Luckily, the Silence = Death collective was still meeting, and I was happy to have their support. Relationships took up the lion's share of our discussions anyway, and for weeks I focused solely on Steve, bringing in the latest tales of behavior I considered odd. "Isn't it weird he's stopped writing for the *Village Voice*?" "Why did he refuse the Christmas gift I still wanted him to have?" "Why in the world would he suddenly build a floor-to-ceiling book shelf that entirely surrounds his bed so he has to crawl into it, for privacy from a roommate he's had for years?" "Why did he thank me instead of saying good-bye the last time I saw him?" It felt to me as though something else was going on. I simply wouldn't let it rest, and I went on that way throughout January, dragging everyone who would listen to me into it.

"Stop it!" Jorge finally insisted, in a moment of uncharacteristic impatience. "I can't take this anymore!" The collective was stunned into silence. "I just saw Steve at the Spike, and he was with someone else. He doesn't want to be with you. It's over, and I can't listen to this. It's over, and he's not interested in you anymore." The floor beneath me seemed to open up. "Why can't you just accept it and move on?"

I'm certain I was every bit as abrupt with Oliver when he dragged us through his alternating obsessions and ambivalence over a latest crush, or with Jorge's affairs that flared into supernovas before burning out. It was part of how we functioned as a group, for support but also to call each other out. Still, I had never seen Jorge this disgusted before, about anything. I'm sure he was trying to help me. He was also very angry. He never got angry, at least not like that. But this is not where the story ends.

Within days of Jorge's outburst, we found Steve dead, after two months of careful planning. Perhaps Jorge was right and he was done with me. But I was soon to find out his breaking it off dovetailed with events that traced the outlines of his suicide plan, so he may have also tried to spare me. Either way, he'd misjudged my capacity for detachment. After Steve took his life, I searched for evidence to justify it, sleuthing his final weeks, forensically following his every last step. I drove everyone around me mad about it. I got his roommate to admit that he'd prescribed the antinausea drugs to keep his overdose down without asking why he needed it, and I went to his family's open-casket service in St. Louis, slipping a page from my journal with a Silence = Death sketch into his pocket. I thought I was going there to rub his family's faces in his lost, final days, but once I saw that they actually had no idea who they were burying, I just repeated every story he'd ever told me about them in the hopes of easing their confusion. His mother sent me a note, on good stationery, to say how the cruelty of New York must've eaten away at him, apparently unaware it was cruelty at home that had driven him away. Steve was so thorough about disentangling from everyone who might be hurt by it, he'd even visited his therapist to convince him he was doing well. The therapist was so stunned by his death, I think he needed closure as much as I did, and was looking for clues about what he might have missed.

But there is no understanding suicide, no matter how hard you try. It defies accommodation. It is irreconcilable. I have no idea why people leave suicide notes when no note can modify it. It's violent, defiant, and I suppose

even powerful, the last power any of us holds. But it's also insulting. It's shaming for those who are left behind, whether or not it's meant that way. It's a death so declarative, it's public, yet the more you look at it, the more private it becomes. The pain leading up to it is too frighteningly intimate to contemplate. That it could have gone unnoticed is unforgivable.

For some reason, I felt compelled to give testimony about his final weeks in a memorial eulogy for ACT UP, the new community that came along too late to save him. All I had was a tiny typewriter, and I was too freaked out to go back to Steve's apartment to use his computer. Larry Kramer insisted I use his. So I sat there, lit by a lone desk lamp in his office, in that apartment of his with the floor-to-ceiling bookshelves everywhere, quietly crying as he read in the other room. I was trying to put into words something our newfound community of activists had been too focused on AIDS to realize: there were still other ways a person could die. To this day that eulogy is too harrowing to read, because it wasn't about him, of course; it was about me, and I wish I'd never have written it. It was pointless, and vain, and humiliating. I meant it to paint him as a fallen hero, but I'm afraid it just fleshed out my own cowardice, my inability to bear his unhappiness alone. I delivered this eulogy, which I meant to be political, and then, when I invited people to share their own memories, one after another of his ACT UP friends stood up and talked about how hot he looked in a bathing suit or the first time they saw him on Fire Island. I left the Community Center in tears and took a bus out of town. I should have just left him; blue in his bed, behind the wall of books he'd built, so his life could finally drain away. I should have kept it all to myself, the way he did throughout those long weeks of planning. I should have just left him where he lay.

By that point I'd already decided closure was futile, and Jorge was not the only one sick of my ruminating over Steve. As it turned out, that was the last meeting I would ever talk about it. In fact, it was my last Silence = Death meeting. I never went back, except to plan Oliver's memorial. While I was attending the War Council retreat called by the national lesbian and gay

Read My Lips

organizations inside the Beltway the last week in February 1988, I decided to quit the Silence = Death collective and join Gran Fury full time.

At my first Gran Fury meeting members were passing out copies of their very first poster, *One In 61*, and the collective was assessing the result. We met that evening at a building in Lower Manhattan well known within organizing circles on the Left, in a room I understood to be part of a production office used by one of the two filmmakers in the group. That building had maintained the feeling of a 1940s Hollywood movie: a maze of brightly lit corridors leading to offices and suboffices, all of them low ceilinged and compact, some with windowed doors. A few of us were seated while others sat on the edge of an oversized desk. I stood, leaning against a wall, and the meeting had a distinctly different temperament than those of the Silence = Death collective. For starters, it was twice the size. It had an overlit self-assuredness about it. People were talking all at once, and the air was full of purpose. Having grown out of the museum project, Gran Fury had a subliminal sense of authorization, and while there was also a feeling of discovery, the group dynamic showed limited traces of serendipity. The meeting had a joking collegiality, but it still managed to feel somehow formal. Most noticeable of all, though perhaps only to me, was the fact that this collective was born of a quite different moment, an activist moment that was not simply the opposite of isolation but that exceeded any version of collectivity I had experienced, even during the antiwar movement. Where it had been a struggle for the Silence = Death collective to articulate the complexities of AIDS a year earlier, leading us to spend half a year on one poster, I couldn't help but think there were people in this room who would hear their voices *only* in this new context, with the power of ACT UP coiled behind their punch. Gran Fury not only reflected a shift within ACT UP; it was also a shift in the world that surrounded us and in how the world would imagine what fighting AIDS looked like.

That is what the meeting was like. Here is how it felt to me. The Silence = Death collective meandered, and loved to get lost in its discussions. We shouted at each other and routinely cried, and we made each other food. It was neurotic, working-class, decidedly ethnic, and completely familiar, like the Workmen's Circle retreats my family was so fond of. There was one person of color in Gran Fury, and the poster was about AIDS in communities of color, but it managed a more conspicuous whiteness than the Silence = Death collective, and it felt as if I'd wandered onto a closed set. It smacked of brain trust and seemed Ivy League in comparison, a culture shock that would eventually reveal itself to be a two-way street. Silence = Death was organized as a political collective. I knew Gran Fury saw itself that way as well, but based on my experience, it didn't feel that way to me. I wondered if I was a good fit for this new collective, and so I decided to sit back and watch, a rare thing for me. I actually considered leaving.

Here is why I didn't. Mark Simpson was there. He was the only one I knew in the room, and although I'd never heard him speak on the floor of ACT UP, he didn't stop talking here. That made me feel safe, but there was something else going on for me. He seemed entirely different in this new roomful of people. I had always known how smart he was, but smartness mattered differently in this crowd, which was *conspicuously* smart. Mark had also always been charming, but here his charm had gravitas. I'd seen him act as the instigator at many dinners over the years, making sport of one of us with his smoker's chortle, but being an instigator in this crowd conveyed deeper powers. Here *everyone* listened when he talked, and I too wanted to hear what he had to say. I could see there would be no backbenchers in this collective. Still, Mark had the earmarks of a star player, possibly even a coach.

In truth, I'd always been skittish around him. Mark had an unarticulated rage that could bore a hole through you, which he hid with a Texas smile. In Gran Fury his anger had a place, and he led with it. It added dimension to

Read My Lips

everything else about him. In addition, Mark had remained oddly aloof after Don died. Mark later confided that his boyfriend had fucked around on him, and I came to realize Don's death was a little too close for comfort for him. But he had no need to hide the subject of HIV in Gran Fury, as he had within our tightly knit circle of friends. Here, he was willing to admit we had life-and-death business to attend to, and all of a sudden Mark began to make sense to me. He was finding himself, or becoming it, which I suppose was true for every one of us.

And so Mark was the reason I stayed that night at Gran Fury.

By March I was there full-time. We met weekly, sometimes at the offices of AIDS Films, or at an architecture studio where member John Lindell worked. Frequently we landed at another architecture office on Fourteenth Street inhabited by an ACT UP member who had worked on the window, and it became a kind of Gran Fury clubhouse. But several members of the collective were in the Independent Study Program of the Whitney Museum of American Art, as were other ACT UPers, so throughout that first spring and summer many of our meetings took place in the common spaces of its studio program on Lower Broadway.

My folks couldn't afford grad school for me, so the Gran Fury meetings at the Whitney studios were as close as I ever got to it, infusing those early meetings with a sense of connection for me. It transferred a profound feeling of familiarity, safety, and belonging, and it looked, felt, and smelled like my art school past. We were not there to make art, and it wouldn't have felt like art making even if we were, because at that point we were completely attached to the political process that ACT UP had already laid out for us. Gran Fury was still an unofficial "subcommittee" of ACT UP, open to anyone in the organization who came to hear about it. It maintained the same revolving door, ad hoc immediacy, and urgency.

So everyone in the world was a member of Gran Fury in the beginning, and the meetings were open to anyone. There were some who always showed

up, and there were others who came for a few weeks and dropped out or disappeared for long stretches of time. I remember one meeting where the circle of chairs was so large I couldn't hear the other side of it, and others that had only three to six people. It was not uncommon for a decision to be reached at one meeting only to unravel at the following one, with completely different attendees. The open membership of Gran Fury made it difficult to even establish an agreed-upon working process, much less resolve projects with longer lead times. Still, we found ways to work. For a while we mimicked ACT UP, agreeing that anyone who hadn't attended the prior meeting would not vote. Other times, we broke into subgroups to tackle specific projects, and each subgroup was responsible for itself. That is how we approached the five posters we produced for the nine days of AIDS actions in fifty cities coordinated between ACT UP New York and the national network of AIDS organizations known as ACT NOW (AIDS Coalition to Network, Organize, and Win). Loring McAlpin and I worked on the poster for AIDS and Prisons. Richard Deagle took on AIDS: A World Crisis. John Lindell chose the AIDS and People with AIDS day of actions, and Mark Simpson and Don Moffett collaborated with the ACT UP Women's committee on the AIDS and Women poster. I worked on the AIDS and Homophobia action poster, *Read My Lips*, with Tom Kalin and Mark Harrington, who was a member of Gran Fury before shifting his focus to treatment activism.

From the earliest moments of the gay liberation movement, sexuality and identity have been politically intertwined, built as it was on feminist critiques. So the clash between the sexual components of queer identity and state-mediated sexuality have roiled in queer circles since the beginning, playing out in notable controversies like the one over Larry Kramer's 1978 book, *Faggots*. AIDS fanned it into a bonfire that has raged ever since, from the earliest conversations about safer sex and the closing of the bathhouses, to debates about disclosure, criminalization, status shaming, and the controversies triggered by Pre-Exposure Prophylaxis (PrEP). Sexual expression

has always been a critical component of queer identity, and ACT UP tended to favor a more radical sexual politics. Gran Fury was looking for a way to articulate it, and *Read My Lips* was our first stab at it.

The 1969 riots at the Stonewall Inn were little more than a decade old when the initial reports of AIDS were filed, and America was just in the beginning phases of separating its anxieties over gay sexuality from its understanding of queer identity. Still, it seems inconceivable in the post-gay twenty-first century that images of queer kissing could ever have been so controversial, but the layering of queer sexuality and AIDS was explosive in our culture at the time. When ACT UP NY staged its first Kiss-In in 1988 on the AIDS and Homophobia day of the ACT NOW demonstrations, television had witnessed only a smattering of primetime lesbian and gay characters and had yet to see its first queer kiss. In 1989 *Thirty Something* had to cancel an episode featuring two gay men in bed, just talking, after threats of a national boycott. The first queer primetime kiss wouldn't come until 1991, when the show *L.A. Law* included a lesbian kiss in an episode. Perhaps even more inconceivable was the fact that at the national ACT NOW organizing meeting in D.C. during the 1987 March on Washington, a raucous floor fight erupted over whether we should even sponsor an AIDS and Homophobia day of actions, with many gay men leading the argument against it. Some activists believed that underscoring the homophobia that AIDS had placed front and center on the American media landscape would overpower the concerns of other communities we were seeking coalitions with, even though they were suffering blowback from that homophobia themselves.

Read My Lips was not the first work by the newly formed Gran Fury, but it was the first to bring us national recognition, by symbolizing the growing queer nationalism ACT UP had precipitated. The homophobia that was one of the root causes for the crisis had activated much of queer New York, and the Monday night meetings at the Center were a point of assembly around it.

ACT UP was also politicizing people who were there to do something about AIDS but had not done activism around homophobia before. So while *Read My Lips* was just one of five posters we'd designed for the nine days of action, it was the only one to capture the attention of the larger lesbian and gay community and to have a life beyond its original use. In the process, it drew a lot of attention to the collective.

Reagan's vice president, George H. W. Bush, sent up a trial balloon that captured the American imagination during an early stump speech for his 1988 presidential campaign, saying, "Read my lips: No new taxes." It became a defining sound bite during his uncertain candidacy, which had been plagued by accusations of spinelessness from his party's far-right base, and by critiques from the media for its patrician manner and overall lack of vision. ACT UP NY had already decided that a same-sex kiss-in would be our demonstration here in NYC, and Tom, who was drawn to the AIDS and Homophobia day because of his own work as an artist around images of kissing, threw down a proposal: what if we appropriated this slogan, coupling it with an image of a same-sex kiss? Over the coming years we would frequently argue over text for weeks on end, but this was the first of the rare "Aha!" moments Gran Fury occasionally had. With one gesture, it clearly illustrated the point of the demonstration, squatted on Bush's newfound defiance for our own ends, and dragged the neglectful Reagan AIDS policies onto the playing field. This particular meeting at the Whitney studio space was somewhat well attended, and not one person spoke against it. It was decided, right then and there. We agreed to all search for images to bring to the following meeting. The poster's concept was unanimous and swift, but choosing the images would stretch out over weeks and involve individuals, committees, and organizations outside the collective. By the time we were finished, we'd generated three separate posters for this action, one with the male image and two with lesbian subjects. The lesbian image then underwent one subsequent revision after the poster was finalized.

Mark Harrington was trying hard not to grin at the next meeting as he unveiled the image he'd found in a fifties gay porn magazine. Even though both men's genitals were exposed, that is not where your eye went. It was toward the lip-lock, one with great gestural power, and it seemed oddly passionate for pornography. The vintage photo added layers of historical certainty to the affirmation of queer existence, further rooting the politics of the project. Only a handful of people were there, and by my recollection none of the women or people of color working in the collective were at this meeting, which raises the question of whether its whiteness would have been so immediately acceptable at another meeting. But I recall no discussion about it that day, or any time spent considering alternatives. In fact, because it captured both the tension and irony we were looking to convey, we spent little time even extolling the image's virtues. I instigated a brief discussion about whether the sailor insignia would sideline the political rationales for the demonstration by eroticizing militarism, and Mark Simpson and I spent some time considering retouching it before being overruled.

In terms of the poster's design, *Read My Lips* was our first conscious foray into appropriating the work of other artists, a strategy we came to draw on to up the ante for other artists who had yet to engage with the topic of AIDS, especially those whose work was political. It was Tom's idea to mimic Barbara Kruger's formal aesthetic in this case, and it was far too tempting to resist, given the vintage black-and-white photograph and the declarative nature and maleness of Bush's use of the slogan. Tom had studied with her, and suggested we use her font, Futura Extra Bold Italic. It did not go unnoticed by her, as she wryly confirmed with mock annoyance when he bumped into her on the street sometime after the work had been well publicized.

We naively presumed that finding a comparable image of a lesbian kiss would be even easier, and were unhappy with what we found. Most images

of this sort were historically staged for the male gaze, and we had trouble finding a sexually charged image that wasn't. So Tom asked the Lesbian Herstory Archives in Brooklyn for an archival image of women kissing, assuming they would present tons of options. Instead they encountered the same stumbling block, and the only example they had with a passionate kiss that didn't feel staged was a Victorian image far more anachronistic than the sailors and not nearly as sexy. The collective was not happy with it, but we thought we might be missing something, and the imprimatur of the Herstory Archives carried some weight. So we decided to mock it up and run it by the Women's Committee. They hated it. It just wasn't cool enough for ACT UP. We went back to the archives to request a twentieth-century image closer in temperament to the sailors and were presented with an image of two flappers (fig. 4). It was closer in period, but extremely chaste. One of the women was kneeling at the feet of the other, gazing longingly into her eyes, limply holding her by the fingertips. The other woman returned the gaze, with her hand gently lifting her chin as if to guide her into a kiss. It was close, but still not what we were looking for, and we felt the ACT UP Women's Committee deserved better. The printing deadline forced us to go with that image for the demo poster, but no one was happy with it. We subsequently devised a final revision after shooting our own image during our commission for Art Against AIDS On The Road, *Kissing Doesn't Kill*. Both subjects were ACT UP members (fig. 5), and the image was cooler and expressed more diversity than the men's image. It became the image that ACT UP used on the women's version of the *Read My Lips* T-shirt and postcard. It was so sexy, ACT UP boys started wearing it.

The shirts nailed the zeitgeist within my immediate circle, many of whom went on to form the group Queer Nation, and it became a badge of courage within activist communities. We added the T-shirts just before Pride that year, and in no time, they were outselling *Silence = Death*. Soon there was enough demand for them to lead to national distribution through additional

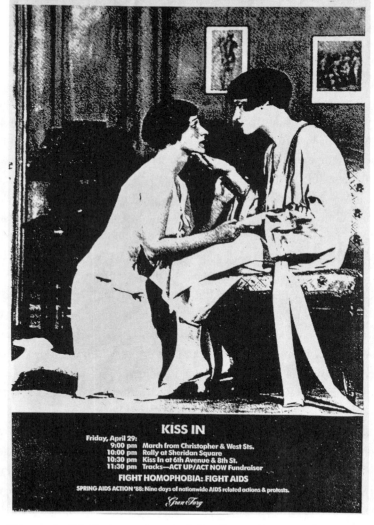

Figure 4. *Read My Lips* (women's version), Gran Fury, 1988, poster, photocopy on paper, $16\frac{3}{4} \times 10\frac{3}{4}$ in. ACT UP, Spring AIDS Action 1988.

Figure 5. *Read My Lips* (women's version 3), Gran Fury, 1989, postcard, black and white, $4\frac{1}{4}$ × 6 in. For ACT UP.

sales outlets and other ACT UP chapters. Several months later I got a message on my answering machine from the manager of the ACT UP workspace, who had fielded a call by a man who wanted to be put in touch with the image's designers. There was a chance it could lead to another project for Gran Fury, but I was also nervous about it. I swallowed, deeply, and dialed the California area code. A man answered, and I introduced myself as a member of the collective.

"Oh! Thanks for getting back to me," he said. He sounded a little surprised to hear from me, and older, but he would not have been older than I am now.

"So, what can I do for you?" I asked after we exchanged pleasantries.

"I'm one of the men in that picture," he answered calmly, with a little amusement and no trace of menace.

I was not so calm, but I tried to sound as if I was. It is the kind of call artists who work with appropriated images live in fear of. I looked at the floor and then scanned my bookcases.

"Wow. Really?" I swallowed again. "So what can you tell me about it?"

"Well," again, calmly, "the other man was actually my boyfriend. We met in the navy, stationed on the same ship. We were on leave in San Diego at the time."

"Wow," I said again, vamping while I took it in, my mind racing. "So the sailor thing wasn't just for the pictures?" I was actually surprised by that. I assumed the military aspect was staged. But the kiss was so charged it seemed to transcend performance, and now I knew why. "Who took the picture?"

"Well, one night we were approached by a photographer at a local gay bar who told us he was assisting a famous photographer on a fashion shoot in LA. They had come down to San Diego to go to the bars."

"Was it Horst?" I interrupted, for no particular reason. I had recently worked with Horst, and knew not only that he was a flirt but that he shot a fair deal in LA during that period.

"That sounds familiar," he responded, but I got the sense I had led him into that answer and he was being polite. He was very polite.

"Anyway, he asked if they could take pictures of us, and we said, 'Sure.' So we went back to the studio with them, and he started taking our picture." He sounded delighted as he told me the story. "And then he asked if we would kiss, so we did, and we got a little *carried away*." The cropping of the demo poster conceals the fact that the men were semi-erect in the original image, and he delivered this line a little coyly. He actually seemed shy about it.

"I thought no one would ever see it," he went on, as if some kind of jig was up, and he was possibly a little embarrassed. I wasn't sure he even knew we'd found the image in a skin magazine, and decided not to mention it.

"That is some story," I circled back. And then I waited, afraid to say anything else. I was actually waiting for the other shoe to drop.

"Anyway, you can imagine how surprised I was when I saw someone wearing that T-shirt at Gay Pride here in LA!"

I swallowed again. "I'll bet!"

". . . So I asked him where he got it, and he said it was from ACT UP!"

"I'd love to send you one!" It seemed like the right thing to say.

"Oh, god, no, I would never feel comfortable wearing it." He sounded completely sincere, but he also seemed to like saying it. And then it went quiet for a beat.

"Anyway, I just wanted you to know how great it is for me to know it could be used to help the community, especially now. It makes me so proud, and I just wanted to thank you."

No shakedown, no request for royalties, no cease and desist. Just pride. Which is exactly what it felt like to declare yourself during that terrible moment, to stand up and be counted when you were needed, simply because it was the right thing to do.

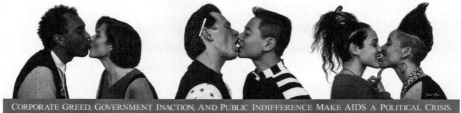

Figure 6. *Kissing Doesn't Kill*, Gran Fury, 1989–1990, four-color bus-side poster, ink on PVC, 30 × 140 in. For Art Against AIDS On The Road.

Kissing Doesn't Kill

Although it was not named Gran Fury when it produced The New Museum window, after the installation was completed, we eventually stopped being listed as a working committee within ACT UP, and our meetings were largely organized through word-of-mouth. We reported back to the floor throughout the ACT NOW posters project, mainly from within the other subcommittees we were working with. So Gran Fury quickly slipped into a gray area somewhere between an affinity group that would act autonomously and request funds from the floor for actions and an offshoot of Outreach, Fundraising, or one of the other individual caucuses, such as the Women's Committee. We also worked within other affinity groups, like Surrender Dorothy, which was targeting the New York City health commissioner. Some ACT UP members thought of us as a poster-making committee and brought requests to us. But we came to consider ourselves individual artists or activists who wanted to pursue our own projects, which we sometimes did with one another without using the Gran Fury name. Within months of our formation as a somewhat informal collective, we realized we needed to rethink how we would interface with ACT UP, a question driven home by a contentious general meeting in which we requested a percentage of the sales from the *Read My Lips* T-shirts for the production of new works, a proposal that had the support of the Fundraising Committee. The argument against the request was that no other affinity group received ongoing

working capital, a contention strengthened by the fact that the Silence = Death collective had made no similar request for operating expenses. The counterargument was that no other affinity group regularly generated capital to support the work of the other committees. The request ultimately passed, but the discussion left a bitter taste in our mouths, and the money was piecemeal and hard to account for. Within no time we stopped following up on it.

By the summer of 1988 it was already becoming clear Gran Fury needed to redefine itself, and we saw this as the appropriate time also to reevaluate how we worked as a collective. Once the ACT NOW deadlines were behind us, and with some members leaving to focus on personal commitments, our ranks had begun to dwindle and a core membership was organically beginning to self-select. Within this framework we embarked on a series of discussions about pursuing outside funding, allowing us the independence other affinity groups enjoyed. It also seemed the appropriate time to revisit some earlier, unresolved conversations we'd had about closing the membership of Gran Fury as a matter of working logistics. If we were to undergo a funding transition, it seemed logical to discuss closure in earnest, and so we did, for months. The two proposals seemed to go hand in hand, with some of us arguing that if we were to be offered commissions, the consistency of a regular membership would be the only way we could fulfill them. Eventually it was agreed upon, but there were still traces of discomfort, which we soothed by agreeing that it might be temporary and that we'd revisit our closure if strategies for adapting to a fluid membership emerged out of our work together. Although it took many months to actualize, with this pair of decisive gestures Gran Fury slowly began the process of morphing from being an ACT UP committee into a collective. Once the collective closed, its members were Richard Elovich, Tom Kalin, John Lindell, Loring McAlpin, Marlene McCarty, Don Moffett, Michael Nesline, Mark Simpson, and Robert Vazquez. Participants in the broader collective had included Steven Barker, Leonard

Bruno, Richard Deagle, Mark Harrington, Todd Haynes, Amy Heard, John Keenen, Terry Riley, Don Ruddy, Neil Spisak, and Anthony Viti.

There are those in Gran Fury who refer to it as having been a political collective, not an art collective, and in the beginning it functioned that way. Most of us have proven capable of talking out of both sides of our mouth on this question, depending on the specifics of the discussion. Gran Fury showed traces of contrarianism all along, but it became more exaggerated after we closed, and even now this question exists within an ever-vacillating framework in the collective, which can play out as political differences but at this point might also be accurately described as familial: a dependence on the roles we've assigned one another, which are continually evolving throughout a shared history and are attached to a common vernacular frame of references couched within a somewhat complicated domain of mutual respect. I think it fair to comment that those of us who have established art careers tend to refer to Gran Fury as an AIDS activist collective, while those not identifying as artists generally refer to it as an art collective. I have fallen on both sides in this regard—then identifying it as an art collective, and now more willing to concede the extent to which it was a political one—and the interviews with Gran Fury members in the ACT UP Oral History Project offer firsthand insights into how other members felt regarding their personal relationships to the art world or our work together; in particular, the members of the collective once it closed.

Speaking for myself, I mostly consider Gran Fury to have been an art collective. I say this because I participated in the original conversation that led to its formation and it was with a museum curator, because of the art world support we experienced; the number of curators, scholars, and art historians who championed our work; the art world sponsorships and commissions we would come to rely on; the number of relationships we either had, nurtured, or maintained with people in the arts; the consistent level of strategic thinking that focused on the art world and other artists; the position we occupied

Kissing Doesn't Kill

in relation to the other individuals who identified as artists, academics, curators, and writers within ACT UP; the fact that the majority of our members were either in the arts, had been in the arts, or were trained in the arts; the fact that some of us have dedicated our lives to cultural production or teaching it, or both; and the fact that fewer than half of us were involved in ACT UP's ongoing organizational structure. It's true, Gran Fury was organized as a subcommittee of ACT UP, ACT UP is a political organization, and Gran Fury's output can really be described only as political. But I would refer to it as political work organized around cultural production.

After our constitution as a collective many skirmishes erupted along the borders of the question of how we found ourselves situated within the art world. In my estimation, much of the conflict was a function of varying relationships to our own politicization—specifically, that politicization is an individual process, a project in constant flux, and that the many complexities of the politics of AIDS were only beginning to be revealed through the ongoing work of ACT UP in 1988. And because our individual politics were in flux, the rest of the collective did not always share my political perspective on our work. There were those in the collective who felt that the dividing lines I was mapping between cultural production and political activism were unnecessary, even as we critiqued the art world over that particular distinction, and as the line between art and activism often strained the relationships our colleagues had with the art institutions they had talked into sponsoring us. Some also believed it disingenuous to accept art funding and act as though we were outsiders, which is a fair observation to make about any critique that takes place within institutional frameworks. I wanted to say no to many more projects than the rest of the collective, and felt our relationship to our art funders functioned similarly to the way any institutional funding can neutralize forms of political dissent, by offering select individuals a "seat at the table," which naturally blunts the meaning of an ongoing critique. I freely admit that if my political perspective had prevailed, it would

have blocked several projects that proved tremendously affecting, and the world might be the worse for the loss.

Ultimately, I can speak only for myself on these accounts, and while I'm as proud of the work we did together as any political work I have ever been part of, I also still believe cultural production, however political, is not the same thing as political resistance, and its primary use lies in supporting institutional power structures. I'm aware that saying this appears to disregard the fact that this topic is in constant flux, and I know there are decades of scholarly consideration of social and archival practices and newer theories about the meaning of public spaces that offer increasingly nuanced views on the subject. But unfortunately, augmenting the granularity with which we contest art spaces as sites of colonialization does not in itself change the continued fact of it, and from an organizing perspective the intra-institutional work many of us do to counteract colonialism remains in tension with the exponential increases in value of the institutional holdings that are *not* put to the use of resistance to colonialism; for example, holdings used in support of gentrification through institutional expansion. I also can't help but notice that as gentrification has made our cultural centers more hostile to self-sustaining art practices, culture work continues its drift toward institutional settings, and that through my years of mentoring young artists, activists, archivists, and historians, they appear to be increasingly locked into individual struggles with these questions, perhaps more than ever.

But to be clear, I was uncomfortable participating in characterizations of AIDS activism as cultural production for political reasons *other* than a critique of art systems. It was not that the groundbreaking work within art, curatorial, and academic circles had no political meaning or use, or that there are intrinsic hierarchies in the ways individuals might choose to express their agency. It was because as the AIDS crisis raged around us, it was becoming extremely clear that institutions representing structural

Kissing Doesn't Kill

power—political, economic, *and* cultural—were squatting on every single aspect of what we were doing, and that they each had very different uses for the conversations we were generating, as well as the meanings that might be assigned them. Moreover, I was fearful that the media's focus on our cultural production would make productivity fetishes out of something I considered to be resistance work, which would have a distancing effect, rather than stimulating people to become politically active themselves: as in, "I read in the *Times* that artists are educating the public about AIDS. Whew. Thank god someone is doing something about it."

And, finally, Gran Fury was not the only context in which I favored resistance to institutional power structures over working within them, as I had done since I was old enough to understand how this schism played out. It's where I fell on these questions in the antiwar movement and the Black Power movement, and when they surfaced in ACT UP as well. True, there were tensions surrounding those debates in ACT UP, but I was not in the minority there. In Gran Fury, however, I was, and I consequently found myself at the center of some of the tensions we experienced along this divide.

If you are researching Gran Fury, its work-product generally hangs together in an agreed-upon chronology, but there are still discrepancies within it. I believe that is owing in part to the fact that before we closed as a collective, the subgroups in Gran Fury often worked independently, and although the larger collective still met and worked collaboratively on projects, it also functioned as a kind of rotating, collaborative agitprop workshop within ACT UP where individuals could develop ongoing partnerships. Perhaps as a result of those loose confederations these works were not always officially signed as Gran Fury's, even though the collective ultimately claimed them, such as the three bloody hand posters. Others are only sometimes claimed, or were signed by the collective but disowned, or signed for a particular iteration and attributed to individuals at other times. Although one could

certainly argue our best work was ahead of us, the period while we were still an open committee was extremely prolific, and many of the collaborations that came out of it became fodder for other projects during the following years. The local bloody hand posters were later nationalized for the FDA action, and several ACT NOW posters became the basis for other Gran Fury projects or individual collaborations, like *All People With AIDS Are Innocent*, which was included in the Group Material Democracy project, Art Against AIDS On The Road, and became a street banner for a project at Henry Street Settlement, and *Men Use Condoms or Beat It*, which had multiple lives—as the rejoinder in the ACT NOW poster, a sticker funded by GMHC, a proposed shopping bag for Patricia Fields, and half of our installation at the Venice Biennale. And *Read My Lips* became the foundation for our first public art commission in America, *Kissing Doesn't Kill*.

Several members of Gran Fury already knew Ann Philbin when she approached the collective about producing a work for a series of national public transportation advertisements she was helping assemble for the American Foundation for AIDS Research (amfAR), Art Against AIDS On The Road. The project was organized through Livet Reichard, an arts funding adjunct set up by amfAR, which was a hybrid of the earliest community research initiative in New York, the AIDS Medical Foundation, and Elizabeth Taylor's LA-based National AIDS Research Foundation. AmfAR was considered somewhat problematic within the activist community for being more focused on its celebrity fund-raising machinery than on the research projects it was granting to, but the organization was nonetheless still funding needed studies and many ACT UP members worked there at some point in various capacities. Regardless, Philbin's proposal seemed the perfect opportunity to speak about AIDS in a broader way than we'd previously attempted, on the streets of multiple American cities. After serious discussion, we decided the pros far outweighed any cons, and there was no substantive dissent. This project would become our first American public art commission,

and one that also helped solidify a set of aesthetic strategies we had begun to explore.

Partly as a reflection of the unexpected resonance of *Read My Lips*, and partly because we'd barely scratched the surface of the depth of homophobia revealing itself in the early years of the crisis, we began our discussion there. The ACT UP Kiss-In was about homophobia, but what made it strategically bold was the fact that among the many unresolved questions over known routes of HIV transmission, the data over saliva was still inconclusive and somewhat controversial. HIV was traceable in saliva, but some assessments were also indicating that the predigestive enzymes in saliva might incapacitate the virus. And so, beyond the political defiance situated within the same-sex kiss, it entered into the debate over transmission that factored heavily in the public's imagination after Rock Hudson's diagnosis had caused the continuous replay of his on-screen kiss with Linda Evans on *Dynasty*, which the tabloids claimed had exposed her to HIV.

We had already staged our first appropriation throw-down with Barbara Kruger, when we produced *Read My Lips*, and as we began to imagine the commercial space we were being offered, it seemed only natural to consider the advertising context even more strategically and, in particular, what might be borrowed from advertising in terms of ubiquity. At that moment in time no other word could be used to describe the effect of the bottomless pit of marketing dollars thrown around by the Italian ready-to-wear apparel company Benetton on behalf of its United Colors of Benetton brand. Benetton stores were as omnipresent as Starbucks and were often found within blocks of one another. European fashion photographer Oliviero Toscani, who had gained a commercial foothold with the help of the French magazine *Elle* in the seventies, was given carte blanche by the fashion company in the early eighties, and he swiftly branded the rising interest in multiculturalism through the juxtaposition of models of different races to play off the word *color* in the company name. In much the same way we had hoped to push

Kruger to address AIDS by stealing her font, we decided to hold Benetton's feet to the fire by riffing off its commercially imagined utopian egalitarianism. Over images of mixed-race couples kissing, our text read, "Kissing Doesn't Kill: Greed And Indifference Do," which was explained in the rejoinder, "Corporate Greed, Government Inaction, And Public Indifference Make AIDS A Political Crisis."

The brand effectively "owned" bus side panel advertising real estate in Manhattan. Toscani was extremely fond of the horizontal format, which suited filmstrip-style storytelling. It also suited us, since we would need a similar space for multiple models to represent a range of identities, ethnicities, and races, our primary objective for squatting on Benetton. We further reasoned that although bus advertising rates are based on the market demographics of the neighborhoods serviced by each route, buses are still sites in motion. As such they had greater potential and cross-class reach over stationary sites, leading us to choose bus sides over the bus shelter spaces made available to us.

The entire collective was extremely familiar with the graphic elements of Benetton's branding. But as one of the oldest members of Gran Fury, I was well versed in the stylistic aspects of Toscani's work, having been exposed to it throughout the early seventies via the expensive European fashion magazines that Nan Goldin and I were routinely dispatched to steal from Reading International on Brattle Street by our trans and drag pals. I was also then a senior art director at Vidal Sassoon, and was responsible for most of the seasonal beauty photography that came out of America. As the person who hired and directed photographers and talent, I knew this sort of photography intimately and could mimic Toscani's style in my sleep: white seamless, fill strobe lighting to neutralize shadows, bounced strobe on the background to envelop the silhouettes, bold graphic clothing, and models with lots of personality. So I was elected to help organize the styling aspects of the shoot. Loring did the still photography, which we shot in his loft, and Tom directed

the video at another time with cinematographer Maryse Alberti, who was also part of the circle of friends Mark and I shared and who would go on to work with another former Gran Fury member, Todd Haynes. The video was a daylong shoot that turned into a central casting call for the Lower Manhattan arts community, including Nan Goldin, David Wojnarowicz, Tabboo! (Stephen Tashjian), Sharon Niesp, Gregg Bordowitz, Ann Philbin, and Douglas Crimp. It had a voiceover by the Wooster Group's Ron Vawter.

Benetton was originally known for its knitwear, and a neighbor of Chris Lione represented a designer who specialized in boldly colored sweaters. She gave me the run of the showroom, and I left with bags of tops carefully wrapped in tissue paper. The rest of the clothing was styled with European flea market finds from my closet. In terms of the models, all advertising is casting-dependent, but this type of photography is so stylistically neutral, the model is the only thing that will bring it to life, which was doubly true in this case: we wanted to replicate the slick look of the ads, but not its hollowness of meaning. Authenticity was an important layer to consider and we decided to keep the casting close to home. Two of the models, Robert and Mark, were both in Gran Fury. Another model was from my affinity group, political organizer Heidi Dorow, and the rest were artists and activists we knew from ACT UP, including photographer Lola Flash and performance artist and Clit Club founder, Julie Tolentino.

As we finished the shoot and were finalizing production, Livet Reichard called us for a meeting in SoHo. We suspected there was an issue with the work, and it was decided Mark and I should go. It was a bright day, but the office we met in was dimly lit, as offices can be in older buildings outflanked by the skyline, especially when New Yorkers in them have fantasies about the illumination windows should provide. It was quiet enough for me to hear my pulse in my ear, and everyone was smiling in a way I sometimes find ominous. There were intros and pleasantries, and the offer of refreshments, all of which were followed by an opener I hadn't quite anticipated.

"I can't possibly go to our funding partners if you use the phrase 'corpo-rate greed,'" we were advised by a member of their team, with an openness of expression cultivated among art-world professionals for this exact sort of conflict, which is genteelly posed as an exploration of options toward a pre-supposed resolution and which is a simultaneous indication they have no intention of backing down from it.

I had no intention of backing down either, but I doubt I appeared remotely open about it. I like to say I lunged across the table, but I believe I just said, "You're kidding," with thinly veiled derision. Mark did not say a word.

Again, the smile, but a little more firmly this time, "No, not at all. I can't ask for funding for this project as it is." Perhaps that's when I lunged.

"But surely any corporate sponsor willing to fund an AIDS project is aware of activist accusations about the institutional hurdles involving drug companies?" I asked. For some reason that appears less hostile on the page. "Besides," I reasoned, "we name the government and the public as equally responsible," but I did not feel reasonable at all. I was coming to a simmer, and I hope I didn't pound the table, but there's every chance I did. "And unless you're going after pharmaceutical money, the piece is not talking about *every* type of corporation."

The smile downshifted to a smirk that may not have been intended as diminishing, but it functioned that way. "*Of course* we'll be asking for phar-maceutical money," they said. "I can't go to our partners with this."

"What about just removing the whole second line?" I'm not sure who suggested it, and then somebody else added, "It would still be very hard-hitting."

"But it makes no sense at all without the rejoinder," I said. I have no way to gauge how agitated I sounded, but at that point I was seeing spots in front of my eyes. I was undoubtedly overly emphatic, a problem of mine. And then I believe I said, with no authorization whatsoever, "There's no way we're removing it."

Maybe I pulled out of my chair, because that's when Mark calmly interjected, "We'll have to discuss it as a collective, and see if there's a way we can resolve this."

I can be diplomatic, and often warm, but in situations like this I find it difficult to mask my enmity. I hated the fact that a message this clear was about to papered over with layers of code, having been raised to believe that art that isn't about communication is about class, and communication, after all, was the point of the exercise. It's the reason that I feared participating in The New Museum window, and although I'm easily swayed by poetics in other people, I tend to throw in with flat-footedness. But I cannot place myself here in implied opposition to the rest of the collective, because we had spent a long time massaging that line of text and we fully knew it would be a radical proposition for amfAR. I'm not altogether sure how we came to imagine the rejoinder would not be an issue. It's not that we were in a bubble about it, and if we were, it didn't feel that way to me when we wrote it. It would be more accurate to say it's that we thought we were right, because we were, and if anything, it seemed we were stating the obvious. As action packed as the message was, I loved that it was also perfectly clear, and indisputable. If anything, we expected there might be issues with the same-sex kisses, which hadn't raised one eyebrow in that room.

Without the rejoinder, I felt, it was essentially a safe-sex poster pinkwashing pharmaceutical money. Without the rejoinder, the piece didn't *mention* AIDS, and if it weren't for the Art Against AIDS On The Road logo on the side panel, you might be confused about the connection between kissing and HIV transmissibility. When we discussed it as a collective, I recommended walking away from it, but a lengthy discussion eventually changed my mind. John made the strong case that even though the HIV message became unclear, the images were not, and in the public spaces in America at that time, images of same-sex kisses were nowhere to be found and there might be tremendous value in that alone. The project preceded

Queer Nation by over a year, and it seemed foolish to turn down the opportunity when rampant homophobia in America was making life hell for so many People With AIDS. In scrambling to make sense of the opportunity, we also came up with an elegant counterproposal that had a symmetry I found appealing: we would remove the line if amfAR paid for a run of posters with the original text, to be donated to ACT UP as a fund-raiser to help its fight against pharmaceutical greed. AmfAR agreed to it and we proceeded with the project.

The foundation agreed to the poster, but not everyone in ACT UP wanted it. When we proudly brought the *Kissing Doesn't Kill* poster to the floor as a donated fund-raiser, some ACT UP members spoke against it, others did not like it, and still others wanted to redesign it, making this another thorny run-in with the floor for Gran Fury. Largely owing to decades of curatorial practice that have made the cultural production associated with ACT UP so familiar, we have come to perceive ACT UP as a sort of AV club for the AIDS crisis, or an art-world cabal. But it's important to note that while there were influential people from the art world among its rank and file, a larger portion of the ACT UP membership had had no exposure to art practices at all, and its members had little more understanding of the intricacies of visual culture than most New Yorkers have. There were far more working-class people on minimum wage, community activists, health care workers, actor/singer/dancer/caterer waiters, social workers, teachers, students, journalists, middle-management types, and video store employees than there were artists or academics in ACT UP. I do not point this out to create a sort of inverse hierarchy, but to paint a fuller picture of what is commonly referred to as an image-savvy organization. Many of us were media savvy, but overall, the grasp of visual culture was spottier. Producing these images at times involved workarounds, and some of them were never presented to the floor before they hit the streets. The truth is, while most everyone had opinions about the images we used, there were many who did not understand the

strategic thinking that went into making them, or how they were designed to function.

The response to the *Kissing Doesn't Kill* poster, coming right on the heels of our having agreed to reconstitute ourselves as a closed collective, seemed a confirmation of that decision. Gran Fury is most commonly referred to as the art department of ACT UP, and many in ACT UP did appreciate how graphic production enhanced our ability to activate public spaces. But it would be more accurate to say that the notion of ACT UP as a welcoming place for cultural production is in large part a function of hindsight. Generally speaking the images we associate with ACT UP arrived mystically at its doorstep with little understanding of their creation and, often, with skepticism. That Gran Fury decided it could not function within ACT UP was not dissimilar to the eventual spinning off of core members of T&D (the Treatment and Data Committee) into TAG (Treatment Action Group), but no one was at all concerned when we left, which is an appropriate reflection of priorities, but is odd when you consider how essential the ACT UP graphics were to the telling of its story, especially in hindsight.

As was true for many People Living With AIDS who flocked wherever hope could be found, one of my closest friends decided to move back to San Francisco in 1989 to enter an unauthorized Project Inform trial of Compound Q. It was a treatment rumored to be promising, and he was rapidly progressing at a time when little else was in the FDA pipeline. While pharmaceutical companies were reportedly taking the plant-based Chinese abortifacient seriously enough to attempt replicating it into a patentable form, it was being smuggled into the West Coast "unofficially," so that is where Edward went. It made him sick, but he stuck with it, even after he sent me a letter to say it made him forget where he lived. He continued to take it, because there was simply nothing else for him, until the trial was suspended after several people in the study died, making it suddenly unavailable. At that point he had

already left his life in New York—given *everything* away, left his job and the people he knew—and moved in with one of his oldest friends, who also had AIDS and had never left San Francisco, to become each other's care team. I decided he might be lonely, and so I would visit him, with the man I'd decided to build my life around after Steve killed himself, an ACT UPer who was in my affinity group and whom Edward had met but never approved of.

He'd traded down considerably in his living conditions now that he wasn't working, and his place felt threadbare and a little transient. I saw no trace of him in these new surroundings, because there wasn't any, but he insisted he was happy. All I could think about was how many flights of stairs he had to navigate to get to this dark apartment, and all of those hills, which gave *me* trouble without infirmity. He took us around the city for a day and a half, to his favorite Thai place, which wasn't so much great as it was close enough to walk to, and up to Stinson Beach, where we lay in the sand in our underwear because it became too hot not to, as he hid from the sun under his jacket. We went back through Sausalito to stop at a health food store he liked, and then we prowled around shop after shop that sold stained-glass birds on suction cups, but he wouldn't allow us to stay for dinner because he said Sausalito was touristy. By the time we left to drive south to Big Sur, he seemed completely worn out, and I was as well, after days of feigning enthusiasm for his new life and failing at it. It had only been months since he'd left New York, but he was unrecognizable, and I don't mean physically. I'm not sure he'd actually pictured anyone from New York ever visiting, and he'd already detached from me and everything else he'd left behind. I had no access to this new person, who had replaced the one I'd known so intimately in his New York life. By then I'd become adamant about fighting the politics of AIDS, and he was fighting a different battle. So mostly we sat near each other in silence, realizing it would be the very last time we saw each other, while both pretending it wasn't.

That is how I came to be in San Francisco the first time *Kissing Doesn't Kill* appeared in the streets of America, in the debut city of Art Against AIDS On The Road. I have never been much of a tourist, but I decided I would buy a camera and take pictures of *everything* this time, and it was poised in my hand to snap a picture of one of those very wide intersections in a then-messy neighborhood between the center of the city and the Castro, which I should know the name of but don't. I was waiting for the light to turn and wondering if I could ever make it all the way across once it did, when a cable car ambled by. I say ambled, because it was pushing its way up a hill, which San Franciscans take in stride and I always feel exhausted by. Spanning the length of the car, close enough to run my hand over, was *Kissing Doesn't Kill*. But it did not look anything like the work we'd settled on.

Maxine Wolfe, one of my closet pals in my affinity group, decided no propagandists worth their salt should be ignorant of the feminist interventions into advertising spaces in the United Kingdom, and gave me a copy of Jill Posener's *Spray It Loud*. She was right about that, and I had practically memorized every page of it. The sheer ingenuity of repositioning work somebody else paid gobs of money for opened my eyes to the resourcefulness of this form of activism. So I immediately assumed this reimagining of *Kissing Doesn't Kill* to be the work of lesbian activists who had erased every other image but the lesbian lip-lock with white spray paint. At their best, public spaces are intrinsically dialogic, and here was the San Francisco community I'd heard so much about, at its most articulate. I was surprised enough to have dropped my jaw, but conscious enough to run off two frames as it passed. The same-sex kiss amfAR had had no concern over had superseded the text for at least one activist. And our impulse to overlook the censorship was completely vindicated by this one simple gesture I might never have otherwise seen. We had given voice to another intervention, one that validated our efforts and tribulations, at least in my eyes.

So did the appearance of the work in Chicago, but for an opposing set of reasons. Alderman Robert Shaw was so outraged by the two images of same-sex kissing, he unofficially organized an intervention to paint over the images, this time in black. In an attempt to ameliorate the uproar, then-mayor Richard Daley requested its replacement with less controversial submissions. When the transit authority officials decided they were unable to ban the images because the law prohibited only obscene materials and these did not qualify, state representative Monique Davis led an effort in the Illinois General Assembly to introduce a bill that prohibited posting same-sex kisses on public transportation, which I jokingly referred to as the Gran Fury Law. As it turned out, amfAR had inadvertently exacerbated this controversy through the censorship of the rejoinder, making it easier for critics to claim the piece had nothing to do with AIDS, and harder for advocates to defend it. The *Chicago Tribune* said as much in the title of its article on the controversy, "Kissing Doesn't Tell Much about AIDS," which concluded that the same-sex kiss was not the problem; it was the image's lack of clarity.

You already know I agreed with that.

I do not draw attention to the censorship of this piece because one of our best-known works was hobbled from the start, making it an object lesson in the machinations frequently associated with the colonizing of dissent, though it most certainly is an example of that. It's because the rhetorician in me cringes when I consider how this project was drained of greater meaning during a moment of tremendous importance by the censorship of one of the most powerful, concise, and eloquent statements of political fact we would craft, "Corporate Greed, Government Inaction, And Public Indifference Make AIDS A Political Crisis." It was a turn of phrase that in my estimation surpassed "Silence = Death" in terms of clarity and definitiveness, and it was *exactly* what needed to be said in the streets of America, right there and then.

Although this piece is now understood to include its rejoinder and activists in Chicago protested its having been defaced, bringing conversations

about AIDS into public spaces that would otherwise not have happened, many published images of this work don't include the statement. I also realize it would also be impossible to prove lives might have been saved if the piece had been printed in its entirety at the time, though that's not implausible.

Those of us who think about the meaning of images live in a bubble the rest of us don't occupy. The rest of the world lives in a domain where images are simply a given and appear to speak for themselves. I honestly don't know if I would say the world would be better or worse now if I had had my way and we had walked away from the *Kissing Doesn't Kill* project over the censoring of the text that firmly situated it in terms of HIV/AIDS, nor does my opinion matter. I am more concerned with what that dyke in San Francisco who graffitied it or the lone queer tween reading about it in the Chicago papers would have to say about that. But I think they should know about the text modification that we were asked to make while they consider their answer. It would be reductive to say *Kissing Doesn't Kill* was rendered meaningless by the deletion of its rejoinder. But future study of this work, without the understanding of how this line came to be removed, might be.

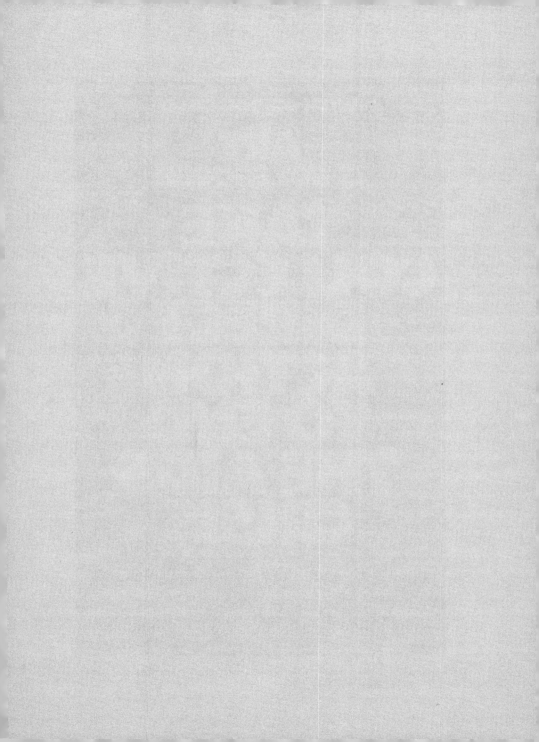

Figure 7. *Art Is Not Enough*, Gran Fury, 1988, poster, offset lithography, $21\frac{1}{2} \times 13\frac{1}{2}$ in. For The Kitchen, New York, NY.

Art Is Not Enough

While we prefer to think of art as a reflection of our culture that mirrors our higher selves—and frequently it is—art can also serve as a dividing line. Without the education needed to access the class codes within the canon of Western European aesthetics, it can be impenetrable. And without the economic mobility that allows us to visit the great galleries of the world, or the simple leisure time to go to a museum just a few train stops away, art can easily exceed our reach. So there can be no discussion about the meaning of art without also considering the many institutional walls that surround it.

Running parallel to that reality, however, is an alternative tradition of art made in direct response to these walls, art practices that pierce class codes, stand in resistance to them, or defy commodification. This is art in the public sphere, political art, performance art designed to activate our social spaces, and art that insists on the deployment of vernaculars. This is the kind of art I was raised around, the art that hung on the walls of our home, the art my parents' friends collected or made, and the art that filled the galleries we frequented as a family.

I was sixteen when the May '68 strikes in France first exposed me to the situationist critiques—formative years for me that coincidentally formed one of the most radical political periods in twentieth century America, the apex of the Vietnam War. For those who were not there: I came of age at a time

when American cities were being burned in protest, the two most popular prime-time TV shows were political satire revues, and even the stoic news-man Walter Cronkite eventually turned against the war. Perhaps if I hadn't discovered these critiques during such a pitched political moment, or was not a teenager when I did, and my own family hadn't always been so girded for battle—after the Kent State shootings my mom made me keep a packed bag under my bed because "the next step after gunning down students is a fascist military takeover"—these critiques might not have left the impression they did.

Situationism also contributed to a tectonic shift in art practices, helping to tip the transition from the postmodernist preamble of Pop toward more radical anti-art practices, and I shifted along with it. During my first year at college my work began to explore the relationship between the construction of gender and cultural mythologies, through psychoanalysis and religion. By my second year I had shifted my focus to drawing connections between gender and the valuation of cultural production, and sexuality as objectification. During my third year, I began questioning the object altogether, after Laszlo Toth knocked the nose off Michelangelo's *Pietà* with a geologist's hammer. It reminded me how unmoved I was seeing the *Mona Lisa* on loan at the Metropolitan Museum when I was eleven, and I began to wonder if I would have had a more meaningful experience of that painting if I had thought it would be incinerated the following day. I began destroying my own work as part of my practice, once I felt I'd learned what I could from each piece. At my faculty review I got a year's extra studio credit showing shards of that semester's work on gender and sexuality, recounting the meaning of each one as I did, and was able to graduate early. As it had for many artists of my generation, the political ramifications of art had been thoroughly called into question for me, and the meaning of my own practice, even though it already stood in critique of hegemonies, seemed politically retrograde from a class perspective. So, when I graduated, I chose not

to apply for the traveling scholarship that customarily led to a teaching post, and decided instead to discontinue the rarified privileges of art making to seek work where my own advantages had no meaning, a working-class profession I would feel less ethically conflicted about, while I decided what to do next. I was friends with photographer Nan Goldin through the photographer David Armstrong; and most of our mutual friends who were not artists—the subjects of her earliest photographs, the working-class gay men, lesbians, queens, and transwomen from the outlying neighborhoods of Boston—were either sex workers or hairdressers, or both. I was not enough at ease with myself for sex work, and although I never "believed" in hair the way hairdressers tend to, it seemed like honest work that did not trade off my privilege, and I decided to try it. My father cried when I told him.

I was raised in a radical way during a radical moment, one that gripped my entire generation, and it led to a radical art practice. I completely supported the Weather Underground and the Panthers, and carried a copy of the *SCUM Manifesto* around in high school. But I was still just a kid, so none of it had any functional meaning. Then, when Vietnamization began, I drew a high lottery number. Overnight, Vietnam became the war I fought against. AIDS, on the other hand, was the war I fought *in*. I was sent straight to the front. If I'd had other experiential trajectories, the critiques that molded my relationship to art might eventually have faded, but that is not what happened. Don got sick so early on, it only solidified my political convictions, and I threw my energies into the Silence = Death collective, never imagining it would lead me back to the art world, through Gran Fury.

Not all who found their way to ACT UP shared my political worldview, but neither was I isolated in it, and given my family history, I had never been weaned from radical ideas about political resistance. My father never got over the fact that there was no Bolshevik revolution in America, and his father watched *The Price Is Right* to monitor capitalism. So it should come as no surprise that I sought the circles within ACT UP that saw the politics of

AIDS from a resistance perspective. As an organization, we generally agreed on nonviolent coalition strategies, but we also built a structure that allowed individuals to draw together around political affinity and to work autonomously, and my affinity group was assembled around radical queer politics. Many of us believed we were about to die anyway, and gave serious consideration to assassinations and body bombs as a result. We advocated queer separatism. We assembled street patrol gangs and martial arts training sessions. A few of us even organized firearm practice. The ACT UP I was a part of centered on ultraradical conversations, an aspect of this history that has drained away from most accounts. But it was there, for sure, all over the place, and I was far from alone in it.

Partly as a reflection of my upbringing, and partly because I was one of the oldest members of Gran Fury, by the time AIDS was shadowing our lives, I had already made up my mind about some of the things other members of the collective were only beginning to explore or experience. I had spent two decades formulating my ideas about the politics of my art practice. I also carried radical political practices into Gran Fury, which advocated riots and civil war as rhetorical devices but was not actually organized around radical politics. So I found myself in conflict with the rest of the collective on many occasions, at times to the point of discomfort.

Owing to these differing political and experiential perspectives, some members of Gran Fury found me overly dogmatic about our participation in the art world. From my perspective, I was not conflicted about accepting institutional money if it included public projects, but remained opposed to gallery installations throughout our working relationship and, as a matter of principle, chose not to participate in any honors or perks, such as funding for travel to do talks or installations. Still, I never blocked any of those projects, even ones I raised a holy stink about, mostly in deference to familial allegiances I felt for Mark, who supported them. I do not point this out to imply

I was correct about it, but to help you understand my individual perspective at the time this work was made.

Neither am I saying Gran Fury was less political than I was. It was thoroughly political. I'm saying our politics existed as an ever-shifting set of collective ideas about it or, more accurately, a shifting set of individual relationships to the meanings of these ideas as they underwent the ultimate test—battlefield decisions about what was important in the face of our own mortality and that of our loved ones, and how we chose to articulate those priorities. It also bears saying that since the political arguments we engaged in largely centered on the art world, I became aware that our practice may have felt much more political to the members of the collective who were more invested in the art world than I was at that point in my life. I recall only one instance of political disagreement about a particular image, and even then, it was not over the question of how radical it should be. Our disagreements were mostly over whether we should accept a project to begin with. I also do not mean to paint a picture of myself as a lone dissenter within an otherwise monolithic consensus: if Gran Fury was anything, it was contrary, and there were plenty of shoving matches that had nothing to do with me or with the art world.

I also need to say the collective was extremely mindful of our own privileges of access, which we shared when it did not feel colonizing, and unanimously agreed to press for public spaces outside gallery settings, which were ultimately my two lines in the sand. So I tried to make room for the fact that we were all dealing with unimaginable circumstances, and I was ultimately willing to compromise, though never without a fight. I respected our collective's intellect and disposition, even when I strongly disagreed with the group, our decisions, or individual members.

And that, I believe, was the key. What drew Gran Fury together was not actually political affinity, but a simple agreement about the need to make

work. The force of the collective resided in the work alone, in its strategic agreements about the combined meaning of image and language, and there no discord existed whatsoever. Gran Fury was less an affinity group than an organic accident of proximity given form by a single opportunity, the offer of The New Museum windows by Bill Olander, itself a likely by-product of the most organic of all things, the threat of his own death. As political projects go, Gran Fury was more unpremeditated than any other I'd ever been involved with. The same could be said of its group temperament, which can only be described as an extremely productive clash of influences: urgency from the Weathermen, ingenuity from the feminists, humor from the Yippies, postmodernism from academia, a pickpocket sleight-of-hand from the Silence = Death collective, irony from the gay ghetto, formalism from European graphic design, and the plain-spoken logic of the American South.

Many artists preceded us with more comprehensively defining practices centered on critiques of the art world, but Gran Fury managed to twist our form of critique into a postmodern Möbius strip, reorienting it to simultaneously coexist as an insider's and outsider's perspective. While invariably accepting the terms of our sponsoring institutions, which I was less happy to do, the collective was conversely hard-nosed about holding other artist's feet to the fire, particularly those who hadn't addressed AIDS yet, to drag them into the conversation in much the same way our colleague Michelangelo Signorile chased down influential closeted lesbians and gay men to force them to stand with what we saw as a community under siege. We stole Barbara Kruger's font and Annie Leibowitz's photograph of Jesse Helms, and added the RIOT painting to our first group show that included General Idea's AIDS wallpaper without alerting the curator we were doing it. Given my antipathies, one might imagine I had a hand in these strategies, but I had no part in it whatever. They appealed to my punk side, but it was the members of the collective more invested in the art world who instigated them. And perhaps as a function of this investment, the collective was, I felt, fairly

constructive in its public but coded throw-downs with other artists (with the notable exception of the *RIOT* painting, which was slightly mean), refusing to negate cultural production as a response to AIDS while simultaneously promoting direct action as a parallel response. As sensitivities go, this approach was also self-serving, since we were ourselves deploying cultural production as a strategy and thereby critiquing our own work in the process. From a street fighter's perspective, these mud-wrestling matches seemed less vicious than bratty to me, and at times almost formal and somewhat genteel, like a form of dueling. But I turned out be wrong about that. Apparently, the art world is a place where you can never be genteel enough.

In the same way office workers in ACT UP routinely stole Xerox access, it was common practice for artists, writers, and curators in ACT UP to help commandeer resources for its use, like Tony Feher arranging the use of Jennifer Bartlett's West Village studio space to fabricate the extratall vertical banners for the storming of the Bush family compound in Kennebunkport, Maine, or Patrick Moore's arranging for us to use the storied New York performance space The Kitchen to paint and stitch some of our most massive banners. The Kitchen also agreed to Patrick's suggestion to invite artists to produce their marketing materials, and once they did, he came straight to Gran Fury with the following proposal: if we would design a mailer that included the listing information for two months of programming on one side, we could do what we wanted with the other side, and it would be wheat-pasted around Manhattan as a poster.

This happened very early on in our collective work together, and in hindsight I realize I hadn't yet understood the relationship some members of the collective had or wished to have with the art world when we accepted this project. As I said earlier, I had no dog in that fight, or more accurately, I had long ago decided art contexts were too inherently reinforcing of hegemonies for anyone to have political expectations of them. But it is my nature to project my own politics and affinities onto almost every situation, and at

that point I still saw our work together as having a shared politics. In fairness, all of us probably did, but the differences about what that might mean had yet to be revealed. Although artists with political practices have since expanded my thinking about working within art contexts, at this time, I was happy to seize access when it was directed to public spaces and not one drop interested in what the art world was thinking or doing about AIDS. And while our access was founded in privilege, I was not conflicted about using it if it might contribute to dismantling institutional power in front of nonart audiences. So I was easily convinced by the others in the collective that we should use The Kitchen project to address the question of the art world's response to AIDS—if the poster was mounted in the streets of New York.

It felt to me that in struggling to strike a balanced critique, the collective was bending over backwards *not* to implicate the specific artists whose performances this mailer would announce, and in fact, we knew some of them had already taken an activist stance about AIDS. In the process of brainstorming, we'd even convinced ourselves that while some people might be peeved at our finger-wagging, no one could possibly object to the phrase "TAKE COLLECTIVE DIRECT ACTION TO END THE AIDS CRISIS." Of course, it also said, "WITH 42,000 DEAD, ART IS NOT ENOUGH." The latter was in a slightly smaller font, but it was all caps and extrabold, which was certainly *very* readable, and while it seemed reasonable to us, it did not feel that way to some of the artists who were performing. They apparently did not so much disagree with it as resent having been conscripted by us, and their complaints made their way up to the board of directors of The Kitchen. According to Patrick, when he was pulled in to discuss how unhappy the other artists were, he stormed out on the spot and took the story to the *Village Voice*. If the sixties were politically pitched, so was New York in 1988, and ACT UP was pushing everyone in a more radical direction, with the exception of disengaged or reactionary elements in the gay community, some of whom were pushing back.

At the time, I believed the poster was quite moderate. It sounds shriller to me now, but compared to other conversations I was privy to, it was a simple entreaty, not an accusation, and little more than a recruiting poster for ACT UP. We did not say, "Art can no longer have meaning," or that cultural production had no political use. The poster said that it was not enough to *only* make art while people's lives were at stake, and in the same way we insisted everyone else in the country take any number of concrete direct actions to intervene in the crisis, we were saying people in arts communities and their audiences had a similar responsibility. Not only did Gran Fury stand by the work, as did Patrick Moore, but we carried versions of the strategy forward, in the printed program for the Bessie Awards for the downtown performance community and in a book edited by Jan Zita Grover, *AIDS: The Artists Response*.

I should not have been surprised by the response, but I was. I believed speaking out on behalf of social engagement would be universally agreed upon, especially in the face of the death toll in art communities. It was the sort of reaction that seemed to parody every impression I had formed about the machinery of culture-making, and for better or worse it caused me to push back more ferociously when it came to future projects that took place in art settings. I am not saying my impulse to resist some of the opportunities we were afforded was more correct, only that as the collective became increasingly comfortable within art settings, I became increasingly uncomfortable with them. Even though we were highly conscious of the level of critique within our work as a collective, and everyone was well aware where we stood within cultural power structures, we were still entering a canon I considered problematic, and more than anyone else, I was dragged kicking and screaming into it. It is my impression that if other members of Gran Fury felt a similar discomfort, they mediated it by saying we were *not* making art, though that assessment, I think, skirts the question of how our work was deployed inside and outside the art world.

One example of my problem with both—how we were situated within the art canon and what institutional uses our work had beyond that context—can be traced through the poster Gran Fury created for the FDA demonstration, *The Government Has Blood On Its Hands* (fig. 8). It was intentionally iconographic and is likely one of our most recognizable images. It represented ideas that were relatively easy to understand. But it was based on two preceding posters that are far less easy to grasp, which is meaningful and symbolic of a larger set of political questions, and so I'd like to map the specific regional, political skirmish that this poster is based on, and I do it for the following reason: I believe the political meaning of this work has been imperceptibly but definitively degraded throughout the process of our consideration of it.

When we describe art as a reflection of our culture, that presupposes participation in it. In this way, it tacitly assigns assent. Fair enough, if the goal of its production is cultural. But posters such as this one, made during times of crisis, are a call to action. They are an advertisement for individual agency and have a completely different set of goals. Political activism is not necessarily cultural production. A community in crisis is not art.

So, when political posters enter the canon, this undetectable mechanism— the one that implies assent—strips them of their potential as gestures of resistance, deactivating an entire set of functions. That's not to say their only meaning is political and they may never be explored as artifact. I am saying that once the echo of the moment dissipates, all that remains is how we talk about this work, and any canon that elevates the "art of dissent" simultaneously domesticates it by privileging its contribution as cultural production over the critiques that generated it. It is transformed into a form of cultural sausage, proof of democracy in this case, at which point multiple power structures can stake a claim in this work as a symbol of productivity rather than the symbol of resistance to institutional dominance it was actually intended to be,

Figure 8. *The Government Has Blood On Its Hands*, Gran Fury, 1988, poster, offset lithography, $31\frac{3}{4} \times 21\frac{3}{8}$ in. ACT UP, FDA Action.

blurring the line between assent and critique in the process. It is a defanging. I prefer to talk about its teeth.

On July 19, 1988, then New York City commissioner of health Stephen Joseph suddenly halved the number of estimated AIDS cases in New York City, a move that simultaneously threatened to drastically reduce funding for AIDS services. The cut was purportedly based on cohort studies in San Francisco's gay community, but the data were also rumored to have had partial basis in a position paper by a right-wing think tank that called the Kinsey Institute analysis of the number of gay citizens into question, offering a downward re-estimation in its place. Regardless of its origins, ACT UP NY instantly mobilized and declared war against Joseph.

During a sit-in at Joseph's office a copy of his itinerary was taken, and it became the basis for a campaign spearheaded by an ACT UP affinity group, Surrender Dorothy, named after the sky-written threat by the witch in *The Wizard of Oz*. The itinerary was largely circulated throughout ACT UP, and we followed the commissioner, day and night, to public and private meetings, forums, lunches, and dinners, and it occasionally even led us to his apartment building. The pursuit of Joseph was so public and so relentless, it became somewhat high-profile here in New York, creating skirmishes between local gossip and news columnists over whether protester calls to the commissioner's home could be considered fair. Joseph was so unhappy about the scrutiny, it culminated in a late-night visit to one activist's apartment by a New York Police Department intelligence case squad generally tasked with police slayings, after a harassing call was placed to Joseph's private residence from there. The *Village Voice* reported Joseph as having been responsible for the investigation, which led several lawyers within ACT UP who had movement experience to conduct a teach-in on the history of covert FBI surveillance, infiltration, and disruption of domestic political organizations from 1956 to 1971, in particular the operation known as COINTELPRO (Counter-Intelligence Program), aimed at destabilizing the American

Communist Party, the civil rights movement, the antiwar movement, and the Black Panthers.

Deepening this already-tense political climate was the Tompkins Square Park Riot, which began within days of the phone harassment of Joseph. It was an incident referred to in the *New York Times* as both a "police riot" and a "war zone," and that was not an exaggeration. The standoff, staged around the homeless population in the East Village park, included mounted officers doing battle with bottle-hurling protesters, and low-flying helicopters combing the rooftops with searchlights. Many ACT UP members lived near the park, and formed an obvious presence in their ACT UP T-shirts during this protest over the gentrification threatening all of Lower Manhattan, precipitated by Reaganomics. Mark Simpson lived a half block away in a gutted squat, and we could see the helicopters flying over the buildings from his window. If the protest had begun as a spontaneous battle precipitated by hostile police actions, it spun out of control within hours, impacting public sentiment, policy, and cultural production for years to come.

It was within this setting that several Gran Fury members became involved in the effort to remove Joseph from office, myself included. In the early months after the formation of Gran Fury, and before the group's decision to close the collective, then-member Mark Harrington proposed the bloody handprint image as a poster to support the campaign. We produced two versions of the 8.5-by-14-inch poster, with different texts and two different bloody hand splatters. One read "YOU'VE GOT BLOOD ON YOUR HANDS, STEPHEN JOSEPH. THE CUT IN AIDS NUMBERS IS A LETHAL LIE" (fig. 9), and the other said, "YOU'VE GOT BLOOD ON YOUR HANDS, ED KOCH. NYC AIDS CARE DOESN'T EXIST." Because his hand suited the aspect ratio of the page, Harrington was one of the blood splatter hand models. The posters were wheat-pasted around NYC by members of Gran Fury, Surrender Dorothy, and ACT UP. To support the posters, we organized a small budget and brought buckets, red paint, and rubber gloves to the floor of ACT UP to

Art Is Not Enough

Figure 9. *You've Got Blood On Your Hands, Stephen Joseph*, Gran Fury, 1988, poster, offset lithography, $14 \times 8\frac{1}{2}$ in. ACT UP.

instigate a parallel graffiti campaign of bloody handprints that would go where the posters could not, reinforcing the image's ubiquity. In truth, there were not that many takers, but we didn't need very many of us to saturate the area. Handprinting the East Village, Lower Broadway, and SoHo was my first date with my boyfriend at the time, who had to talk his way out of getting arrested that night.

Two weeks prior to the Joseph re-estimation of AIDS cases in NYC, ACT UP had attended a meeting of national activists in San Francisco and proposed targeting the regulatory agency responsible for the testing of potential AIDS therapies in the United States, the Food and Drug Administration (FDA). Given the high and rapid mortality rate, it had become increasingly clear that the risks the medications carried did not exceed those the withholding of therapeutic intervention posed, and that the clinical trials for the safety and efficacy of these drugs were de facto health care for individuals confronting the then-fatal disease. ACT UP NY's Treatment and Data Committee (T&D)—the committee Mark Harrington left Gran Fury to devote his efforts to—developed a powerful rationale and an accompanying handbook that walked our membership through the history of the FDA and its structure, as well as the topography of policy making by the public health services inside the Beltway. Gran Fury decided to do a poster for it.

"You understand iconography," Tom Kalin said while consulting me on the kind of image that might be needed to support the work of the national network of activists coordinating the effort. "What do you think we should do?"

"Nationalize the bloody hand," I immediately responded.

I can't speak to why Mark Harrington thought the bloody handprint was the right image for our battle against Stephen Joseph. I know why I did. I had felt radical gestures were necessary since conceiving of the *Silence = Death* poster as the first in a series of three that would eventually call for riots during the 1988 elections. By the second year of ACT UP I was nearing desperation. The American death toll had surpassed that of Vietnam, a

Art Is Not Enough

number that had mobilized my entire generation. And it had been almost a year since *AIDSGATE* upped the critiques in the rejoinder of *Silence = Death* to charges of genocide against our national leadership. I thought the FDA action provided a perfect rhetorical opportunity to hit harder in this same direction, and it was an argument I'd observed an increasing appetite for within ACT UP, from the concentration camp float to the Nuremberg Trial reference in *Let the Record Show*.

ACT UP had been solidifying a more radical voice throughout the Joseph actions here in New York, and that voice suited the language being floated around the FDA action. "We're going to seize control of the FDA" was the exact phrase Gregg Bordowitz used when the action was brought to the ACT UP general meeting for approval, and when he said it, the room shouted its consent. From a rhetorical perspective, I imagined a poster that would not only serve as a backdrop against which to unpack the decision to target the FDA—the vise grip of pharmaceutical companies, the mechanisms of institutional scientific research in America, and the intricacies of the drug approval process—but also hint at more sweeping critiques and act as a broader umbrella under which a series of related conversations might be able to reside. I was hoping for an image with a much longer shelf life than a simple, single-message demonstration poster.

So I proposed the nationalization of this image to Tom, and there was agreement in Gran Fury. We used the graphically superior handprint from the Joseph campaign and produced a larger version of the poster that read, "THE GOVERNMENT HAS BLOOD ON ITS HANDS," with a statistic drawn from an ACT UP fact sheet, "ONE AIDS DEATH EVERY HALF HOUR," a figure later amended to "EVERY FIFTEEN MINUTES" on the sticker versions we made to replicate the gesture of the graffiti handprints in a way that imposed less legal risk. We also made T-shirts to be worn as agitprop and sold as fundraisers. We considered these iterations of the image to be marketing collateral for the ACT UP Media Committee's strategy for feeding the story to

media outlets, and worked with Fundraising and Outreach to usher the image through. Although the poster was used throughout the following years, this version was intentionally debuted at the FDA so it would be linked to that action. Several affinity groups used the image or fabricated individual versions of it, including Patrick Moore's affinity group, which splashed bloody handprints on the back of the lab coats they wore during the daylong demonstration at the FDA. I hand-painted the bloody hand on the back of my own leather jacket.

The FDA action was a turning point for ACT UP NY and for the AIDS activist movement, one that impacted the history of other social movements in America and around the world. The action kick-started the streamlining of the drug approval process: therapies languishing in the pipeline became more readily available; the parallel-track drug access and compassionate use protocols proposed by ACT UP were instituted; more People Living With HIV/AIDS, people of color, and women were included on advisory boards, to name just a few accomplishments—and by and large, the political meaning of this work of agitprop has been linked to those accomplishments. The FDA action also prompted the head of AIDS research in America, Anthony Fauci, to invite members of ACT UP NY into meetings with researchers and policy makers, on the proviso that their critiques be adjusted to suit the customary collegiality of those proceedings. So I have come to think of this poster as having an alternative set of meanings, as the signpost for another major turning point in the AIDS activist movement: the transition from critique of the system to an investment in it, a pivot that directly paralleled, as it happened, Gran Fury's growing relationship with the art world, occurring at exactly the same moment.

The phrase *pharmaceutical industrial complex* is like nails on a chalkboard for treatment activists. It assigns nefariousness to committed people who work in the fields of medicine, scientific research, and health care, and it sounds, well, melodramatic. What is undeniable, however, is that these

disciplines exist in an institutional bubble that demands buy-ins at every level, and even activists who were so convinced of its corruption that they decided it was necessary to "seize control" of the federal research and drug approval bureaucracies experienced a form of Stockholm syndrome once the doors were opened. The gesture of "seizing control" fulfilled its radical potential from a rhetorical or grassroots organizing perspective, but it also triggered institutional mechanisms similar to the ones that degrade the political intention of the "art of dissent," namely, the neutralization of dissent through absorption, creating a situation where AIDS activists became part of the system they were otherwise pitted against. The critiques that brought us to the table set the stage for a defusing of other critiques, as witnessed in what would become tense strategy debates in ACT UP NY surrounding women and AIDS, concerning the specifics of how the campaign against the Centers for Disease Control (CDC) to expand the definition of AIDS was conducted, and regarding whether there might be political implications in accepting pharmaceutical money for community-based research.

For similar reasons, I also consider noteworthy the way this suite of posters has crystallized within the canon. The national bloody hand poster has come to represent both an orchestrated campaign to expand access to lifesaving AIDS medications and the effective deployment of collective direct action to do it. But in historical terms, the fact that the national version of this image has eclipsed the original versions of the poster also serves to underscore the inherent deficiencies of a "consolidated" AIDS historiography, as opposed to a more expansive one.

This image had its genesis in a local skirmish that has been jettisoned from the story because it makes no greater point. In my estimation, however, it was politically significant. Even though you may never have heard about it, the pursuit of Stephen Joseph was no less pitched or potent than having taken on the FDA. This small sit-in at the local Department of Health office

was instrumental in ACT UP NY's finding its voice, and it set the stage for an ongoing relationship with the commissioner that spilled over into a local pilot needle exchange program, another essential story underplayed within the dominant narrative.

Within this unwieldy story is a tale of a community, compelled by despair and the urgency of the moment, covered in red paint and doggedly willing to risk arrest over and over again, simply because it was the right thing to do. The klieg light of the national media was not trained on this story, but ACT UP would not back down. And as a result, a tiny affinity group, powered by the tight solidarity of an only slightly larger collective of enraged individuals, took risks that created tensions between ACT UP NY and the police that led to ongoing surveillance of the organization, and the political deterrence that accompanies it.

During this period the FBI did, in fact, keep files on ACT UP (fig. 10). It would be difficult to say whether or how the Stephen Joseph protests contributed to their genesis, but one document explains the chain of command to the FBI's Canadian counterpart if an act of "terrorism" by ACT UP occurred at the Fifth International Conference on AIDS, where Stephen Joseph was scheduled to speak. It warns, "Threats have been made against a number of guest speakers," and points out that members of ACT UP who were arrested by the New York Police Department would be there, advising they "SHOULD REMAIN ALERT, THROUGH ASSET AND OTHER COVERAGES," which may be a reference to infiltration (the capitalization is in the FBI document). It then gives instructions to notify the FBI "SHOULD AN INCIDENT OCCUR FOR WHICH THE FBI HAS INVESTIGATIVE JURISDICTION, THAT IS, VIOLATIONS OF TITLE 18, UNITED STATES CODE (USC), SECTION 1203, WHICH MAKES IT A CRIME TO TAKE A U.S. NATIONAL HOSTAGE; AND/OR TITLE 18, USC, SECTION 2331, WHICH MAKES IT A CRIME TO KILL OR ASSAULT A U.S. NATIONAL AS PART OF A TERRORIST INCIDENT."

The New York FBI field office also sent a memo to domestic terrorism units in D.C. and elsewhere in the United States detailing the Tompkins

FORMS.TEXT HAS 1 DOCUMENT

INBOX.2 (#286)

TEXT:
VZCZCHQO178

PP AFO ALO

DE HQ #0178 1470752

ZNY EEEEE

P 261815Z MAY 89

FM DIRECTOR FBI (163-0)

TO ALL FBI FIELD OFFICES/PRIORITY/

ALL LEGATS/PRIORITY/

BT

UNCLAS E F T O

CITE: //0555//

SUBJECT: FIFTH INTERNATIONAL CONFERENCE ON AIDS; MONTREAL,
QUEBEC; JUNE 4-9, 1989. FBI ASSISTANCE - SPECIAL EVENTS;
OO: FBIHQ.

 FOR INFORMATION OF RECIPIENTS, CAPTIONED SPECIAL EVENT IS
TO BE HELD JUNE 4-9, 1989, AT MONTREAL, QUEBEC.

 INFORMATION HAS INDICATED THAT THREATS HAVE BEEN MADE
AGAINST A NUMBER OF GUEST SPEAKERS WHO WILL BE ATTENDING THIS
CONFERENCE. IT HAS ALSO BEEN LEARNED THAT A GAY ACTIVIST GROUP
IN NEW YORK UNDER THE NAME "ACT/UP" HAS BEEN VERY ACTIVE IN
DIRECT CONFRONTATIONS AND IS PLANNING ON SENDING SEVERAL

[handwritten annotations: Special Events management 185-1-60; Milwaukee 163-0-48; 262-0; SEARCHED FOIMS. MANUAL b7C; MAY 27 1989; MILWAUKEE]

Figure 10. Photocopy of FBI memo, "Subject: Fifth International Conference on AIDS, Montreal, Quebec," ACT UP FBI Files.

PAGE TWO DE HQ 0178 UNCLAS E F T O

MEMBERS TO THE CONFERENCE. THE NEW YORK POLICE DEPARTMENT HAS
APPARENTLY ARRESTED A NUMBER OF MEMBERS OF THIS GROUP.

SHOULD AN INCIDENT OCCUR FOR WHICH THE FBI HAS
INVESTIGATIVE JURISDICTION, THAT IS, VIOLATIONS OF TITLE 18,
UNITED STATES CODE (USC), SECTION 1203, WHICH MAKES IT A CRIME
TO TAKE A U.S. NATIONAL HOSTAGE; AND/OR TITLE 18, USC,
SECTION 2331, WHICH MAKES IT A CRIME TO KILL OR ASSAULT A U.S.
NATIONAL AS PART OF A TERRORIST INCIDENT, WHILE SUCH PERSON IS
OUTSIDE THE TERRITORIAL LIMITS OF THE UNITED STATES, AND WITH
HOST COUNTRY APPROVAL, THE FBI WOULD RESPOND. FURTHER, THE FBI
WOULD BE INVOLVED SHOULD FBI ASSISTANCE BE SPECIFICALLY
REQUESTED BY THE HOST COUNTRY.

IN LIGHT OF THE HIGHLY EMOTIONAL NATURE OF THIS CONFERENCE
AND RECENT VIOLENCE WHICH HAS BEEN ASSOCIATED WITH LIKE
CONFERENCES, IT IS REQUESTED THAT RECIPIENTS REMAIN ALEPT,
THROUGH ASSET AND OTHER COVERAGES, FOR ANY INFORMATION WHICH
MAY INDICATE A THREAT TO ANY ASPECT OF THE FIFTH INTERNATIONAL
CONFERENCE ON AIDS, AND TO ANY WAY IN WHICH FBI COUNTER-
TERRORISM RESPONSIBILITIES MAY BE IMPACTED UPON, PRIOR TO OR
DURING, THE COURSE OF THIS SPECIAL EVENT.

Square Park Riot, claiming it was triggered by an earlier demonstration on July 31, 1988, organized by "ACT UP" and "SKINHEADS" (a reference to the anarchist band Missing Foundation, which was associated with the incident), during which "BOTTLES AND DEBRIS WERE THROWN AT OFFICERS." Another FBI file was precipitated by an offhand death threat in *Mother Jones* by an ACT UP member against right-wing U.S. representative William Dannemeyer and Senator Jesse Helms. The member quoted the Gran Fury poster *All People With AIDS Are Innocent* to make his point.

It would be years before the files could be obtained through the Freedom of Information Act, but it did not exactly matter once they were. The case squad visit had already riddled ACT UP with rumors about who within our membership might be informants, and if there were any, it would be hard now to gauge the effect it had then. The threat of surveillance did not appear to overtly deter our collective work—in fact, it became kind of an in-joke among many of the rank and file—but it would be impossible to say how individual members or members with previous police records were affected by it, how many people never made it past the announcement at the top of every meeting calling for undercover police and FBI agents to identify themselves, or the effect that announcement might have had on activists of color in the room who might have been differently impacted.

More to the point, however, the radical reputation solidified by escalating episodes with various divisions of law enforcement in New York and D.C. was a factor in ACT UP NY's ability to exert influence over national HIV/AIDS research protocols. In fact, the Stephen Joseph saga may be one of the reasons why the FDA action succeeded, and why you've heard of the national bloody hand poster in the first place. I am not juxtaposing the two stories to downplay the importance of treatment activists' ongoing participation in the drug approval process or how research was being funded in America. I do it to help explain that it was grassroots political organizing that made it possible, and to point out that the high wire running between critique

and consent exists every place where power is institutionalized, most notably in cultural production and in scientific research, two disciplines that power structures love to vaunt as symbols of the very meaning of human achievement, and two areas commonly cited as ACT UP's clearest accomplishments.

Affinity

Figure 11. *Sexism Rears Its Unprotected Head*, Gran Fury, 1988, poster, photocopy on paper, 16 $\frac{3}{4}$ × 10 $\frac{3}{4}$ in. ACT UP, Spring AIDS Action '88. Courtesy Fales Library, New York University.

Men: Use Condoms or Beat It

There are certainly other meanings, but in grassroots organizing, assembling people into affinity groups is a device for managing larger demonstrations that include a component of civil disobedience. The strategy of breaking into smaller, more manageable groups enables organizers to track the movements of demonstrators who share a willingness to risk arrest, which in turn makes it easier to provide them with legal, emotional, and physical support. It also assures a safe environment where participants can process on-the-spot developments that might change how they choose to express their agency as individuals or as a group. In many cases people are broken into affinity groups during civil disobedience training. That happened during mine, but it felt inorganic to me and I eventually joined an affinity group my closest friends formed. For affinity groups to function to their potential, they need to be far more than a unit of measure.

While it was not uncommon for ACT UP affinity groups to stay together for years, I'm convinced mine managed to stay "together" only by constantly morphing to accommodate shifting orbits of personal and political connection that allowed affinities to change or grow, the same way our shared history did. As a result, I have come to think of political engagement in a similar way, as a project in flux, one that needs to evolve to sustain itself. It might not have been the case for everyone, but it felt natural to me for the

core group I was working with to mutate or change, and while analyzing either the vitality of ACT UP or its "demise" might be useful for study, comparison, or measurement, it also seems to miss its own point. To see the ebb and flow of agency and affect as an articulation of successes and failures is to accept the framing of political engagement as an accomplishment rather than as an ongoing project that is more useful when it continues than when it is measured, and to view political change as a discrete "thing," rather than a process that needs no endpoint to express efficacy. It frames the resistance to power structures in the same terms as that which it is intended to resist, as capital, as the acquisition of an object or, in this case, an objective. The goal of capitalism might be the acquisition of things, but I believe resistance is more accurately described as a project. By its nature it cannot be acquired; it can only be activated. It dies when we cease participation in it, but it's reborn the second another of us picks it up. At least in terms of the individuals I have been involved with throughout my activist life, every collective endeavor I've been a part of has been an extension of a previous project or projects. My stuffing envelopes for the Poor People's Campaign was an extension of my family's involvement in the Peekskill Riots; *Silence = Death* was an extension of the May '68 strikes; Gran Fury was an extension of the Silence = Death collective, as seen through the eyes of a curator expressing his own agency; and so on.

So I am asking you to step away from any narrative that constructs ACT UP in terms of discrete accomplishments—the "objectness" of the things we have to show for our efforts—to make room for alternative narratives, ones that suggest political engagement might be closer to a series of gestures than to objects, gestures that are the antithesis of ownership. I'm also asking you to disregard the objectness of the posters described here and consider them as gestures too, and I think this is the perfect place to begin, in the context of a grounded description of some of the ways the communities we point to as case studies functioned. I'm suggesting this shift in perspective as the

person who was advised by everyone I spoke to about *Silence = Death* before ACT UP formed that the poster would make *no sense* to the world, simply because the world had yet to make sense of AIDS, but that is what the poster was designed to help it do. Gesture may have been what was missing, and the poster was one such gesture.

Having already argued the distinctions between Gran Fury and Silence = Death, I am now also asking you to begin to understand them as a connected set of gestures as well, because they were, and to see them as connected to the set of gestures made every time a person put a sticker on a tollbooth or an ATM, or made by the queer couple who snuck them into the NSA, or by every person who wore a *Silence = Death* button to work, or ploughed through reams of research data, or picketed at 3 AM during the four-day demonstration at the AIDS Treatment Evaluation Unit of Sloan Kettering, when no camera could possibly see them. And connected even to the gesture in the direction of resistance made by a person reading this paragraph in 2075. Every gesture of resistance is connected to every other one, past, present, and future. Unless you accept the terms you are given for it, the story of ACT UP is not a story about the past.

As politically fertile as my childhood was, it was also extremely lonely, so I came to seek a level of connection in my relationships most people have only a casual capacity for. Don was my first real success at it. The Silence = Death collective served as a replacement. What I couldn't know was the kind of bridge it would offer to still-deeper communities of connection. ACT UP changed everything, overnight, and I went from having one small social setting for support to many, expanding versions of it. I quickly realized I was not alone in my craving for deep comradeship, and this new feeling of connection was overwhelming after so much isolation. I was not the only one who felt parched for connection, and I believe this to be one of the main reasons so many of us went to meetings every night of the week. It wasn't only that lives were at stake, our own in many cases. When people refer to ACT UP as a

community, it misunderstands the deeper necessity for it. We weren't building a community. We were building a home. ACT UP was a barn raising.

And if ACT UP was a form of communal shelter, affinity groups were far more than a way to manage the safety of participants in large demonstrations. It was the family unit within ACT UP, binding individuals in need through pacts of acceptance, empathy, and shared history. In this particular context, the affinity group was a gesture that directly linked political collectivity to caregiving. Before ACT UP you were generally expected to choose between the two. Once they were combined, their force was intensely affecting. It shaped everything we did.

"I know you won't want to, but you need to listen to me," Lee said, sitting next to me on the bench. It wasn't cold outside, but it felt that way to me. I pushed to the edge of the bench, and he was leaning against its back, one elbow wrapped over the top rung. He'd made me step away with him so he could smoke, and it was dark where we were, in the shadow of an enormous tree as the sun dropped. I hated that about him, the smoking. He said there would be no point in stopping, now that he had AIDS, and tried to convince me the stress of it would be more harmful than continuing it. But I'm pretty sure he never believed that, and he didn't really care if I did. He was simply going for broke.

"You know I'm going to die, right?" he said. I tried to look at him, to signal that I was really *with* him, but I just couldn't. So I looked down instead, shaking my head back and forth, trying to hide the fact that I was crying.

"You don't know that," I tried. "None of us do. They could find something tomorrow that could change everything . . ."

"Stop it," he interrupted, ". . . and look at me." I wanted to, but I saw the rest of our affinity group silhouetted against the streetlights that were warming up on the other side of the tree, and I sensed the mixture of exhilaration and exhaustion in our friends that always follows a demonstration.

They were waiting for us, and I was sure we were facing a long night of drinking. "You need to look at me," he repeated. I wished I were over his shoulder, in the safety of that crowd.

"I *want* to be strong, but I'm not," he went on. I had had extremely close relationships over the years, and been spoken to this directly many, many times, but there was nowhere to hide in this conversation. I don't think I'd ever heard anything that honest before, at least not from someone who just said he was dying. "It's okay, though—it really is. I'm not afraid," he continued, pulling on his cigarette. "It's just too late for me."

I wasn't ready to stop crying, but I made myself. "Why are you telling me this?" I said, relieved that my voice wasn't cracking, "Why are you doing this?"

"Because it's important to me that you face what's happening," he drew in again, and he was looking right at me. As he said it, I was thinking about the time Don tried to talk to me about denying treatment if he got PCP again, and how I shouted at him for even considering it. It felt as if Lee was giving me the chance at a do-over, and knowing him, he probably was. "And I need you to do something for me," he added.

"Anything," I said, but I don't think I really meant it. I was not as strong as I wanted to be, either.

"You have to stop spending money on stupid things just because you can." He was talking about the fact that every time I went to visit him, I brought a cheap toy to cheer him up. "You have to promise you'll start putting money aside." Lee had a way of controlling things that was too planted in concern to object to. I hated that too, that he could be paternalistic and also be right. I thought that was it, but he was only warming up.

"And you have to promise me you'll look after Joey," his boyfriend, who was also in our affinity group and who hardly needed looking after. "He's not going to handle this well," Lee said, and I didn't realize how right he'd be about that either. He savored another inhale. "I want you to make sure he finds someone else . . ."—he was smirking now—". . . you know, after an

appropriate amount of time." I was relieved to have something to laugh about, to cut into the moment, so I did. He looked right at me again in a way that made me wonder what he was actually asking of me, but then he interrupted my train of thought again before I had the chance to continue it.

"You know, this isn't how it was supposed to be," he said. "You and I were supposed to be together." And that's when *he* looked down, after revealing something so deeply personal. "But I fell for Joey first, and then you met someone else."

I paused before saying, "You don't mean that," since I didn't share his feelings and couldn't see any point in saying so. I was too wrapped up in my own embarrassment over the intimacy of it to understand that this was it, that deathbed scene in the movie, the one where you get to say what you never had a chance to, only it was playing out on a bench, in public, and I didn't want to admit he was dying.

Lee actually lived another year before acute pain sent him to Beth Israel. He told me they thought it was pancreatitis, something we did not yet fully understand to be associated with nucleoside reverse transcriptase inhibitors. He also had redness and pustules, which he thought was triggered by Bactrim photosensitivity, but was apparently Vancomycin-resistant Staphylococcus. He looked bad. He felt worse. I knew his black moods intimately, had rattled around in them for hours on end after he was too sick to work, while he delivered his wicked and skeptical analyses of the relationships between everyone we knew, sitting by his floor-to-ceiling windows that overlooked the blank stare of one of the earliest big-box leviathans in New York, Bed, Bath and Beyond. But I'd never seen his gallows humor abandon him like this before. Not to say he was angry. And he didn't seem sad, exactly. I can't think of a way to describe this hospital visit, except to say I felt like I was in an observation room, on the other side of a one-way mirror, playing a passive part as something terrible unfolded, something happening against my will.

If there is an overexposed glare the morning after somebody dies, that final hospital visit is quietly neutral. You have no real way of knowing it is the last time, but you know something has changed. It's as if there were no actual light source, as if everything were interiorly lit, but not glowing. No shadows, no highlights, just the sixty-cycle-a-second hum of it. Nobody wants to be there, nobody can leave, no one knows what to expect. It's the inverse of every scene in a movie: not dramatic, not resolute, just a Klein bottle of matter-of-factness, drained of human implication. It is that dream in which you are the only one naked and it's too late—everyone sees you—only, everyone is looking at you, yet you want to be alone, to consider what might be your last moments. But you're not; you're in a hospital room with an endless stream of visitors. They are talking and you have nothing to say, or they have nothing to say and you're left with the task of making it seem OK.

After years of sharing every thought that ever popped into our heads, all I could offer was, "I know you're in pain, but they're treating you and you're going to get better."

"It doesn't matter," he winced. "I've decided to stop treatment." I don't know if he meant it or was testing me, or just needed to hear himself say it out loud. I can't say if he was telling or asking me, though I was sure he didn't want me to weigh in, and no response could ever be appropriate anyway. It was not a conversation, unless a conversation is something you silently watch.

"It's okay," I had learned to say after years of hearing this particular declaration from people I loved, but it wasn't. And he wasn't listening to me anyway. I didn't brush his hair away as I said it, because it was not in his face; but in a movie, I would have done it anyway. I pretended my eyes weren't starting to brim over, and he pretended he didn't notice it. I told myself, "He will forget he said this tomorrow, after he feels a little better," but had no intention of saying that out loud. And I'm not sure whether he actually did stop treatment or not, because either way he was dead the next morning.

I think it's important to understand that woven into the feeling of power people often speak about when they describe ACT UP, there was powerlessness as well. Tucked between the strategy sessions and demonstrations and the connectedness and hilarity, there were the intimacies that only brought pain. We talk freely about the care teams, but the emptying effect of years of participating in them is much harder to explain, and I will try to say why. When we talk about affinity groups in ACT UP, we are not only talking about a sense of communal support. We are talking about failing each other as well. We are talking about the particular sort of quiet that envelops you when someone you've adopted as family tells you the fight is over. We are talking about moments like this one. Every story we tell that might be heroic is in the shadow of two where we wished we'd done more. It's one thing to refer to this cumulative burden in passing. It's another thing to talk about what it did to us, since very few of us actually understand that one. But it's there in every one of us, in the eyes, if you look closely enough. It's a hollowness.

After Steve took his life, I felt so lost, I decided to throw myself into Gran Fury. Two people in the collective who had known me before ACT UP urged me to join, but in the context of the collective I felt no particular support from them. Although some of the members were becoming pals, it was not really a place where people talked about themselves. Gran Fury nurtured a particular microclimate I never fully adapted to. It was collegial, but also somewhat aloof, perhaps even slightly professional. I quickly sensed it did not intend to function the way affinity groups did in ACT UP, or if it did, I would not be included. And so, having left the Silence = Death collective and feeling in need of a new support community, I immediately began to look elsewhere for environments more suited to my temperament and my politics.

By then I was already extremely close with a tight circle of activists who were all deeply involved in the inner workings of ACT UP, and they eventually became my affinity group. Originally it was called the Delta Queens, but

the group renamed itself the Costas, after the death of the first of our members, Costa Pappas, from the video collective DIVA TV. The Costas bonded by organizing a month of demonstrations throughout the South, which ACT UP referred to as the Freedom Ride, and as a consequence was involved in the formation of ACT UP Atlanta and South Carolina, and infiltrated the floor of the 1988 Republican Convention in New Orleans. Two of our members facilitated the Monday-night general meetings and became extremely high-profile as a result. The Costas was definitively feminist, which felt more comfortable to me than the male-inflected Actions and Coordinating Committees I served on, and a third of our members were women, including Terry McGovern and Emily Nahmanson, along with Maxine Wolfe, Heidi Dorow, Maria Maggenti, Marian Banzhaf, Ellen Neipris, Illith Rosenblum, and Polly Thistlethwaite, all of whom researched, wrote, edited and published *The Women and AIDS Handbook* (along with fourteen other women from the ACT UP Women's Caucus). The women in the Costas also spearheaded the effort that eventually forced the CDC to change the definition of AIDS to include the manifestations of HIV common to women, and were responsible, together or in various combinations, for the early Dyke Dinners, the ACT UP Women's Caucus, the ACT UP Women's Committee, the Dyke March, the Lesbian Avengers, the CDC Committee, and the ACT UP National Women's Committee. All of the men in the group were either directly or peripherally involved in the organization of the CDC actions, and we attended them, with some being arrested.

Costa members were involved in the formation of the Lesbian & Gay Activist History Project in ACT UP (which led to the *His & Herstory of Queer Activism* handbook and teach-in on the floor of ACT UP in 1989), and the lawsuit brought by Terry McGovern against the Social Security Administration on behalf of women living with AIDS. Anonymous Queers came out of this affinity group as well, a collective that published three broadsheets in print runs of fifteen thousand for the Pride March in New York City (one that

included a notorious screed we got into lots of trouble over, *I Hate Straights*, another that included work by the art collective fierce pussy, and contact materials for the political funerals The Marys affinity group was organizing), along with two poster and sticker interventions, embroidered patches, and ten thousand spell-casting necklace talismans with the phone number of the White House on it. Costa members also had a hand in the formation of Queer Nation, the Pink Panthers, and the ACT UP needle-exchange program in NYC. The Costas was one of the largest affinity groups, with up to twenty-six members ranging in age from twenty to forty-nine, and its relationships were cemented through the process of "living together" over many long road trips and caring for one another through arrests, illnesses, and losses. Among them were writers, artists, filmmakers, photographers, academics, archivists, servers, lawyers, doctors, professors, chefs, students, computer programmers, medical students, art directors, editors, librarians, and polit-ical organizers. Every one of us shared an orientation toward radical queer politics, and we were involved in the organization of martial arts and other self-defense training workshops. Within the group were four to five long-term couples, almost half our membership, and four of us eventually died. We traveled together, spent holidays together, gave one another work, men-tored one another, and broke the law together. If affinity groups in ACT UP were familial, those bonds were exaggerated within the Costas. In many ways, it was much more than a family. The Costas was like a small village.

I can't say whether a similar interdependence existed in other affinity groups, though I'm certain each one of them was meaningful with equal particularity. Regardless, every affinity group also reflected something quintessential about the organization of ACT UP, a cellular representation of its capabilities. The Marys were fearless. Wave Three was wonky. Action Tours was ingenious. The Costas were relentless. Affinity groups were com-ponent pieces of the ACT UP zeitgeist, unplanned but interlocking parts of an ever-evolving whole, the academic accounting for which is still largely

fragmented. It might take a lifetime of cross-referencing every entry in the ACT UP Oral History Project to comprehend the intricacies of this organic substructure, after which you'd still be left with the following realization: many politically useful stories will barely be marked in the margins of the popular tropes about ACT UP.

Affinity groups were so intrinsic to its overall disposition that ACT UP developed a constantly mutating symbiosis with them, basking in the impact of their unsanctioned accomplishments, such as barging onto the *CBS Evening News*, and sheathing Jesse Helms's house with a giant condom. The actions of these smaller constellations of individual activists became eloquent representations of ACT UP and were at least as powerful as the words of our media spokespeople, even when the results sent out ripples of discomfort, as did the throwing of a communion wafer on the floor of St. Patrick's Cathedral during the Stop the Church action. These sorts of provocations provided media outlets with compelling visuals. The media also used Gran Fury to provide visuals, but we were not an affinity group and, fairly early, ceased interfacing with ACT UP the way other affinity groups did, so not everyone in ACT UP imagined we were as profoundly attached to it as the media did. We started as an open committee and then became a closed collective that functioned solely through art world support—in effect, "leaving" ACT UP.

There are ways this trajectory parallels that of the T&D Committee, several members of which were invited into the research hierarchies of the FDA and the National Institutes of Health (NIH), and some of those key players eventually spun off to form the Treatment Action Group (TAG), with financial backing from outside ACT UP. There is also a primary similarity between Gran Fury and TAG in the ways the impact of our work has been sustained within the narrative of the AIDS crisis by observers of ACT UP, which I believe is worth reiterating: regardless of their obvious differences, art and science are two disciplines Western culture loves to claim in the name of human achievement, and have done so since the Enlightenment. They are productive,

literally, so ACT UP's contributions to art and science are easily vaunted in the name of social capital. Political resistance is not considered productive, even though it most certainly is, so ACT UP's radical organizing strategies—which included the affinity group structure—are less comfortably claimed.

The reason Gran Fury gives for our closure as a collective and our need to become independent from ACT UP is essentially the same one TAG would eventually give: we could not figure out how to continue our work within ACT UP. But when we severed functional ties with ACT UP, it was not considered a brain drain. It was when members of TAG left T&D, a drain that hobbled the organization. It could simply be that cultural production was not considered lifesaving and treatment activism was, though inside my bubble some might argue differently. Perhaps it was that we "left" several years earlier than TAG did, before ACT UP's identity became intermingled with its many treatment accomplishments.

During that first year, however, ACT UP's ability to turn out large, impassioned demonstrations was considered an accomplishment in itself, something *Silence = Death* played a part in. So our identity *was* tied to cultural production from the start, but it never factored as a strategic priority on the floor. In a way, the cultural production of the designers who contributed work to ACT UP was the first thing to be "professionalized" by the organization, and aside from the debate over copyrighting *Silence = Death*, no one seemed to mind it. The floor appreciated cultural production and always had things to say about it, but it never touched the level of strategic consideration that political decisions around AIDS treatments did. And so, as ACT UP evolved, its identity became increasingly tied to its treatment research capability, and by the time Gran Fury stopped seeking its approval, ACT UP had only a vague understanding of our practice, our membership, our relationship with ACT UP, and the distinguishing characteristics between our work product and that of the many other talented graphic artists and collectives that routinely turned up at demonstrations, exhibitions, and in the streets of New York.

The official art world sanction built into our origins may have further accounted for Gran Fury's seamless segue from any intraorganizational "professionalization" to our institutional professionalization. Here again, the closest parallel would be T&D and, later, TAG, whose members were eventually invited to sit alongside some of the most influential people in AIDS research and became extremely influential themselves, in a professional sense. By the time this aspect of professionalization had articulated itself within ACT UP, however, its implications would become a disorienting blow to the ACT UP identity.

Although it differed from my affinity group on every other account, Gran Fury was fully aligned with the Costas on one key question: the impact of HIV on women. Four of the collective's major works were devoted to it, and issues specifically relevant to women were integrated into seven others. Gran Fury's commitment to women's issues made it particularly easy for me to feel connected to the work we were doing, and to see it as connected to the work I was doing within my own affinity group. In the earliest moments of my joining the collective, in fact, the two directly overlapped.

I did not work on the Gran Fury women and AIDS poster for the ACT NOW Nine Days of Action, though Chris and I did work on fabricating the action's banners (which is how I met Maxine Wolfe). Mark and Don Moffett worked on the poster, and they sought approval from the Women's Caucus, many of whose members would become the Delta Queens. The specific action for that day, an intervention at Shea Stadium, had not yet been decided on when we began the poster, so it was meant to be a conceptual placeholder. The slogan, "Sexism Rears Its Unprotected Head," was illustrated by a visceral black-and-white photograph of an erect penis, and the tagline read, "Men: Use Condoms Or Beat It. AIDS Kills Women." Moffett was coy about the source material when he presented it to the rest of the collective, and there was a requisite amount of adolescent ribbing as

speculation ensued over which ACT UP member had served as the model and whether it was retouched. Gran Fury loved it, and was relieved to hear the committee had approved the poster. I later heard from my pals in the caucus that there had been parallel hilarity when they saw it. I accompanied my caucus friends when we wheat-pasted the posters, but they did not stay up very long: we didn't realize it at the time, but we were being followed around the neighborhood by someone who found them so offensive, they were peeling them off the walls before they even dried.

As a consequence, the "dick poster" did not get the airing we felt it deserved, so we recycled the text "Men Use Condoms Or Beat It" several times without the image, most notably as a large sticker funded by GMHC, and we proposed it as a printed shopping bag for a store with a strong queer and trans following, Patricia Fields. The image appeared in several books, but was used only one other time as agitprop with the full text of the poster, in *The Pope and the Penis*, one of a pair of murals for the Aperto 90 section of the XLIV Venice Biennale (figs. 12 and 13).

We had been nominated for inclusion in the Biennale by Linda Shearer at the Museum of Modern Art, and requested outdoor space in Venice during the exhibition, which the Whitney denied us. As a consequence, I did not want to participate in it, but was the only one who felt that way. Once we decided to accept, we were unanimous about wanting to discuss women and AIDS, reproductive autonomy, and condoms as prevention on the Vatican "home court." Since there was no outdoor space for us, we decided to mount a pair of "billboards" inside the gallery, juxtaposing the text and a color image of the penis against an image of the pope and a statement that New York's John Cardinal O'Connor delivered at the 1989 First Vatican Conference on AIDS: "The truth is not in condoms or clean needles. These are lies . . . good morality is good medicine." The image and the quote were flanked with our somewhat lengthy rebuttal:

SEXISM REARS ITS UNPROTECTED HEAD

MEN

AIDS KILLS

USE CONDOMS
OR BEAT IT

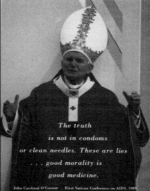

WOMEN

Figure 12. *The Pope And The Penis* (second panel), Gran Fury, 1990, ink on PVC, 96 × 216 in. For Aperto 90, XLIV Venice Biennale, Italy. Courtesy of The New York Public Library.

The Catholic Church has long taught men and women to loathe their bodies and to fear their sexual natures. This particular vision of good and evil continues to bring suffering and even death. By holding medicine hostage to Catholic morality and withholding information which allows people to protect themselves and each other from acquiring the Human Immunodeficiency Virus, the Church seeks to punish all who do not share in its peculiar version of human experience and makes clear its preference for living saints and dead sinners. It is immoral to practice bad medicine. It is bad medicine to deny people information that can help end the AIDS crisis. Condoms and clean needles save lives as surely as the earth revolves around the sun. AIDS is caused by a virus and a virus has no morals.

The truth is not in condoms or clean needles. These are lies . . . good morality is good medicine.

John Cardinal O'Connor · First Vatican Conference on AIDS, 1989

Figure 13. *The Pope And The Penis* (first panel), Gran Fury, 1990, ink on PVC, 96 × 216 in. For Aperto 90, XLIV Venice Biennale, Italy. Courtesy of The New York Public Library.

The Catholic Church has long taught men and women to loathe their bodies and to fear their sexual natures. This particular vision of good and evil continues to bring suffering and even death. By holding medicine hostage to Catholic morality and withholding information which allows people to protect themselves and each other from acquiring the Human Immunodeficiency Virus, the Church seeks to punish all who do not share its peculiar version of human experience and makes clear its preference for living saints and dead sinners. It is immoral to practice bad medicine. It is bad medicine to deny people information that can help end the AIDS crisis. Condoms and clean needles save lives as surely as the earth revolves around the sun. AIDS is caused by a virus and a virus has no morals.

It is unclear how the event's director of visual arts, Giovanni Carandente, discovered the content of our piece in advance, but a complaint was leaked to the Aperto selection committee that the work might be blasphemous. The story I heard was that he was tipped off by someone from the United States Information Agency, established by Dwight D. Eisenhower in 1953 to promote cultural propaganda in an effort to influence foreign publics on matters of American national interest. Of course, we were unable to confirm that, or to establish how the committee could have known about the content without access to some level of inside information. Nonetheless, the work was seized at customs, forcing the collective to declare what had happened in a handwritten note on the blank walls of our exhibition space, which in turn caused other artists to say they would withdraw their works. Gran Fury members at the installation were threatened with imprisonment pending an assessment by local magistrates, who eventually deemed the work permissible. The Vatican reportedly considered asking the Italian Parliament to have the billboards removed, but by then the entire text had been circulated within national media reporting, transforming a work I feared would be shrouded by the insularity of an international art event into arguably one of our most public projects.

In spite of the publicity generated by this iteration and a continued familiarity with this project in certain cultural settings, neither version of *Men Use*

Condoms Or Beat It is as recognizable as some of the other Gran Fury work product. It is somewhat pointless to speculate whether this is a function of the sexually candid text, the religious references intrinsic to condom use, and the erect phallus, or it simply was not as strong as some of our other work. I think it would be a mistake, however, not to also consider the terrain that conversations about women and AIDS have occupied since the beginning, and it is easy to lose sight of the fact that heterosexual transmission was commonly contested in America at the time *Men Use Condoms Or Beat It* was crafted. In fact, a full year after we designed the poster, the *New York Times* displayed its blistering ignorance on the subject in its 1989 op-ed *Why Make AIDS Worse Than It Is?* which maintained that the only straight people at risk of contracting HIV were the sex partners of drug users and bisexual men.

It also bears mentioning that the threat of litigation had had a historical influence on American scientific research protocols ever since the U.S. Senate passed the Kefauver-Harris Amendment in 1962 in response to birth defects associated with Thalidomide use overseas. The brutal fact is, it was less politically and economically risky to deploy misogynist assumptions about women as vectors of transmission, or to shift concern, through the insidious semiotics constructed around "innocent victims," to children with HIV. It was also more comfortable to shroud racial biases toward affected individuals beneath institutionalized colonial "concern" for women with HIV in other regions of the globe, than to rub salt in the wounds of race in America and risk opening a Pandora's box of having to care for our own carefully crafted and routinely ignored underclasses.

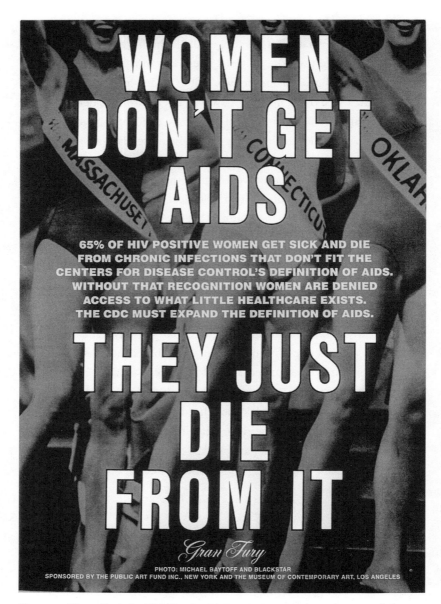

Figure 14. *Women Don't Get AIDS, They Just Die From It*, Gran Fury, 1991, bus–stop shelter sign, ink on acetate, 70 × 47 in. Public Art Fund, New York. The Museum of Contemporary Art, Los Angeles. Courtesy of The New York Public Library.

Women Don't Get AIDS, They Just Die from It

That HIV would impact women was clear from the start. The extent to which we have allowed ourselves to care about that is another matter. By 1987 AIDS was already the number-one cause of death for women between the ages of twenty-four and twenty-nine in New York City. Yet the U.S. agency tasked with epidemiological surveillance, the CDC, would not include the manifestations of immunosuppression common to women in their definition of AIDS for another six years—*twelve years into the pandemic*—even though clinical drug trials, public health standards of care, and American AIDS policy was based on these guidelines and the World Health Organization drew on CDC epidemiology for its own definition. The general exclusion of this startling fact reveals a giant gap in the dominant storytelling about the early years of the pandemic, which prefers to long-jump over it to the protease inhibitors that have come to symbolize the successes of AIDS activism.

That media conversations about AIDS were bypassing gender was of immediate concern to activists, especially those who came out of the women's health movement of the seventies. When the ACT UP Women's Caucus (which included all of the women in my affinity group, the Costas) took on the job of unraveling the specifics, however, they quickly uncovered a lethal chain of effects no one had seemed to notice before. Not only were women excluded from clinical drug trials, which we already knew, but the fact that

surveillance data on women were never included in the CDC definition of AIDS meant many women had AIDS without ever thinking to look for it, and their doctors and caseworkers never considered it a possibility either, leading to a lack of routine testing for the physiological markers of immunosuppression clinicians were accustomed to following. And when they did discover it, differences in the treatment protocols for women had yet to be established. As a result, women were not simply dying of AIDS but were doing it undiagnosed, six times faster than men, without access to appropriate treatment or benefits, and long before they could develop the opportunistic infections that fell within the original case definition constructed through cohort studies of gay and bisexual men.

After a year of exhaustive research, the Women's Caucus organized a 1989 teach-in based on the comprehensive "ACT UP Women's Caucus Women and AIDS Handbook" (later adapted and published as *Women, AIDS, and Activism*), which members had compiled and then circulated in an edition of 1,500 copies to the network of activists, health professionals, clinicians, journalists, policy makers, and organizers doing work around women nationally and internationally. The handbook not only laid out the basics of transmission, diagnosis, and access to clinical trials but did so through detailed analyses of Census Bureau data, provided a historical basis for understanding the treatment of women by the medical establishment, and analyzed how the politics of the feminist health movement might apply to AIDS activism. It also mapped out relevant epidemiological issues, offered a critique of the case definition, gave an overview of life expectancies, covered the specific ways AIDS Related Complex (ARC) applied to women, and listed the major gynecological and twelve other infections presenting clinically in women with HIV immunosuppression.

The handbook served as a basis for the detailed "Research and Treatment Agenda for Women with HIV Infection" and for a backgrounder for the first major action against the CDC that included critiques and analyses of CDC

and service providers, all of whom got copies of the treatment agenda and eventually stood in support of the three simple activist demands: change the CDC definition, guarantee benefits, and include women in research protocols. The committee also met with Gary Noble of the CDC and his staff, the transcript of which meeting was widely circulated, and began a national endorsement campaign that culminated in a full-page ad in the *New York Times* with three hundred signatories. Representative Ted Weiss held a House hearing, and Deborah Glick passed a resolution in the New York State Assembly in support of the demands that was used as a model for progressive legislators around the country to pass in their own states and municipalities. Firm coalitions were formed with a network of organizations focused on prison populations and women with AIDS, including ACE OUT (AIDS Counseling and Education Outside) and Lifeforce. It was a dogged, ethical, intelligent, integrated, resourceful, relentless, and comprehensive, internationally coordinated plan of attack, during which the CDC attempted four inadequate changes to the definition, all of which were strenuously resisted. In 1993 they finally proposed a change that was acceptable.

Throughout this period my entire affinity group was involved in the CDC campaign, and I was on the organizing committee for the CDC action in New York, designed its posters and stickers with Richard Deagle, and was part of my affinity group crew that organized the logistics, fabrication, and rooftop drop of a three-story painted banner. Everyone I knew was absorbed in the issue, and it went on for years. I was not the only member of Gran Fury concerned with women and AIDS, so I fed updates to the collective. In 1991 we were presented with the opportunity to create a project for the Museum of Contemporary Art, Los Angeles, and the Public Art Fund in New York, and decided to add to the pressure on the CDC with bus-stop shelter ads in two sets of communities directly impacted, greater LA and the boroughs of NYC. The poster *Women Don't Get AIDS, They Just Die From It* is not without problems, but it's a project I'm also proud of.

It was customary for the collective to have extensive debates over how to best reduce complex issues into advertising vernacular. It could be very tricky to hammer out the exact tone of a text, and we sometimes spent weeks on it, arguing over every inflection in every phrase. Occasionally, however, a tagline would land quickly, and this was one of those cases. It came so easily, in fact, that it slipped out of the mouth of one Fury member as a snarky aside while the rest of us were mulling over another phrase. I was so startled by its laser sharpness, my attention was torn away from my notebook. The whole room was jolted into the sort of clamor of recognition that signaled one of our rare moments of unanimity, and no further modification of that line was even entertained. The expository text took a fair amount of time, and although it is a fairly surefooted synopsis of the treatment and policy issues unearthed by the Women's Caucus, it might have sacrificed clarity for brevity: "65% of HIV positive women get sick and die from chronic infections that don't fit the Centers for Disease Control's definition of AIDS. Without that recognition women are denied access to what little healthcare exists. The CDC must expand the definition of AIDS."

The image, on the other hand, did not come easily at all, and it caused rifts that would prove painful and have deep ramifications for the collective. When crafting messages for an image culture, there are moments when words are elusive, and others when pinpointing a single image to represent a complex set of ideas can prove challenging. How do you depict the gendering of biomedical research for members of a public that is completely detached from the social, legal, political, and economic intricacies of gender in scientific research? In the case of *Women Don't Get AIDS*, I believe the text is infinitely more resolved than the image is.

I'm not sure who suggested it or how we actually came to agree on the beauty pageant image, but by my recollection the discussion extended over several weeks. I agreed it would create ironic tension with the tagline used to explain the issue. I was less convinced than other members of the

collective that the image of a beauty pageant was a reference with intergen-erational resonance, or that it remained familiar enough within our cultural vernacular as a signifier of contested turf for its irony to be clear to audiences less versed in earlier feminist critiques. It was meant to serve as a coded reference to the ways women are deployed as cultural symbols while remaining invisible. The decision to use such an image did not approach the "Aha!" moment the tag line produced, but it was not as controversial as the particular beauty pageant image we finally zeroed in on.

In a subsequent meeting, we reviewed a sampling of chromes that had been assembled from an image archive we had connections to. There was a half sleeve of slide options that had made the first edit, and out of those, one in particular appeared compelling to a majority within the collective. It depicted a manic tension and an undercurrent of expectation, which seemed to trigger the sort of political discomfort we were hoping for. It also triggered a level of political discomfort we were *not* looking for. All of the women in this image were white.

The image did capture some of the intricacies of the story we were trying to tell, except for the intricacies of race, which in the case of representation, identity, and access to health care, was a major caveat. We debated it, somewhat hotly even for Gran Fury, and there was no one who did not understand why this particular image was extremely flawed. Only two of us were strongly opposed to the image, however. Robert Vazquez-Pacheco, the only person of color in the collective, was one of them, and I was the other. He insisted that with the large number of women of color in the pageant world, there had to be alternatives. The sleeve of slides in front of us did, in fact, include images with women of color, and during the meeting we combed through them again. Robert and I strongly pushed for selecting one of those, but others pushed back. If you have any familiarity with the process of photo editing for advertising or publishing, you know that the exact squint of an eye, curl of a lip, gesture of a hand, or tilt of a head can radically change the

effect an image has within the public spaces it is designed to appear in, and roomfuls of people consult over the emotional signals within every image that reaches our shared spaces. In fact, it's not uncommon for agencies and editors to stage a reshoot if every single aspect of an image is not perfect. On the grounds of the story that the women's faces in this image told alone, certain members made a forceful and unrelenting case.

Gran Fury had a collective process that could be, well, furious. Depending on where you stood in this particular debate, I would characterize this as one of those moments. The argument became heated, and it centered on whether women of color who were waiting for a bus would identify enough with the image to think they were included in the conversation. Robert and I felt that problem far outweighed any aesthetic considerations at play, and since we could not figure out how to mention the demographic complexities in our streamlined text, we thought it would be a huge problem if the image did not address the question of race. But the members who loved the image dug in their heels. As a concession, I suggested we recolor the image to obfuscate the skin color of the women depicted, something the Silence = Death collective had discussed when considering the use of a tattooed body for our first poster. But I wish I hadn't, because that is what we ended up doing, and otherwise, we might have chosen another image. Cropping their heads and toning the poster purple might have "masked" the obvious flaw in the image selection for an audience who came cold to it, but the tensions surrounding its choice remained exposed in the collective.

Gran Fury moved on from the conflict, but Robert could not. During the debate one member of the collective insisted, "If I were a woman of color, I would understand this poster." The comment led Robert to quit the collective. I'm not certain anyone other than the two of us remembers the details of this conflict; if they do, I have not heard it discussed. But as this controversy played out in Gran Fury, the question of race and women with AIDS began to affect my affinity group in ACT UP as well, in ways that would quickly eclipse it.

Women Don't Get AIDS, They Just Die from It

In the previous chapter I draw parallels between the institutional profes-
sionalization of the work products of both the Treatment Action Group (TAG)
and Gran Fury. I also map some of the ways affinity groups within ACT UP
related to its sense of capability, which, while productive and defining of our
collective identity, may also have inadvertently Balkanized our experiences,
most notably in the areas of caregiving and political strategy. I point this out
here because the most extreme example of this problem may have been the
clash over the moratorium on meetings surrounding the CDC campaign and
the 076 AZT trial, which is frequently painted as having fallen along a gen-
der divide and which directly involved members of the Costas and T&D. The
complexities of this debacle are frequently papered over by generalizations,
which at the time also greatly contributed to inflaming the situation. I will
explain it in broad strokes here; more granular accounts can be found in
Moving Politics, by Deborah B. Gould.

In the wake of the Kefauver-Harris Amendment, female participants in
American AIDS research protocols were practically nonexistent, and preg-
nant women and women of childbearing age were completely excluded. Be
that as it may, 1991 saw the beginning of recruitment for a new treatment
protocol, the 076 trial, conducted through the ACTG, which set out to prove
AZT's efficacy in preventing perinatal transmission of HIV. For statistical
reasons, it was an unusually large trial (fifty-nine sites) and included a more
representative sampling of women of color than most other trials at the time.
Unfortunately, the trial was also shot through with ethical sticking points,
among them that some HIV-positive women and infants would receive a
placebo and thus would receive no potentially beneficial treatment; that the
overall toxicities of AZT were still unclear; that infants who were not HIV-
positive would be receiving a drug that they did not need and that had
acknowledged toxicity in adults; that participants were not guaranteed a
continuation of treatment once the study concluded; that the trial treated
the mothers as procreative vessels and bypassed their own medical needs;

that the informed-consent clauses excluded factors such as a risk of vaginal tumors that had turned up in animal studies; and that without intervention a majority of children born of HIV-positive women are born HIV-negative.

Regardless of these objections 076 continued, and the results were promising enough to be published early, laying the groundwork for a shift of emphasis away from the waning marketplace for AZT in America toward a newly implied viability in Africa. Although this transition alone is not without political meaning, 076 might not have rocked the activist community had it not also put ACT UP members from several women's committees, caucuses, and affinity groups (some of them Costas) on a collision course with T&D, which had just fought for and won concessions within the AIDS research community, some of which took the form of the Community Constituency Group (CCG) at the ACTG. As a result of the timing of these parallel campaigns, a set of strategy conflicts erupted over how to pressure members of the research community on women's issues while other ACT UP activists were directly involved with them. One conflict was triggered by a date overlap between the Women and HIV Conference and a meeting with members of T&D, Anthony Fauci, and a key National Cancer Institute biostatistician. Another was caused by the disruption of a hearing on 076 by a handful of activists working on women's issues, after which T&D emphasized the resulting accusations of racism by some people of color on the CCG, a conflict exacerbated on both sides through open letters to a local queer publication and on the floor of ACT UP in the form of open missives and responses filled with brutal invective. A third dispute raged over T&D's exploration of pharmaceutical funding for community treatment research through amfAR. But the straw that broke the camel's back was a proposed six-month moratorium on meetings with government officials, which was characterized as an across-the-board proposal even though it focused solely on meetings about women and AIDS and applied only to claiming "official" ACT UP sanction during those meetings. It appeared to suggest that all meetings cease, placing lives

Women Don't Get AIDS, They Just Die from It

in the balance. Although the proposal was more moderate than that interpretation, it still came to be voted down, but not before irreparable damage had been done over strategic differences highlighted in the debate—which might have been worked through had the alarms of betrayal not been sounded in the process—causing key members of T&D to leave ACT UP and form TAG.

I point this out here because the profound influence of women on every aspect of the AIDS activist movement has been distorted beyond recognition by a misogynist trope that came out of these conflicts: that the demise of ACT UP was somehow situated in strategic differences between men and women and, by further implication, the divide between seropositive and seronegative activists—an analysis that continues to be destructive when you consider the importance of women in this social history, and that is facile, since the most superficial research refutes it. ACT UP NY is far from dead. It still meets every Monday, as it has since 1987.

If there was a divide in ACT UP that contributed to a flagging activism, as opposed to a flagging interest in its story, it was not along gender lines or serostatus. It entered the room on each of our coattails as we passed through its doors. The divide existed over where we put our best hope, through critiques of the system or participation in it, and there were men and women, people of color and white people, and HIV-positive and HIV-negative people on either side. The strategic differences cannot be constructed along lines of gender or serostatus with any accuracy. I knew women involved in the CDC campaign who had or went on to have healthy careers inside the Beltway, and some of my closest male friends in my affinity group who died of HIV/AIDS themselves supported the moratorium and made the CDC definition their final days' work.

What is missing from the dominant HIV/AIDS narrative is plain enough on the ground if you know where to look, but can be best understood from fifty thousand feet up. The backstories of the three Gran Fury projects about gender discussed in this and the previous chapter (*Sexism Rears Its Unpro-*

tected Head, *Pope and the Penis*, and *Women Don't Get Aids*) hint at the sort of critical counterweight that becomes increasingly essential to understanding this time and place. Even though they are rarely mentioned in the media storyline, women and AIDS in America were far from a sidebar in the activist movement, as can be seen by a simple analysis of the five-year timeline between the 076 trial and the development of protease inhibitors. It serves no political purpose whatsoever for power structures to highlight any larger connective tissues at work here. From an activist perspective, however, the story of HIV/AIDS has no political purpose without doing so.

This set of stories illustrates how politically useful tales such as these are in the context of comprehensive analyses of HIV/AIDS by a younger generation of activists, archivists, and social historians doing work on intersectional critiques, and it would be criminal not to unearth them while the generation who was there can still point to where the remains are buried. So many critical sagas are hidden beneath the dominant narrative that an AIDS historiography begins, by necessity, with an archaeological dig.

And I believe it's worth considering that the matrix of what happened between TAG and ACT UP may have been anticipated a few years earlier by the trajectory of Gran Fury within the art world, which foreshadowed how AIDS activism might eventually become absorbed by the institutions it critiqued.

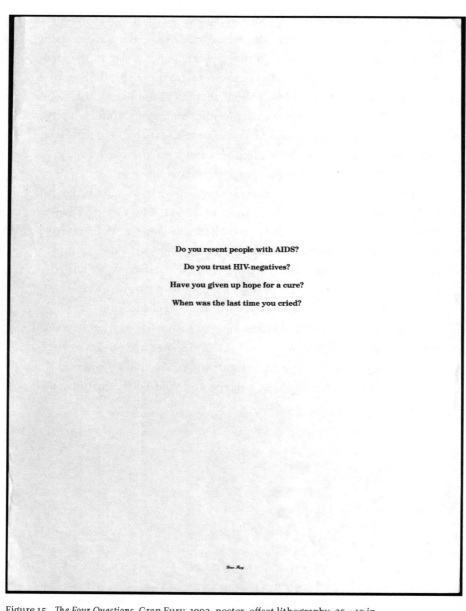

Figure 15. *The Four Questions*, Gran Fury, 1993, poster, offset lithography, 25 × 19 in.

The Four Questions, Part 1

The Viral Divide

> Do you resent people with AIDS?
> Do you trust HIV-negatives?
> Have you given up hope for a cure?
> When was the last time you cried?
>
> Gran Fury

There are times when articulating political complexities may mean bypass-
ing political questions in favor of more intimate ones, to help give a project
shape. That is precisely what *The Four Questions* does. I can see how the per-
sonal tone of this work might be read as a signifier of a waning sure-footed-
ness, but I think the opposite is true. I consider this one of the most incisive
works to come out of Gran Fury.

Even though it was technically penultimate, from the perspective of
symmetry this work neatly bookends *Let The Record Show* as a portrait of the
collective in flux, only this time in dissolution rather than formation. As
such it tells a story that may surpass the tale of our genesis in terms of its
political uses, because it discloses a second crisis brewing within the larger
one, one that has grown in relevance over time, and it holds a mirror to a
community during a critical turning point in a way that is uncharacteristi-
cally bald for Gran Fury. The *Four Questions* poster intentionally sidestepped

its own artifice without overlooking it in an attempt to articulate an issue that has attached itself to almost every conversation about HIV/AIDS since the poster's making. It also maps personal conflicts for the collective, making it retrospectively revealing. But none of this explains why I am telling this story last: I consider *The Four Questions* the only Gran Fury work that was simultaneously momentary *and* prescient.

I would say it is a work that was only fully claimed in hindsight, however, since half of our members had already left the collective when we made it, which led us to a divergent awareness of it. In fact, some of us had never actually seen it in person until we were assembling our thoughts for the retrospective of our work at New York University's 80WSE Gallery in 2012. Our first meeting to discuss what might be in the show was held in the exhibition spaces. We set folding chairs in a circle in the front gallery, and as suits our practice, there was a fair amount of talking over one another and jockeying to be heard. While we were tossing around ideas, somebody asked, "If we were to mount one of the works in the streets of New York now, which one would still be relevant?" There were really only two candidates, but the space was so echoey, the exchange seemed to have tremendous life. Most everyone settled on *Welcome To America, the only industrialized country besides South Africa without national healthcare,* with the obvious caveat that South Africa now has a national health plan.

"I agree, that piece really holds up," I said. "But the only work that is still one hundred percent true, with no alteration at all, is *The Four Questions*." You could've heard a pin drop. This poster is something of a third rail in Gran Fury. It was the first project we tackled after Gran Fury decided to stop working together as a collective, and it is closely associated with Mark Simpson, who died soon after we made it.

The generally agreed-upon reason Gran Fury gives as the explanation for disbanding is that the issues were becoming too complex for us to reduce to advertising shorthand. I disagree with that assessment. The issues were always

complex. I believe it more accurate to say that as our generation of activists became increasingly politicized, we were made more *aware* of those complexities, and Gran Fury became increasingly apprehensive about being reductive. Nonetheless, it is possible to tell complex stories concisely. *Silence = Death* articulates layers of complexity in a few sentences. But complexities have a way of rattling nerves, particularly if you're uncomfortable with your own fallibility. Since that is not a particular frailty of mine, I was opposed to concluding our work together. So was Mark, who had always felt as compelled as I was by the need to tackle HIV/AIDS in public spaces, so much so he'd lobbied to be in the Silence = Death collective after we formed and was the first person in the corner of the room when I assembled the New Museum window committee in ACT UP. He was angry, on many levels, when the collective folded.

Mark was every bit as goyish as other members of Gran Fury, but the circle of friends we shared before ACT UP formed was not, and that group was his adopted family. Perhaps as compensation for a remoteness he'd experienced during his own childhood, he'd chosen an alternative family in which intimacy and connectedness were requisite, effectively becoming a New York Jew in the process. For better or worse, Mark had mistakenly transferred some of these expectations to Gran Fury. And although Gran Fury did not act politically in ways affinity groups customarily do (specifically, through civil disobedience arrests, a primary basis of the affinity group bond), he was consistently surrounded by the attendant intimacies of this particular bond everywhere else in ACT UP, and I believe he transferred some of that to the collective as well. To say he felt let down by Gran Fury as individuals and as a collective doesn't touch on how enraged he became toward the end of his life. And so, in spite of being extremely popular within the collective, he was also responsible in some unnamed ways for tensions that were the result of his unmet expectations, which became more exaggerated as his health declined.

Since we shared the same history, my allegiances to Mark actually solidified during this period, and never more so than while making this poster.

There are some in the collective who consider *The Four Questions* Mark's poster, but that is likely because they were not involved in its making and are unaware of how it came to be or of the reasons that I've always felt more deeply connected to it than to any previous Gran Fury work. Mark was not the only one driven by anger and sadness over what was perhaps *the* overriding question of affinity within ACT UP at that time, one I was on the front lines of during the CDC campaign because several members of my affinity group became embroiled in the 076 trial controversy: the question of the growing viral divide.

No lawyer worth their fee would ever ask a question in court without already knowing the answer. So, when Ronald Reagan proclaimed, "Mr. Gorbachev, tear down this wall," I assumed the dismantling of the Berlin Wall was at least a handshake deal, if not a certainty. Reagan's Brandenburg Gate speech was precisely the sort of heroic gesture he loved, and it obfuscated what was plain to see if you were immune to the spell of his Hollywood version of Beltway stagecraft. Once the wall came down, not only would the Soviets be free to more openly indulge in something political insiders had already been enjoying there for decades, the advantages of capital, but we could be free as well to do more surveilling and become more authoritarian, which is exactly what happened.

That Reagan's admonishment of Gorbachev was sandwiched in the weeks between ACT UP New York's first demonstration against his administration in D.C. and his executive order for the first and highly dubious Presidential Commission on the HIV Epidemic might have meaning to me only because of how focused I was on him surrounding the creation of *AIDSGATE*. Soviet scholars will no doubt be rankled by my free association linking *glasnost* and Executive Order 12601, which created the commission, Reagan's *glasnost* with HIV. The cow was out of the barn by the time Reagan paid any attention to AIDS, as it was when the Soviets finally "tore down" the Wall,

meaning both acts of *public openness* might be more accurately described by an alternative translation of this word, *publicity*. But the translation is not where I am taking my license.

When I was helping my dad pack his house before going into assisted living, I found two portraits of his mother, Lena, that made a startling side-by-side comparison. Together they depicted her journey from Russia, alone, through Canada to Philadelphia. In the first one she was a girl, still living in her homeland and looking collected, for a studio portrait, in a good dress. In the other, she was in the New World, wearing a day dress under a mean cardigan, her hair in disarray, with the weariness I had always known her for already creeping across her face. It was as if she had become my grandmother on that short trip, decades before I was even an idea. It is a picture of a childhood foreclosed upon.

Whenever I tell someone Lena left Russia just before the Revolution, they naturally assume she was fleeing communism. But Lena fell to the left of Karl Marx. She fled to live another day, and so she never said anything bad about communism, yet had no interest at all in going back, which any Jew would understand. Unfortunately for me, she was dead by the time I'd finally made my first trip there for Condé Nast, because I never imagined how much I'd need to talk to her about it.

Technically the Wall was down by that point, but it really wasn't. St. Petersburg was still Leningrad, and we still had to go through Checkpoint Charlie to fly there from East Berlin on a ruined Aeroflot airliner, the insides of which were entirely painted over in silver park paint, including the upholstery. Our production people were all "ex"-KGB, which meant they were watching us at least as much as showing us around, and pretty much all there was to eat were carrots, beets, smoked salmon, eggs, and brown bread, and a chicken stew that cost hundreds of dollars. There were long lines for shoes, and the ruble had turned into Monopoly money, so we traded cigarettes and pantyhose for services, as if it were postwar Berlin. Leningrad was drained of

all life in the nagging dusk of the midnight sun, and it looked as hollowed out as a de Chirico painting. But I still had the epiphany reserved for people on their first visit to their homeland. I had never considered an entire country could be as sad and suspicious and self-deprecating as Lena, or share her suppressed curiosity. She was everywhere, in the unresolved sun that set without setting, in every pothole and every knotted face, in the animal realities of a giardia-infested water system, in the ethnic wildness of the Siberian marble colors, in the surreal gay cruising "promenade" during intermission at the Kirov, in the "inferior" Matisses at the Hermitage (read: off the international art market), and in the unearthly stench of those cigarettes with the cardboard filters. I had always known how deeply Russian Lena was. There was no getting around that. I just never really got what it meant. She was everywhere I turned, and so in the midst of all the high-fiving by the State Department and the nonstop wonderment of the international press corps, I had a reunification all my own on that trip: with my past, with my ancestors, and with the woman I had loved without ever really understanding.

But at the same moment the world was witnessing the dismantling of the wall that defined my childhood—literally, with street merchants renting chisel-point hammers so you could chip off your very own piece—another wall, one that would soon span the globe, was fixed in my sights. I could not take my eyes off it, because this wall was going up, and if anyone else noticed, they seemed not to be bothered by it. This wall appeared to be acceptable, in fact. It was a wall I didn't see coming, because I'd actually backed into it, and there was no scaling it or flying over it. It came in the night and was constructed by morning; silent as air, dense as stone, and by the time I even realized it was there, I was completely surrounded by it.

That there is a wall between those of us who are HIV-positive and HIV-negative should be no mystery. It has been there since the beginning, and if you think about it, it was pretty much destined to be. Not because intolerance likes to draw fiefdoms, which were certainly mapped out from the very

first moments we became aware of HIV. It's that this particular wall predates every one of those prejudices, societies in fact. It's so primal, it's part of our internal architecture and doesn't owe its foundation to HIV. We are born with it. It's the wall that holds our mortality out, the wall between the sick and the well, between the living and the dying. That we rarely talk about it is a testament to its impenetrability. That it has solidified in spite of the pharmaceutical interventions that should've only chipped away at it is more criminal than the docket of HIV nondisclosure cases we pretend have nothing to do with it. It is an invisible wall as rigid as the Iron Curtain, and while millions have scrambled across it, it is hardly ever by choice.

In the early years, while modes of HIV transmission were still being debated, most gay men in New York assumed they had been exposed to it. In the activist community, we knew everyone was at risk, and that knowledge allowed for solidarity, at least in the circles I traveled in. It was unconscionable to draw a line around any one of us, since that line was exceedingly permeable. After HIV was isolated and testing protocols developed, however, boundaries began to be fortified around the real and imagined distinctions between seropositive and seronegative, HIV positivity and ARC, ARC and AIDS. Fair enough that the language around the science of HIV was in flux, but its rhetorical implications for our social affinities were crystallizing, even within activist circles. It did not take long for the primary tenet of the Denver Principles—that the interests of People With AIDS (PWAs) should be self-determined—to inadvertently solidify in the form of hierarchies that impacted the commonality that led to ACT UP in the first place: the idea that each and every one of us is living with HIV. So I watched in panic as the wall went up all around me, and although it started out as thin as a cellular membrane, it quickly toughened to sinew through constant exercise, on both sides of the viral divide.

Neither one of us was ready to dissolve the collective, but where Mark may have assumed Gran Fury would be part of his support mechanism and was

surprised when it wasn't, I had no such expectations. I had found my political and emotional support in my affinity group, outside Gran Fury. Much of my work there centered on AIDS and radical queer resistance, and we had already produced a number of public projects, through Anonymous Queers, that explored the growing rage of PWAs over what was perceived to be the flagging commitment of HIV-negative activists. On these accounts, I thought Gran Fury had been looking in the wrong direction for a while, and the idea that there was no way to resolve the dilemma of our own activist burnout rang hollow for me. I can only imagine how it felt to Mark, coupled with the general sense of abandonment he felt as his health was failing. Others had care teams coalescing around them in ACT UP. Gran Fury scattered when Mark needed it most.

We didn't have much cause to talk about it until after we'd disbanded, so I'm not sure the extent to which Mark harbored anger with other members of Gran Fury while we were still working together, though it would hardly have been out of character. I did get pulled into an unrequited crush he had on another member that he felt quite wounded by. He also had his jealousies. And I *know* he found me to be a pain in the ass. But when his oldest friend in the collective declined to be his care person as he got sicker, it became deep-down ugly, and there was no place to hide, at least not for me. As someone who had known both of them before ACT UP, I was exposed to Mark's unrelenting rages about it. I agreed it was coldhearted, though to be someone's care person was not a thing to take lightly. In fact, it was a tremendous ask. Back then, illnesses could be packed with unforeseen horrors, round-the-clock care, and battles with agencies, doctors, and families. That Mark expected this support was a fairly fraught assumption, and he was certainly aware of the intimacy it entailed, but that only made the denial of his request more insulting. Mark was asking for help, but he imagined it to be a rhetorical question, and there was hell to pay when the answer was no. Within my

circle of friends Mark made every one of us choose sides. For me it also became the elephant in the room in Gran Fury.

Further compounding this denial of support was a sense of betrayal rubbed raw by the belief that the collective was his last chance for an art career. Our work as a collective had in fact opened doors, which proved productive for some of us, but less so for Mark, who was admired by the same influential people but somehow remained a kind of outsider. Of course, that was Mark in a nutshell. Before Gran Fury he had never managed to find his audience. He had been included in shows at noteworthy galleries, but nothing seemed to come of them. He was out of step, he said, and that was hard to refute. His work was unlike what people were looking for, even in the height of a painting moment. It was deeply sad, but sad from a distance. His paintings were brimming with *Weltschmerz* and laden with urban mysticism, abandoned skyways and underpasses, snow-swirled factory districts and lonesome harbors, but it was hard to locate him in them. His surfaces were thin and lacked the expressionistic tooth other painters were successfully proposing. It was equal parts WPA and Jack Smith, a very peculiar sort of queer Social Realism, butch and femme at the same time, all of which was true to Mark, but he never made sense of it for the viewer. He glazed the surfaces in luster dusts, so everything glistened, like mica in the early sidewalks of New York, or eye shadow. He laughed with me about the glazes—we even painted my dining room wall with them after Don died—but not everyone knew what to make of it. I did, but I also knew that moment had passed in the early seventies, when I was drawing with mascara and surfacing my sculptures with white opalescent lipstick. Mark was out of step, placing him either ten years ahead or behind. It's a funny thing, to refer to an artist's voice when the rest of us just open our mouths to speak, but Mark had trouble finding his voice before Gran Fury. On every imaginable level, he took it hard when the collective stopped working together.

I was sensitive to the abandonment Mark felt, and although I might be the only one who saw it this way, I found it hard not to think of our dissolution as reflecting a degree of seronegative privilege. As one of the few Gran Fury members still active in ACT UP, I saw similar tensions erupting there as well, albeit conversely, in the dramatic spinning off of members of the Treatment and Data Committee to form TAG. These tensions were staged around questions of gender and race, but they played out as a disagreement over strategic priorities across the viral divide. The levels of distrust had escalated to personal attacks, all of it happening against a backdrop of highly visible members of the community dying and political funeral actions that were reaching a crescendo. It was an extremely pitched moment. Fairly or not, some HIV-positive activists had come to mistrust the activism of HIV-negatives, believing they had a lower threshold for the depth of the commitment demanded by AIDS activism. And fairly or not, betrayal was felt at the first sign of personal letdown or political disagreement. There were a million reasons one might suspend one's activism, but some came to believe there was a "walk away" clause inherent to seronegativity that People With AIDS did not have. In spite of the fact that negatives were seroconverting every minute of every day and People With AIDS also walked away from activism, this imagined division grew in urgency as the death toll mounted, and it factored heavily into a painful series of overall rifts.

What was happening within Gran Fury certainly did not come close to replicating the set of tensions around the viral divide that existed in the activist community, but Mark definitely felt abandonment along these lines, and I understood it. Eventually, with a decreased number of commissions to structure our thoughts around, a string of projects we considered failures, and an unsuccessful attempt to initiate a text-heavy HIV prevention project, Gran Fury embarked on a series of frustrating discussions about folding the collective. But we never actually decided to dissolve. We didn't have to. Half

of our membership just stopped attending meetings. It wasn't a walkout or anything as dramatic as that. It is possible that people had been discussing it among themselves for a while and I simply sat outside those discussions, or perhaps it was never discussed privately at all. I did not agree with disbandment, nor did I feel we had run out of things to say about HIV. Although it would've been extremely out of character to do so, I found it odd that Gran Fury never considered our own dissolution in the context of the split playing out in ACT UP. Perhaps that's why the viral divide was the first thing I wanted to talk about after we did break up.

I wanted to continue working together, and so did Mark, Loring McAlpin, and for a while, John Lindell. Although Richard Elovich's time was mostly devoted to a pilot needle-exchange program he had spearheaded, he occasionally joined us and let us meet in his apartment even when he couldn't make it. During our first meeting, I suggested it would be productive to use the dissolution of Gran Fury as an opportunity to break from our signature voice and explore the rawness and emotionality elsewhere in the community around the viral divide. I'd been experimenting with this voice in Anonymous Queers, and suggested inviting its cofounder to work with us, another person from my same circle of friends before ACT UP, Vincent Gagliostro. Anonymous Queers had a largely text-based practice, and experience with the long form Gran Fury had unsuccessfully attempted. Our way of working was less hierarchal than Gran Fury's, and it centered on cross-edited broadsheets that allowed voices in conflict to be contained within the same project. Our work was completely unbridled as a result, but it came out of interpretations of both cultural production and political affinity different from Gran Fury's. We all agreed to try it, and so *The Four Questions* came to be situated, at least in part, in the strategies of Anonymous Queers. The poster marks a break in every way with Gran Fury, and makes commentary on it in the form of the tiny, self-parodying signature. The issues are stated with Gran Fury directness, but the language was far more personal. Where Gran

Fury could be tough, Anonymous Queers was bare-knuckled, and less concerned with appropriateness than it was with raw candor.

We did this poster without any institutional support. Vincent billed its production costs to a client, so technically the funding was pilfered. As a consequence, it had very low production values by Gran Fury standards—one spot color on uncoated paper stock. Owing either to the lack of a sponsoring institution or to the personal nature of the content, this work elicited no response whatever at the time. In fact, until Douglas Crimp brought it up in an interview ten years later, I believed no one had even seen it. But the poster was aimed at a series of subcommunities in lower Manhattan, so the lack of response mattered less to me than the act of having said it out loud. *The Four Questions* attempted to name the glaring reality of the deepening viral divide within the activist community, something I thought would be useful to articulate. If this conflict was occurring in activist circles, I thought, it must certainly be true in other communities as well, where it was far less likely to have a voice.

If the period between *Let The Record Show* and *The Four Questions* contains the story arc of Gran Fury, the one between *Silence = Death* and *The Four Questions* is the greater arc that contains it, and it frames not only the visual history of an activist community but my personal one as well. *Silence = Death* was my first AIDS poster during this period, the other, my last. They were both aimed at exploring the same question, community, but seven years apart. That they were graphically opposite—one was black, the other, white—said as much about the differences between these two moments as the text did. The first poster was functionally declarative, and the second was entirely interrogative. One was a call to step away from grief, the other to dive deep into it. These two posters were intended as set pieces, reflections of a community in crisis that were simultaneously political and personal. *The Four Questions* was also intended to reflect the pain of the moment, at the tail of the activist arc just moments before protease inhibitors. I was so

preoccupied by my sense of urgency during these years that it may have been the first time I actually looked up after *Silence = Death* was completed. This poster reunited me with my own sadness, and was closer to my own personal voice than any other work I'd done with Gran Fury. I believe it could not have happened if Gran Fury hadn't decided it was time to give up its own.

In the Passover Seder, the Four Questions is the rhetorical passage in the Haggadah that uses ceremonial inquiry to map out the larger questions contained within the story of Jewish liberation from oppression, the story we are assembled at the table to consider. The youngest person in attendance asks these questions, as a ritual of remembering to help us reimagine ourselves within the historical continuum that binds us together as a community. While not every remaining Gran Fury member was aware of the reference, in Mark's and my circle of friends it was an important holiday. I observed Passover with my ACT UP affinity group, and Vincent's lifelong partner is Sephardic. To the three of us it seemed the perfect framework with which to reinforce the importance of a re-examination of commonalities within a community of activists that was showing signs of spinning apart after years of loss, frustration, and constant activism.

In much the same way the rejoinder text in *Silence = Death* used point size to force intimacy within the social space that contained it, the text in *The Four Questions* is extremely small within the poster's dimensions and cannot be read from a distance. You have to step into it. We decided to "perform" the divide for the reader through two provocative questions that situate them on one of two opposing sides, "Do you resent people with AIDS?" and "Do you trust HIV-negatives?"

The first is a private question aimed at readers who presume they are HIV-negative. The word *resent* is an allusion to a sentiment voiced by many younger gay men at the time, a sense of mourning attached to the reality of being born into a world that denied them the experience of unprotected sex,

a longing many younger gay men felt acutely at the time. While it was rarely articulated as resentment, we decided it would be useful to claim that subtext. It was also the root of the prevalent "street" notion that if you were young and had sex only with other young people, you would somehow be immune from exposure to HIV, a fantasy that still exists within some social circles and communities, deepening generational divides.

The second line drills down further, making HIV-negative people the focus of a social responsibility to act on behalf of PWAs, and it is structured to destabilize any shell of privilege. It touches on the shared responsibility for negotiating chance sexual encounters, but was intended to exceed the sexual pact and shift responsibility for the activist question onto HIV-negatives, asking if they can be trusted to live up to another form of life-impacting communal responsibility, that of acting on behalf of People Living With HIV.

The question "Have you given up hope for a cure?" is meant to establish the first of two bridges across the divide. By presuming there *can* be a cure, it also superimposes a second, unspoken assumption on the reader: there *should* be a cure. At the time of its making, many people in the research and treatment activist communities considered an AIDS cure implausible, and it had created an environment where the very use of the word was considered irresponsible. The phrase "chronic manageable condition" had replaced it, and the first time I heard it, a chill shot down my spine. I remembered sitting at the workbench in the cancer research lab my mother worked in, on a day she couldn't find a sitter.

"Do you think a cure for cancer is possible?" I asked.

"A million times over," she shot back without hesitation, her eyes glued to the pipette in her hand, "but cancer research is too big a business for that to happen."

She was articulating the sort of paranoid certainty that I did not yet realize I would inherit from her, as difficult to substantiate as it is to deny, and that would mold my thinking as an activist. The word *cure* has since reentered

our vocabulary when it comes to talking about HIV/AIDS, but there was a long stretch of time it was considered as naive as my question to my mother. *The Four Questions* was at the very beginning of this moment, and we wanted to reinvigorate the word and attach it to the word *hope*, because there would certainly be no cure without the will for it, and no will without hope.

Although I was fond of many individuals in ACT UP's art circles, for reasons I have already cited, I made an effort to avoid contact with them. In the same way Gran Fury attempted to remain anonymous so as not to overshadow our work, I was uncomfortable with the possibility that fostering conversations about the *act* of our cultural production might eclipse the urgency of its messages and create a cultural "cushion" for people outside our communities, a sense of overall accomplishment that could undercut the necessity for their own political involvement. I was consequently ignorant of Doug Crimp's *Mourning and Militancy* when I suggested "When was the last time you cried?" as the final line for the poster, though Mark or Loring may have been aware of it and failed to reference it. That Crimp wrote this piece so early on is testament to his boldness and insight. I didn't exactly share the same experiences that appear to have informed his thinking; however, for me this particular poster came out of a different set of gestures, gestures closer to Jung than to Freud.

When I was helping marshal the David Wojnarowicz political funeral, the marchers took a turn onto a darkened section of road and suddenly stopped. In the middle of this open and unprotected space the march needed to take a breath. The drumming did not. In fact, it intensified. So did the shouting, and whenever a voice cracked with tears, I could hear it above the mournful chaos. The march had taken another turn as we rounded that corner, into the wild, and as a marshal, I felt it becoming unsafe in a way that caused me concern. Because I had one eye on the traffic we were blockading and one eye looking in at the marchers, I didn't see it when someone started to burn the poster he was carrying, and by the time I became aware of the

flames, they were already building, as more people threw what they were carrying onto the pyre. I heard moans rise up, and the wailing wove through the sound of the drumming. It had ceased being a political act and had migrated onto primeval terrain. I was apprehensive, but it was too late for that: the demonstration was rumbling with a need to articulate some rawer force. So I watched it unfold as I surveyed the streets around us, but it didn't matter what I thought. Its power had overtaken every one of us, and there was no other choice than to surrender to it. It was dangerous. It was furious. It was spinning out of control. It was necessary.

For the same set of reasons, I felt "When was the last time you cried?" was necessary. It was fallible and revealing, a conjuring more than a question, and it clearly broke rank with our previous voice. A return to the personal was the only way I could think to provide balance for the conflict that was hollowing a functioning body politic into an autoimmune shell, a conflict we'd openly avoided within Gran Fury but that had penetrated it all the same. I felt compelled to push us in the direction of emotionality on Mark's behalf, so he could trace the human touch in the collective I feared he was missing, on the chance it might help him feel less alone. I needed to hear it myself, and although I'm convinced rage is what actually kept me alive during those years, I was also troubled by the possibility that it may also have overpowered other parts of us, something Crimp was already wondering about. Within the poster's terrain this phrase attempts to equalize the conflict—for Mark, for myself, and within ACT UP—with language that was as intimate as AIDS itself.

What was occurring within our collective was only one small example of something writ large in the surrounding community, and the viral divide played a part in the crisis of dissolution in both cases. Much has been written about how and why ACT UP chapters split apart, but a lifelong study of material accounts would barely scratch the surface of the many specific, personal events such as this one that contributed to these schisms. I focus on the

Affinity

effect of Mark's waning health within my own microcosm because this poster presents a discrete, albeit messy, point of entry into this larger conversation. But I am also apprehensive about doing it. While I believe studying this poster in this light is clarifying, it also risks continuing to flatten the conflict into archetypes that might encourage further abstractions of the complex realities of viral asynchronicity that continue to exist.

And so I feel compelled to say that although this poster rushed headlong into the concerns I had about what anger might be doing to us, Mark's anger was actually the only reasonable human response to what he was confronting, because his staph-infected Hickman catheter was the opposite of an abstraction: that infection was the cascading force behind every decision Mark would soon make about his life and his death. It was the very real beginning of the end for someone I'd journeyed alongside from the start of the AIDS crisis, and as one of only four people in ACT UP who had actually known Don, he was a touchstone.

In spite of my struggles at that time to understand the conflicts surrounding viral identity, which I hoped *The Four Questions* would help us locate, it did nothing whatever to ameliorate the sadness Mark's suicide would soon bring me. Neither has explaining this poster on these pages done anything to lift it. The only thing that might begin to resolve that for me is a cure for HIV/AIDS.

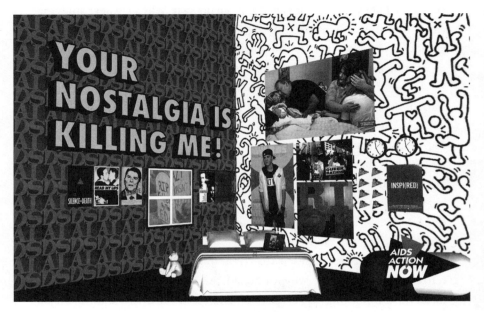

Figure 16. *Your Nostalgia Is Killing Me!* Vincent Chevalier with Ian Bradley Perrin, 2013, digital image for printed poster, 11 × 17 in. For AIDS ACTION NOW! / PosterVirus. Image courtesy of Vincent Chevalier.

The Four Questions, Part 2

Intergenerationality

Everyone I've ever been friends with has been complicated. Although he had a veneer of folk simplicity that made people swear otherwise, Mark Simpson was complicated, too. Anyone who ever did him a favor can testify to that. Still, Mark was pretty much universally loved. I can't think of a person whose back went up when he entered a room. But no one held a grudge quite like Mark if you disappointed him, and every one of us would be made to choose sides when he did. Although it never seemed that way when you met him, Mark was ultimately a person who took up a lot of room. It makes sense that the hole he left would also be pretty big, and he left it in everyone he knew.

He was also furious, and he was that way long before AIDS. In fact, there were times I kept my distance because of it. It scared me a little, but more than that, I had trouble understanding why everyone else seemed to play along with the idea that he wasn't rageful, when it was as plain as the nose on his face. AIDS would soon teach me a rage that rivaled his, so we eventually met in the middle, and I grew to trust him once we did. The more honest each of us became about our anger, the more it bound me to him. It's not a reason you'd like to admit to for getting close to someone, though I didn't exactly choose it. But rage is a kind of pledge, like love, and its bonds might actually be stronger. Even if you've never experienced this yourself, I'm sure you know exactly what I mean.

I'd produced several projects with Anonymous Queers that were practically primal screams, but it was a collective built with that objective in mind, so *The Four Questions* was a kind of "coming out" poster for Mark and me in terms of this style of collaboration. The text was a conscious attempt to use the confessional nature of self-portraiture to reflect the tensions we were surrounded by. It was courageous, or foolish, not to imagine how painful this gesture might become if Mark died, but I honestly didn't think he ever would. That's why this work is so important to me: it's both a document of how Mark's last years changed our relationship and an honest portrait of the rage that was overpowering any responsibility our entire community of activists had come to feel for one another, rage that changed the risks we were willing to take. So I suppose it was only natural after Mark's death for me to see it as a brutal frame for the way the viral divide had presented itself in ACT UP, the callousness of which made some of my closest friends into caricatures, Maxine Wolfe in particular. In contrast, the quiet gentility of Gran Fury's dissolution was made into a caricature all its own, and somehow *The Four Questions* became a fitting frame for that, too. This poster captures the storm before the quiet, if you will, in many personal ways. It's extremely political, but it's not at all a political poster. It leans far more heavily into the realm of art, something I was loath to consider when Gran Fury was still together, and was instinctively drawn to after it dissolved.

While working on this poster, I was also in the midst of a yearlong process of coauthoring a proposal, with Maxine, Mark Milano, Enis Bengul, Bob Lederer, and Scott Sawyer, to create an alternative AIDS research institute outside the NIH, one that would focus solely on pathogenesis, the Barbara McClintock Project to Cure AIDS. After exhaustive research and national organizing, and with the support of institutions and individuals like the magazine *Science* and Martin Delaney from Project Inform, it became the basis of a bill sponsored by New York congressman Jerrold Nadler in the 103rd Congress, HR 3310. Unfortunately, it went up against a competing bill,

pushed by amfAR and TAG, to strengthen the Office of AIDS Research at the NIH, and it did not pass. Watching our work so easily fizzle inside the Beltway was deflating, to say the least.

The combined effect of so many forms of conflict and loss had pushed me further than I knew, and I was rattled in ways I couldn't admit at the time. So, as many activists did when protease inhibitors began drastically reducing death rates, I started putting the relentless war footing aside in the hope of finding my way back home. In hindsight, it was an impulse that tracked with practically everyone else I knew during this period, when HIV/AIDS slowly began transitioning into a muted version of its former self and the world began seeing it as a part of the past. Many have observed that this period was responsible for the meth epidemic in the gay male community, but I had a different journey, a time of inward reflection that triggered the stark acknowledgment that any reassuring constancy my job provided had been transformed by years of death into resentment. As it is with most people trained in the arts who do not become art professors or working artists, or both, I started stringing together a series of creative jobs to replace it, first freelancing as a writer for several now-defunct queer publications and a handful of overseas magazines. I became associate art director on a spec queer literary arts publication, *XXX Fruit*, with Vincent, Anne-Christine d'Adesky, and Marisa Cardinale, and opened a graphic design studio with Vincent. I picked up freelance gigs art-directing fashion, art, and entertainment features for some high-profile magazines, and worked on two of Matthew Barney's *Cremaster* films. After a few years of attempted reinvention, I suddenly quit Vidal Sassoon without warning and moved to upstate New York with my long-term partner. After Mark's decline, I realized how tenuous things still could be, and how foolish it would be not to nest into that moment. We began dealing American folk art with some success, and I eventually resumed the individual art practice I'd abandoned and began showing in group exhibitions. During this period, I also started reintegrating myself

into the LGBTQ and HIV/AIDS communities, lending posters for exhibitions, doing pro bono public awareness campaigns for AIDS organizations, accepting invitations to speak at institutions like Harvard, Yale, Columbia, and NYU, and sitting on the steering committee for the Pop-Up Museum of Queer History.

I was fully functional, but also fully disoriented, as anyone attempting to normalize a decade and a half of death might be. Every street in Lower Manhattan felt permanently haunted, and without really realizing it, I'd begun to avoid leaving the house. I became a constant, silent crier and downshifted from years of self-medicated sleeplessness into what are now decades of psychopharmacology. As I account for these years here in writing, my attempts at reentry seem muffled into a remote thumping that some might refer to as accomplishments, but they were little more than productive stabs at controlling my survivor anxiety, or the swirl of a lost decade winding down. On this side of the keyboard, however, this narration has all the metallic sharpness of those years—jagged, like the day Mark told me he was planning to kill himself.

We were in the middle of his perennially unfinished squat, surrounded by a maze of framed walls without sheetrock, as skeletal as Mark was beginning to become himself. I had just finished making him something to eat, which I recall as being some form of breakfast. I had come to take photographs of his infected Hickman, which I wanted to tuck into the gutter of the blank closing pages of *XXX Fruit*, a reminder of the human meaning of HIV. I was able to pace myself to him while he told me, as I sat on his sofa covered in cat hair and Victorian pillows, since he had started talking about suicide during his last hospitalization.

The only thing I remember saying was, "I understand, Mark. I know." All I actually knew was how pale the despair of the witness becomes compared to that of the dying, though perhaps by way of compensation, it's fade-proof. In fact, it grows more saturated with time, quietly overpowering everything

else, except perhaps the gratitude for having been spared the terrors you were made to watch. The protease inhibitors that were halting disease progression for millions of people were brand new to us in 1996, when Mark's immune system was so shot he decided death was a better idea. It was simply too late for those treatments to work on him. I suppose what seemed to the rest of us a dangling hope on the treatment horizon felt more like a cruelty to him. That year was a turning point for all of us. It was just a different kind of turning point for Mark.

A generation of curators, critics, and scholars had a hand in creating the canon our work became part of, but I did not. I had a hand only in the work. I say this to explain that I can easily understand how the resurgence of interest in AIDS might be alienating for people born after the advent of protease inhibitors, some of whom tell me it feels as if everyone wants to talk about HIV again, but only about AIDS in the past. They're right about that, though that's not actually how I would put it. Now that the future seems more resolved, we're in the process of *simplifying* the past, so we don't have to talk about it at all. But HIV/AIDS is like one of those horror movies where your home is built on an ancient burial ground. There can never be peace until we learn how to talk about the things we let happen.

There are times it feels as though I've surrendered my whole life to learning how to do that, and it's made me a member of a club. There's no secret handshake, but we know one another on sight, and I'm permanently bonded to people I know intimately yet find it painful to be around, and to others I know without ever having met. I need to clarify something, though. The connection I'm talking about is not at all generational. When it comes to people who were there but didn't see a thing, I feel no connection whatsoever. They somehow turned a blind eye to HIV, and the bond I'm talking about exists only with those who let their eyes linger. And here's the funny thing about that: I can feel this connection with people who never saw a Kaposi's sarcoma lesion in person or lost a single person to HIV. And I'll be

able to feel connected to people born after these words appear in print. It's a connection that has nothing to do with having been there. Because in case I haven't explained this in a way that is clear yet, I believe the history of HIV/AIDS has nothing to do with the past.

In late 2013 Karen Herland and Ian Bradley-Perrin of Concordia University in Montreal invited me to do a public lecture for their annual HIV/AIDS series, which I was honored to do. Ian also asked if I'd be open to doing a small workshop the next day as well. For some reason, no one had ever suggested that before, and it foregrounded something I'd been thinking about for a long time. Hearing this body of work described in person brings its context to life in ways no exhibition wall or printed page seems able to do. But the political uses for talking about the work pales in comparison to the potential that exists in sharing the skills that created it. It's not that I'd run out of things to say about this work. I simply wanted to explore leaving something in its place.

"What about forming a one-day collective and mounting whatever we come up with in a public place?" was my response. Ian didn't hesitate to agree to it.

We tell ourselves there is no public interest in the current issues surrounding HIV/AIDS, and overwhelm ourselves with the chicken-or-egg riddle of mobilizing the commons in the absence of a larger movement to try to change that. But after having been asked again and again by roomfuls of people what steps we might take to end AIDS, I see something else. I see that a movement might already exist. It's simply a disconnected one, one that has yet to be mobilized. So, what if we forgo the idea that we need to be connected for a moment, or that we need to say one definitive thing about HIV/AIDS, such as "Silence = Death," everywhere and all at once, and remember that any roomful of people can seize the commons. That's exactly what the Silence = Death collective did. There were only six of us, and ACT UP was a

full year away. What if what we wanted to say about HIV criminalization, for instance, was the point of our collective work, rather than carving an institutional presence on a media landscape? What if the message itself was the point, not our ability to build a movement around it? I wanted to experiment with this idea, in a bell jar, and create a minicollective, just for one day—a "flash collective."

What I had in mind was an experiment in political art-making that came out of a desire to stimulate alternative paradigms for thinking about how to talk about HIV in the public sphere. I wanted to create a surgical and fast-paced format of limited duration to produce a single intervention in a public space, as an exercise in commonality and content, drawing on a balance of permissions and structures to help remove any obstacles superimposed by our attempts to organize a movement. I wanted to try out a concise, result-oriented exercise aimed at the very core of social engagement, collective action, one that cut directly to the point of the work, its content. I wanted to see what might happen if we broke down the overwhelming nature of articulating the complexities of HIV/AIDS into its simple component pieces, as we did in the Silence = Death collective.

In the weeks leading up to the workshop in early 2014, we had many e-mails and Skype sessions about how we would facilitate it, who might attend, what dissemination strategies might be available to us, and the best ways to set up the facilities. I sent proposals for structure, which Ian countered with suggestions that led to further negotiations. Without realizing exactly what was happening, the workshop had already begun. The collaborative consultations were so instrumental in the final result, they were already activating the sort of collectivity I was hoping to explore.

To ensure the collective had the freedom to focus on the collective process and the content, I thought the exercise should be structured in at least one of two ways: the topic or the end result—whether a poster, a billboard, a performance, a website, or whatever—needed to be predetermined. We

The Four Questions: Intergenerationality

agreed on the topic of HIV/AIDS criminalization, which sits at the crossroads of access, stigma, race, and class and concretely addresses the viral divide. It's an issue of great personal concern for me, and Ian told me local activists had been focusing on it.

I also felt it would be essential to include as many participants as possible who had no previous acquaintance, as I'd suggested during the formation of the Silence = Death collective, to help balance any relationships that might have inadvertently calcified, challenging those who already knew one another while creating a more equalized environment for attendees who were outside these circles or might be newcomers to the collective process. During the course of our preliminary conversations, however, I became increasingly aware that several of the attendees knew one another well and had previously worked together. In fact, Ian had worked closely with two of the participants, Alex McClelland, a cofounder of a regional AIDS activist agitprop project, Poster Virus, and Ryan Conrad, an activist, writer, and artist who was a founding member of the Against Equality collective. I knew Montreal had a small but active HIV/AIDS community, and so I assumed it might be somewhat insular. What I did not know was that there was a Shakespearean tempest forming between these particular participants that not only directly implicated the cultural production I was there to lecture about, but touched on the very rationale for the workshop we were assembling. Thunder rumbled in the north, and it built as the workshop drew closer.

After an online conversation, it seems, Alex had paired Ian with a local artist, Vincent Chevalier, to create a work for Poster Virus about the distortions intrinsic to the social media machinery that helps spin cultural memory into memes. It depicted a child's bedroom papered with AIDS agitprop, art, and ephemera, coupled with the phrase "YOUR NOSTALGIA IS KILLING ME!" The phrase came out of an exchange between Alex and Ian about a video by Ryan Conrad, *Things Are Different Now*, which they felt obscured current struggles for People Living With HIV/AIDS by means of an

aestheticizing lens and deployed archival images of AIDS activism in a way that neutralized the potential for political agency in the present. Putting aside for the moment the subjectivity of this reading, the fact they were critiquing the privileging of cultural production over activism but were deploying cultural production to do it, and the issue of whether the poster successfully addressed these questions, I completely agreed with its premise, and in fact the talk I was working on for the public lecture the night before the workshop made a parallel set of arguments about my own work.

I started getting phone calls about the poster to prepare me for what I might be walking into, and the controversy quickly found its way down to Manhattan through another colleague, Ted Kerr, a friend of the participants who was then the programs director of Visual AIDS in New York. He'd conducted an interview with Ian and Vincent about the poster on the Visual AIDS website after it came up at a panel organized by Jason Baumann at the New York Public Library, and the interview was beginning to reverberate throughout the New York HIV/AIDS community. Ted thought the conversation meaningful and decided to plant a link to it on the ACT UP New York Alumni Facebook page. Being a newcomer to New York and of a different generation, he misinterpreted its potential as a consciousness raiser within my cohort, and like a lightning bolt, it sparked a flash fire at least as destructive as it was useful. The New Yorkers were both enraged and perplexed by the idea that there might be alternative ways to think about their lived experience other than those reinforced by the dominant narrative being constructed around us. By the time Ted alerted me, it was already raging out of control, and I knew there would be no point in inserting myself. I suggested instead that we set up a public forum to address it, and when I got back from Montreal, that was what we did, cohosted by Visual AIDS and the New York Public Library.

So within a few short weeks I had found myself in a perfect storm that revealed an unexpected interconnectedness between seemingly opposing

views on collective memory and political engagement that were roiling in multiple communities attempting to come to grips with the same rare moment of historical intersection, and it had swiftly exceeded the battle lines being drawn around the meanings of the words *your*, *nostalgia*, and *killing*. While I was busy working to devise a framework for reactivating social spaces around the topic of HIV/AIDS, a defining set of dilemmas was unfolding right in front of me, and it had scorched the shared borders of dissimilar but contiguous perspectives.

For my generation of activists, thrown into the deep as the world watched but did nothing, the story of the early years of AIDS is hallowed ground. Many lives were lost, but many more were saved, and as a consequence very few stakeholders have felt the need to analyze the moment critically. In addition, the ACT UP alums were more prone to be satisfied with the current construction of the dominant narrative because they had already been bolstered by a defining sense of community that had been disrupted but somehow not erased by the splintering of ACT UP. Once "AIDS activism" had been replaced by "treatment activism," however, the only community left in its place was highly specific, rarified, and professionalized, and no longer a commons built on broader affinities. If you are a young person living with HIV in the twenty-first century, you are in societal free fall. For the generation *born* in the deep, with *no one* watching, there is nothing to grasp onto that doesn't have a pharmaceutical label attached to it.

While my generation justifiably cleaves to a sense of accomplishment that also acts as a balm to help soothe the terrible sacrifices of our past, another is left with a feeling of isolation exacerbated by what is perhaps the most distinguishing aspect of the dominant framing of the story of AIDS: it is a heroic tale of resolution based primarily on viral suppression. In this telling what began as a resistance struggle in response to the death and dying of marginalized communities ends up as the triumph of science over the threat of death. But the triumph applies more to the mortality piece of this story than the marginaliza-

tion part. This narrative does not *say* AIDS is over, or for whom, but privileging the medicalized aspects over the social questions that turned a virus into a political crisis in the first place makes it easier to infer that it is. At the time, there was no choice in terms of priorities, but because this strategy expresses the sort of quantifiable entity that is easier to articulate (scientific outcomes), it perpetuates a more reassuring, "trickle-down" narrative that floats above the ones that are so deeply institutionalized they can barely be parsed in plain language. There are activists from my generation who appear unconcerned with the quandaries this account promotes. People Living With HIV who were born after protease inhibitors, however, are *deeply* concerned about it, and that is what *Your Nostalgia Is Killing Me!* is about. Our AIDS past is being constructed in a way that flings a cloak of invisibility over the present and future.

And so, not surprisingly, those speaking on behalf of this poster also had a distinctly different read on some fundamental questions compared to those who rejected it, pointing to a generational clash far deeper than what an HIV/AIDS historiography might look like. Given that pharmaceutical interventions have not alleviated the stigma that continues to impact People Living With HIV, are they, in and of themselves, a *political* solution to HIV/AIDS? If you *do* subscribe to the idea that HIV medications are the sole determinants in conquering HIV/AIDS, does that mean stigma can be eliminated only in a world where *everyone,* positive and negative alike, is undergoing some form of HIV treatment or prophylaxis? If you do believe in pharmaceutical interventions as a political strategy, is the certainty we assign this approach a reflection on the inner walls of a bubble outside of which people stop listening when they hear there is a pill they can take? Rhetorically speaking, if you believe we still need people to care about HIV/AIDS (and *everyone* in the HIV/AIDS community agrees we do), haven't you just lost your audience, making this political strategy a self-neutralizing one?

Those conflicts put aside, the genesis of this poster still underlined a generations-old political predicament, one with a straight line of descent to

The Four Questions. Ryan was HIV-negative. Ian, Alex, and Vincent identified as HIV-positive, and they were naming what they saw as an absence of critique of AIDS 2.0 as a function of Ryan's seronegativity. Within the twenty years bracketed by *The Four Questions* and *Your Nostalgia*, the viral divide was still very much on the table, and even though it had accumulated many layers of meaning, a core question remained: As it did when *The Four Questions* was created, does the divide continue to perpetuate a fracturing of communities that might strategically need one another for the long haul, which HIV/AIDS has certainly proven to be? Beyond the social or treatment implications of serosorting, are there political implications as well?

Perhaps, but something in this story flies directly in the face of that question. Based on the impact it had just had on communities hundreds of miles and a generation apart, the tensions surrounding *Your Nostalgia* should have derailed this workshop. Instead, the one-day collective at Concordia created a bold and insightful projected billboard, for a window in a multi-use shopping street during rush hour, on the complex topic of HIV criminalization, an issue *rooted in the viral divide*, and it did so with *virally discordant participants*. Moreover, the collaboration included key players in the creation of the fractious poster that had just scorched the ACT UP alum pages, a community vaunted for effective political coalition work. These particular Montreal activists were able to work across the viral divide with one another, but were unable to come to terms with another group of activists on the same side of it. Any presumptive affinity afforded by viral harmony was of little use in explaining *Your Nostalgia* to the New York activists, and viral discordance was not deleterious to the billboard collaboration, even though tensions along this divide had been pushed to the fore by it, begging the following questions. Has the political landscape of HIV changed so much that generational commonality is more potent than viral synchronicity? Did ACT UP NY, an organization named for coalition work, surrender this particular ability in the name of its own historiography? Can *performing* political work function in

place of building political affinity, even where natural affinity fails to lead to political work? And as it was within ACT UP and with Gran Fury, can the agreement for the need to do work—not necessarily the broad need for work, but for a specific task—plug holes that may exist in communal affinity?

Whereas the ACT UP alums were arguing on behalf of work that had already been completed, the activists in Canada were prepared to forge new work and transcend strategic disagreements to do it, opening themselves up to the productive potential of a project-based affinity about an issue they saw as urgent. If the conflict surrounding *Your Nostalgia* could be characterized as *historicizing* HIV/AIDS rather than *doing* something about it, "doing" a flash-collective billboard had resolved this tension, however temporarily. And as with the activist artifacts from a generation before depicted in *Your Nostalgia*, the flash-collective exercise had left something concrete in its place, and I'm not talking about the billboard. It opened a window on several methods for connecting the skills that promoted, through activist output, the first round of AIDS activism with the present struggles of People Living With HIV, by tapping into the strategic thinking whose meaning the poster appeared to question. It was my intention for the flash-collective experiment to deemphasize the historical meanings of the activist canon that had drained away, and reactivate a sense of its *lived meaning*. As it turned out, this was a fairly easy thing to do. Allow me to restate my theory about why that might have been. ACT UP constituted itself around a primary tenet we seem to have forgotten, which I believe studying the intricacies of its cultural production reveals. The affinity that drove it was founded in the death of our loved ones. But under any other circumstances ACT UP might easily have been a sprawling, social mess. It became unified through one very simple agreement: the urgent need to do work.

The Concordia Flash Collective might suggest something else as well: if you agree to the necessity for political work, affinity is possible *without* the battle stations urgency ACT UP coalesced around. I am not maintaining that the participants had no personal urgency regarding the terrible realities of

HIV criminalization, or that there was no communal urgency. I'm observing that the agency in the room was founded on the pact to perform work, for one day, without the existence of a weekly meeting of four hundred activists and a vast network of subcommittees meeting daily in support of it, to generate ongoing, well-planned demonstrations and targeted political pressure campaigns, all of which ACT UP created for itself. The flash collective simply drew on the *historical scrim* of it, coupled with a brief lecture about audience, public spaces, and various strategies for collective cultural production; a trust-building workshop on issues of HIV criminalization; and a mini-teach-in on criminalization and the impact of pharmaceutical interventions like PrEP and PEP on disclosure laws. Based on those tools and the simple agreement to perform the work, the Fuck Laws Flash Collective at Concordia University's Centre for Exhibition and Research in the Aftermath of Violence proceeded to generate a powerful projected billboard: the tagline "I HAVE HIV: CALL THE COPS" appeared over an image of police running in riot gear, with an accompanying text to explain the personal, legal, and policy issues. Through a series of alternating brainstorming, research, and work sessions, followed by our breaking into three working groups—one for text, two for design—the collective executed the billboard and designed and produced buttons and postcards with parallel messages to hand out on site, mounted a Tumblr page, and discussed several follow-up projects. The participants did it all in eight hours with a half-hour lunch break.

Since conducting the first flash collective at Concordia, I've done almost two dozen of them, on topics as diverse as the viral divide, HIV/AIDS stigma and criminalization, gentrification, reproductive justice, gender and identity, race and privilege, immigration and displacement, and policing and mass incarceration, with partners including Visual AIDS, Yale University, NYU, The New School, Tufts University, the New York Public Library, GMHC, Equity Fights AIDS, the Helix Queer Performance Network, and the Hemispheric Institute of Performance and Politics, and I've lectured about them at the San

Francisco Museum of Modern Art, Yale, NYU, Parsons, and The New School. They've been the subject of a documentary, have been featured in *Slate*, *VICE*, and the *Journal of Visual Culture*, and the work of these collectives has been included in several international exhibitions. In the context of this book, I'd like to highlight a few of them that have focused specifically on HIV/AIDS.

I wanted to continue to explore the critical issue of HIV criminalization, so I jumped at the chance to conduct a workshop at the historic HIV Is Not a Crime Conference in Grinnell, Iowa, which brought together American activists working on this issue. We had only two and a half hours to design one image, and I was nervous about time: it was only the third flash collective I'd attempted, and it was the shortest. But I also knew the best minds in the country working on this issue would be in the room. When we began our workshop, I asked the collective to simply explain what everyone in the room knew to be true: that decades of draconian criminalization case law had solidified into legal precedent, right under our noses. Our task was to tell the public why they should care about it. The collective came up with not one, but three images. In one, the statement "You care about HIV criminalization. You just don't know it yet," was coupled with the story and an image of a person serving time after being wrongfully accused of nondisclosure, giving a face to the criminalization cases currently in the courts.

When Jason Baumann and Visual AIDS invited me to organize a flash collective to mount an intervention at four branches of the New York Public Library in conjunction with his exhibition *Why We Fight*, I had high hopes. Jason knows how to push institutional boundaries. When I met the collective, my hopes were exceeded. By the end of our first session we had moved from a mapping exercise that covered the sprawl of questions of class, race, and access to a tightly focused core concept, the question of viral undetectability and its relationship to stigma. In our second session, we started hammering out a text that could inform an audience of indeterminate race, gender, and class while delivering our own political perspective on the questions

raised by the language surrounding undetectability. Because we wanted to illustrate how the question of antibody status is now in flux, as depicted by the ghosting of positive and negative signs, we chose to use lenticular printing (the technique used for 3-D postcards, where multiple images are revealed as you tilt it) for both the posters and postcards. The text underneath it gave a crash course in the medical meaning of the word *undetectable*, and it's social and policy implications, translated into five languages on the back to reach multiple audiences:

> We're at a crossroads in HIV treatment. HIV positive & HIV negative are no longer the only possibilities when discussing serostatus. The word undetectable has emerged in this conversation. Undetectable originated as a medical term for an "acceptably" low presence of HIV in the bloodstream dependent on strict compliance with "successful" antiretroviral treatments. Maintaining undetectable viral levels significantly reduces HIV transmission, but it is not a cure for AIDS & does not remove stigma. Not everyone has access to information or treatments, so the emphasis on achieving undetectability reinforces racial & socioeconomic divides. Because there is more money in lifelong treatment, profit-driven drug companies have no financial incentive to find a cure. Undetectability saves lives. But whose lives? & who profits? Where's the cure?

At Grinnell, I met blogger Mark S. King, who had written several pieces about the viral divide. After the conference, I suggested we cohost a flash collective to explore this question. It took almost a year to assemble partners and work out the logistics, but with the help of Visual AIDS, Broadway Cares/Equity Fights AIDS, GMHC, and the Hemispheric Institute of Performance and Politics, we conducted a flash collective on the viral divide with an equal number of HIV-positive and HIV-negative gay men, who reflected the demographic balance of affected communities in New York. In collaboration with the Illuminator, the collective formed during Occupy Wall Street responsible for projections around the world in support of politically engaged

communities and organizations, we projected a video message on the façade of the Bronx Museum during the opening night of *Art, AIDS, America*, built around the logo "HIV÷" along with a text piece that addressed the viral divide.

In contrast to some activist cohorts whose members feel the world has fully disengaged from the question of HIV/AIDS, my flash-collective work has convinced me the opposite might be true. I believe institutional structures are predicated on our buying into the idea of the hopelessness of sustained engagement, and their power is contingent on our Balkanization. But given the simple opportunity to collaborate, I believe any roomful of people has tremendous potential to do so, and that potential is begging to be unlocked. Every workshop I do convinces me more of the inherent power within our social spaces, and gives me more ideas about how to activate it.

As I enter my third decade of using language and image to put my finger on the exact *right* combination that will finally end the suffering of HIV/ AIDS, I suppose I could feel hopeless. I don't. I'm astonished, instead, by the ceaseless ingenuity of the collective mind. I believe we could form a flash collective on a subway car, and by the last stop we'd have ten ideas about what to do next.

Admittedly, I'm bolstered by a body of work that long ago eased my anxiety over saying the right thing about HIV/AIDS, the definitive thing, the final thing. I've come to believe that everything we have to say about it is the right thing to say. Saying nothing is the only "wrong" thing. The hopelessness lies in our silence. Luckily, that was the first thing I learned when it comes to HIV/AIDS.

The Four Questions: Intergenerationality

Epilogue

Notstalgia

Because of things it asked without meaning to and proved without antici-
pating, *Your Nostalgia Is Killing Me!* turned out not to have been about nostal-
gia at all. To the extent that it might be a throw-down over the past, it makes
its arguments from the future and wanders onto turf that has more to do
with political strategy than historiography. It wonders out loud what mean-
ingful political work might look like in the inverted connectivity of the
twenty-first-century commons, when "talking" about HIV/AIDS appears to
further disengage us from it. It bookmarks the ideas we left on the battlefield
as the remaining political questions going forward. It inadvertently troubles
whether the treatment activism that saved so many lives has outlived its
political usefulness, now that it has delivered a viable market to the doorstep
of biomedical innovation.

And most important, this poster asks whether AIDS 2.0 is the beginning
of the end or the end of the beginning, though the authors of this work know
that question is moot. The story of AIDS *can't* be written yet, because while
many significant turning points are behind us, its lessons lie right here, in
how we talk about it at this moment, during the jockeying for position lead-
ing up to the *actual* resolution of this story, the end of HIV/AIDS. Once there
is a cure, curative, functional cure, or vaccine for HIV/AIDS and that day is

past, all that will remain is how we talk about it, and it's a story smart money is scrambling to own.

When it comes to our AIDS past, it's easy to see why it's tempting to superimpose the familiar rituals of centuries of institutional war memorialization on its survivors. But none of the benefits of that highly evolved form of cultural remembering are conferred on the soldiers returning from this war. Because this past replicates a war story, it's easy to conflate institutional storytelling and collective memory with personal experiences in a similar way, but this combination of effects has little to do with what is happening here. So, for those who survived the early years of AIDS, this moment leads to a particularly painful type of human muddle, the muddle of being disappeared into a past, one's own, but a past that is not recognizable. Huddled just beyond the inner bonfire of AIDS 2.0 meaning-making sit endless rings of those for whom the harm of living through the early years of AIDS has gone unacknowledged, the walking wounded here among us who are struggling in isolation to warm themselves on the institutional glow of AIDS storytelling. We are the ones to whom this history theoretically pertains, but who may have trouble understanding its lessons, as witnessed on the ACT UP NY alumni Facebook page.

On a trip home from college in 1970, in the parking lot after seeing *The Garden of the Finzi-Continis* with my father, I asked him if he thought the Holocaust could ever happen again. I remember shaking my head while he said yes without missing a beat, in the way young people do when they have no context for understanding what they are told about the past. I am glad he's not here to witness the current reinvigoration of proto-fascism, since we would be fighting over its exact meaning. There is one thing we would agree on, however, and that is our duty to build a forceful resistance to it. Here we are again, as my father predicted, being asked to assess the precise level of risk each of us will be willing to take to prevent the renewed international rise of

fascism. Stories of past struggles against authoritarianism can no longer be thought of as abstractions, including the ones in this book, every one of which needs to be read in the context of recent political developments.

As someone who feels a responsibility to history, AIDS 2.0 is disquietingly similar to my father's efforts to situate himself within the attempt to make sense of the Holocaust, as an atheist Jew in the American Communist Party who was sent overseas by a country he was trying to dismantle, to help draw down the fight against Hitler, and he went because he never forgot the price his clan paid for its Jewishness. I wrote this book to map where I sit in a story I had a hand in but others have shaped, in the hope of helping remodel it into a toolbox for resistance in the future, which, as I type this, is apparently now. We are being called again to the continuum of resistance, and are obliged to pick it up.

AIDS was, AIDS is, a political crisis. And silence was, silence is, packed with political meaning. Writing the story of AIDS, I believe, is as political as HIV/AIDS itself. So, as we enter the final stretch, I am finally throwing in with history. History, that is, as an act of resistance.

GRID (Gay-Related Immune Deficiency), 3
Group Material Democracy, 113
Guerrilla Girls, 43
Gypsy (musical), 87

Haacke, Hans, 78
Harrington, Mark, 97, 100, 109, 139, 141
Haynes, Todd, 109, 116
Heard, Amy, 109
Helms, Jesse, 148, 163
Hemispheric Institute of Performance
 and Politics, 216
Henry Street Settlement, 113
Herland, Karen, 206
His & Herstory of Queer Activism handbook,
 161
HIV÷, Viral Divide Flash Collective, *pl.*
HIV/AIDS: ACT UP FDA actions, 142–45,
 148–49, 163; and AIDS 2.0, 1–3, 205–6,
 209–14, 219–21; criminalization of,
 207–17; death of author's friend Lee
 and, 156–59; early assumptions and
 fears about, 1, 5–6, 16, 33–34, 35–36;
 and formation of Silence = Death
 collective, 35–38; *The Government Has
 Blood On Its Hands* poster, *pl.*, 136,
 137*fig.*, 142–43, 144–45; Gran Fury
 battle against Stephen Joseph, 138–39,
 140*fig.*, 141–42, 144–45, 148; The
 Kitchen project and *Art Is Not Enough*
 poster, 133–35; People Living With
 AIDS, 119, 120–21, 143; pharmaceuti-
 cal advances and manageability of
 HIV/AIDS, 3–4; *The Pope And The Penis*
 mural, *pl.*, 166, 167*fig.*, 168–69;
 symptoms of, 15–17, 33; and TAG
 (Treatment Action Group), 120,
 163–65, 178, 180, 181, 192, 203;
 transmission of, 114, 169, 189;
 treatment of patients and spouses prior

to 1984, 30–31; and the viral divide,
 186, 188–90, 192–93, 194–99, 210–14;
 war as metaphor for, 59–60; and
 women, 161, 165–66, 167*fig.*, 168–69,
 170*fig.*, 171–81. *See also* drug therapies
HIV Is Not a Crime Conference, 215
the Holocaust, 220–21
Holocaust metaphor: coded reference
 to in *Silence = Death* image, 44–45, 71,
 73; concentration camp float at NYC
 Pride March, 75–76, 81–82; New
 Museum installation, 80
homophobia: Kiss-In demonstrations,
 98; *Kissing Doesn't Kill* posters, 114–16;
 Read My Lips posters, 97, 98–99, 114;
 treatment of HIV/AIDS patients and
 spouses prior to 1984, 30–31
Horst, Horst P., 104
hospital visits with dying friends, 16–17,
 55–56, 158–59
Hoth, Dan, 173
Howard, Brian, 36–38, 40–50
How to Have Sex in an Epidemic (Callan), 86
How to Survive a Plague (film), 2, 7
Hudson, Rock, 34, 114

I Hate Straights (broadsheet), 162
"I Have HIV: Call The Cops" billboard,
 pl., 214
image selection: *Silence = Death* poster,
 43–45; *Women Don't Get AIDS, They Just
 Die From It* poster, 175–77
immigrants: AIDS immigrants, 25; Don
 singing about the New World, 15; and
 ·Ellis Island, 20–21; and Jewish
 memory, 18; and the past, 25
institutional power: cultural production
 versus political resistance, 111–12; and
 power of collaborative political
 engagement, 217

political posters *(continued)*
public nature and power of, 39; role in social change, 39–40; as series of gestures, 154–55; *Silence = Death, pl., 26fig.*; silkscreening process, 38–39
politicization process: author's childhood and youth, 32–33, 155; author's loss of Don and, 33, 34, 35–36; formation of ACT UP, 54–57; queer identity and the gay liberation movement, 97–98. *See also* Gran Fury collective; Silence = Death Project and collective
Poor People's Campaign, 32, 154
The Pope And The Penis mural, *pl.*, 166, 167*fig.*, 168–69
Pop-Up Museum of Queer History, 204
Poster Virus, 208
Pre-Exposure Prophylaxis (PrEP), 97
Presidential Commission on the HIV Epidemic, 186
Project Inform, 120, 202
protease inhibitors: and feelings of hope, 203; and intergenerationality, 205–6; pharmaceutical advances depicted in *How to Survive a Plague*, 7; and manageability of HIV/AIDS, 3–4; as symbol of AIDS activism success, 171
public space: *Kissing Doesn't Kill* posters, 122–24; and placement of Silence = Death posters, 42–43

Queer Crisis Flash Collective, *pl.*
queer identity and the gay liberation movement, 97–98
Queer Nation, 101, 119, 162
Queers Read This image, *pl.*

race: 076 drug trial, 178–79; *AIDSGATE* poster, 71–72, 73; bias in HIV/AIDS research, 169; diverse community perspectives on HIV/AIDS, 10; *One in 61* poster, 95; *Women Don't Get AIDS, They Just Die From It* poster, 176–77
Read My Lips poster: and Gran Fury collective, 97–101, 103–5; men's version, *pl.*, 84*fig.*, 97–100, 103–5; T-shirts, 101, 107–8; women's versions, *pl.*, 101, 102*fig.*, 103*fig.*
Reagan, Ronald: *AIDSGATE* poster, *pl.*, 48, 58*fig.*, 72, 186; and the Berlin Wall, 186–87; neglectful AIDS policies of, 99
Reichard, Livet, 113, 116–17
rejoinder text: *Kissing Doesn't Kill* poster, 117–19, 123–24; *Silence = Death* poster, 48–49
Riley, Terry, 109
RIOT painting, 132–33
Robeson, Paul, 32
Rosenberg, Ethel, 32
Rosenblum, Illith, 161
Ruddy, Don, 109
Russia, 186–88

Salinas, Mike, 52
Sausalito, California, 121
Sawyer, Scott, 202
SCUM Manifesto, 129
sense of place and Jewish memory, 18
serostatus, 180, 189, 192, 212, 216
sex: gay community reactions to HIV/ AIDS, 37–38; safer sex, 86, 97
Sexism Rears Its Unprotected Head poster, *pl.*, 152*fig.*
sexuality: and connectedness of ACT UP participants, 85, 90; queer identity and the gay liberation movement, 97–98
Shaw, Robert, 123
Shearer, Linda, 166

Signorile, Michelangelo, 132

Silence = Death image: buttons, posters, and stickers, 65–67, 74; and calls for violent protest, 141–42; coded Holocaust references in, 44–45, 71, 73; collaborative design process, *pl.*, 40–50; and concise articulation of complexity, 185; and *The Four Questions* poster, 194–95; negative gay community responses to, 51–52; New Museum *Let the Record Show* installation, *pl.*, 77–82; at NYC Pride March, 76; poster, *pl.*, 26*fig.*; printing and placement of posters, 41–42, 50–52; proposed copyright for, 69–71, 164; recognized and praised at "AIDS Action Committee" meeting, 54–55; on T-shirts, 67–69; video wall of at 2015 U2 tour, 3

Silence = Death Project and collective: *AIDSGATE* poster, *pl.*, 58*fig.*, 71–76, 87; community provided by, 35–38, 91–92, 93–94, 95, 155; dialogue as motivating principle of, 6, 217; and Gran Fury collective, 7–8, 154, 155; "objectness" of isolated posters and images, 4–6, 154. *See also* ACT UP (AIDS Coalition to Unleash Power)

Simpson, Mark: ACT UP concentration camp float at NYC Pride March, 75–76; and *The Four Questions* poster, 184–86, 193–99, 201–2; Gran Fury collective disbanding, 184–85, 189–93; Gran Fury collective formation, 81–82, 95–96, 97, 108; *Kissing Doesn't Kill* funding, 116–18; New Museum *Let the Record Show* installation, *pl.*, 79–81; painting style of, 191; suicide of, 199, 204–5; Tompkins Square Park Riot, 139

situationism, 9, 127–29

Situationist International, 9

Sloan Kettering, ACT UP demonstrations at, 54, 155

Socarrás, Jorge: collaborative poster design process, 40–50; and community of Silence = Death collective, 34–38, 91–92; and formation of Silence = Death collective, 36–38

Social Security Administration, 161, 173

Society of the Spectacle (Debord), 9

Sorbonne Occupation Committee, 9

The Sound of Music (film), 87

Spisak, Neil, 109

Spray It Loud (Posener), 122

Staley, Peter, 68

Statue of Liberty, 54

Stonewall Inn riots, 98

Stop the Church action, 163

Student Mobilization Committee to End the War in Vietnam, 32

suicide: of Mark Simpson, 199, 204–5; of Steve Webb, 92–93

Surrender Dorothy, 107, 138, 139

Tabboo! (Stephen Tashjian), 116

tagline selection: *Silence = Death* poster, 45–46; *Women Don't Get AIDS, They Just Die From It* poster, 175

Taylor, Elizabeth, 113

Testing the Limits video collective, 77

There Is No Safe Space, Helix Queer Performance Network Flash Collective, *pl.*

Things Are Different Now (video), 208–9

Third International Conference on AIDS, 71, 73–75

Thirtysomething (television series), 98

Thistlethwaite, Polly, 161

Tolentino, Julie, 116